Artist's
Photo Reference
WILDLIFE

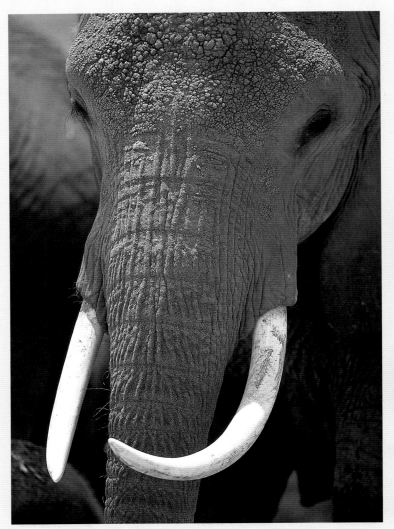
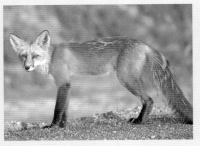
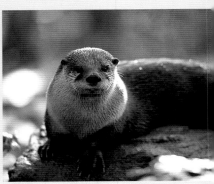
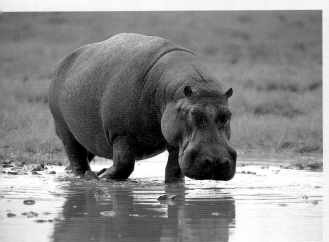
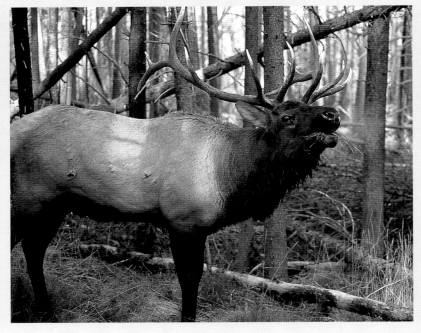

Artist's
Photo Reference
WILDLIFE

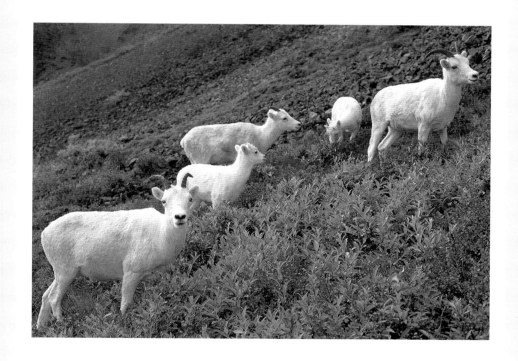

BART RULON

NORTH LIGHT BOOKS
Cincinnati, Ohio
www.artistsnetwork.com

About the Author

Born in 1968, Bart Rulon lives and works on Whidbey Island in Washington State's Puget Sound. He received a bachelor's degree from the University of Kentucky in a self-designed scientific illustration major. He graduated with honors and became a full-time professional artist focusing on wildlife and landscape subjects, specializing in birds.

Bart's paintings have been included in thirteen exhibitions with the Leigh Yawkey Woodson Art Museum, including ten appearances in the *Birds in Art* exhibit and one each in its *Wildlife: The Artist's View*, *Natural Wonders* and *Art and the Animal* exhibits. His work has been chosen for the Society of Animal Artists' exhibition *Art and the Animal*, each of the nine years since he became a member. His paintings have been included in the *Arts for the Parks Top 100* exhibition and national tour seven times, and in 1994 he won its Bird Art Award. Other recent awards include the Henderson Area Arts Alliance Award at the *2000 Kentucky National Wildlife Art Exhibit*,

Rocky Mountain Elk Foundation Featured Artist 2001 and the Audubon Alliance Artist of the Year Award for 1998. His paintings of birds are included in the permanent collections of the Leigh Yawkey Woodson Art Museum, the Bennington Center for the Arts and the Massachusetts Audubon Society. His paintings have been exhibited in over thirty-five museums including The National Museum of Wildlife Art, The Gilcrease Museum, The Carnegie Museum of Natural History and National Geographic Society's Explorer's Hall.

Bart is the author and illustrator of *Painting Birds Step by Step* (North Light Books, 1996), *Artist's Photo Reference: Birds* (North Light Books, 1999) and *Artist's Photo Reference: Water and Skies* (North Light Books, 2002). His work has been featured in four other North Light Books: *Wildlife Painting Step by Step* (Patrick Seslar 1995), *The Best of Wildlife Art* (edited by Rachel Rubin Wolf, 1999), *Keys to Painting Fur & Feathers* (edited

by Rachel Rubin Wolf, 1999) and *Painting the Faces of Wildlife Step by Step* (Kalon Baughan, 2000).

Bart's primary interest is experiencing animals firsthand in the wild. He prides himself on the time he spends in the field researching wildlife. "All this extra effort pays off in the long run because I get to see nature in ways most people never see," he says. "The exhilaration of having an orca surface twenty feet away from my kayak or watching the sun set on a mountain top gives me so much inspiration to paint."

Other fine North Light Books are available from your local bookstore, art supply store or direct from the publisher.

07 06 05 04 03 5 4 3 2 1

Library of Congress has Cataloged hardcover edition as follows:
Rulon, Bart.
Artist's photo reference : Wildlife / Bart Rulon ed.
 p. cm.
Includes bibliographical references and index.
ISBN-13: 978-1-58180-166-8 (Hardcover: alk. paper)
ISBN-10: 1-58180-166-1 (Hardcover: alk. paper)
ISBN-13: 978-1-58180-923-7 (Pbk.: alk. paper)
ISBN-13: 978-1-58180-923-9 (Pbk.: alk. paper)

1. Animals in art. 2. Painting from photographs. I. Title.

ND1380 .R775 2003 2002028594
758'.3—dc21

Edited by Jennifer Lepore Kardux
Cover design by Kelly Sohngen
Interior design by Nicole Armstrong
Interior production by Nicole Armstrong
Production coordinated by Mark Griffin

F+W PUBLICATIONS, INC.

Metric Conversion Chart

to convert	to	multiply by
Inches	Centimeters	2.54
Centimeters	Inches	0.4
Feet	Centimeters	30.5
Centimeters	Feet	0.03
Yards	Meters	0.9
Meters	Yards	1.1
Sq. Inches	Sq. Centimeters	6.45
Sq. Centimeters	Sq. Inches	0.16
Sq. Feet	Sq. Meters	0.09
Sq. Meters	Sq. Feet	10.8
Sq. Yards	Sq. Meters	0.8
Sq. Meters	Sq. Yards	1.2
Pounds	Kilograms	0.45
Kilograms	Pounds	2.2
Ounces	Grams	28.4
Grams	Ounces	0.04

Dedication

To my mom, dad and brother who are the best family a guy could ask for.

Acknowledgments

I would like to say thank you to the following people: First to Kalon Baughan and Sueellen Ross for contributing their beautiful work and techniques for this book. To my frequent travel buddies Kalon Baughan, Dave Sellers and Mark Boyle who were with me on many of these wildlife adventures. You guys are great! To Angie and Meagan for making my life better, for loving me despite the demands of my career, for having patience with me and for critiquing my work. To Sarah Scott for taking me to India! Photographing wild tigers was a dream come true. To Don Enright for always being there for me when I need a critique, or for borrowing this and that. To Shane and Jennifer Aggergaard, of Island Adventures, for allowing me to ride along all summer for some great killer whale photography. To all the talented guides that helped me find wildlife in India and Africa: Tirath Singh from India; Desderius Roman, Samson Mweta and Jackson Mbiha in Tanzania; and Preston Mutinda, Joseph Gichanga, Peter Muigai and Lawrence Nganga Ngugi in Kenya. To Jim Brower, John Morrison and Peter Cramer for being so patient with me wanting to "watch the leopard for five, ten or fifteen more minutes." To John Kipling for always letting me borrow camera gear when I'm in a bind. To my editor Jennifer Lepore Kardux, for being a delight to work with, and for being so patient with me.

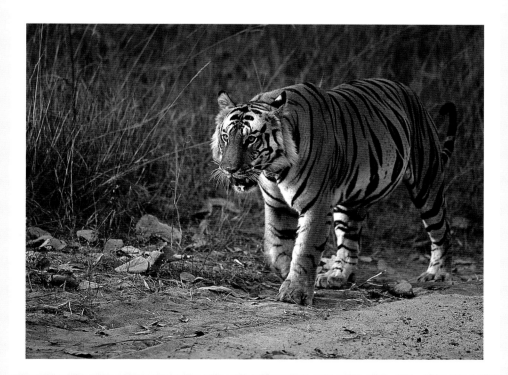

Table of Contents

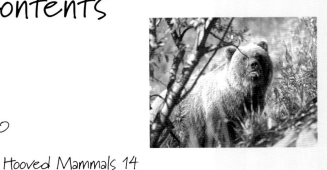

Introduction 8

How to Use This Book 9

Taking Your Own Reference Photos 10

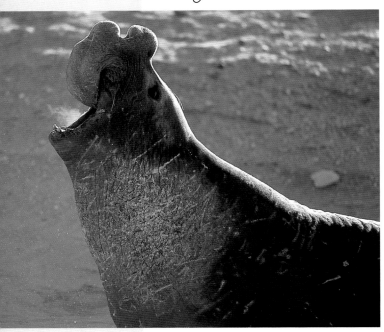

1 Hooved Mammals 14
White-Tailed Deer
Mule Deer
Black-Tailed Deer
Caribou
Elk

STEP-BY-STEP DEMONSTRATION
Elk in Acrylic
Moose
Bison
Mountain Goat
Pronghorn
Bighorn Sheep
Dall's Sheep

2 Predators 42
Brown Bear (Grizzly Bear)
Black Bear
Gray Wolf
Coyote
Red Fox
Bobcat
Cougar

STEP-BY-STEP DEMONSTRATION
Cougar in Oil

3 Small Mammals 64
Eastern Gray Squirrel
Townsend's Chipmunk
Raccoon
Fisher
Eastern Cottontail

STEP-BY-STEP DEMONSTRATION
Cottontail in Mixed Media

4 Aquatic Wildlife 80
American Alligator
Killer Whale (Orca)
California Sea Lion
Harbor Seal
Northern Elephant Seal
Sea Otter

STEP-BY-STEP DEMONSTRATION
Sea Otters in Acrylic
River Otter

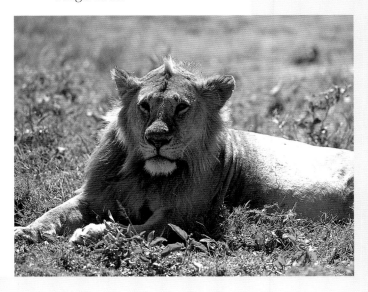

5 Wildlife of Africa 100

Lion
Leopard
Cheetah
Giraffe
African Elephant
Cape Buffalo
White Rhinoceros
Hippopotamus
Plains Zebra (Burchell's Zebra)
Impala

6 Wildlife of India 122

Tiger

STEP-BY-STEP DEMONSTRATION

Tiger in Watercolor
Asian Elephant
Spotted Deer (Chital)
Swamp Deer (Barasingha)
Sambar
Gaur (Indian Bison)
Rhesus Macaque
Hanuman Langur

Contributing Artists 140

Bibliography 141

Index 142

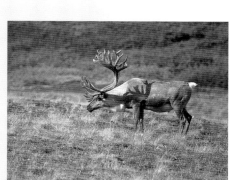

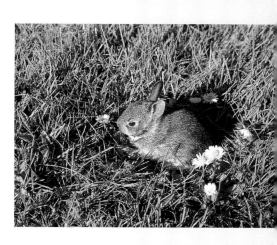

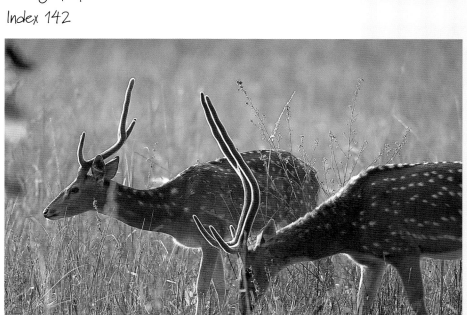

Introduction

Have you ever wanted to paint an animal that you didn't have any pictures of or passed up a painting because you needed more photos of the animal to show specific details? If you've ever been caught in one of these situations before, where you lack references for a wildlife painting, then *Artist's Photo Reference: Wildlife* is for you.

A search through magazines or books for the right reference pictures can take hours and hours. Even if you find what you are looking for in a magazine or book, you might hesitate to use it for fear of getting sued by the photographer. Most artists don't know how much they can copy from a published photo before getting in trouble. That is one of the reasons why I work from my own photographs. Yet there are times when I must turn to magazine files for a subject I don't have, or to supplement what I do have. This book is designed to

help solve some of these common problems. It is full of reference photographs that are put together with the artist in mind to help save time, effort and worry.

I have been taking special trips to photograph wildlife for my paintings for well over ten years now. My library of wildlife photographs has gotten huge in the process. I feel lucky to have spent so many hours observing wildlife in spectacular locations because that's my favorite part about being an artist. But not everyone has the time, money or desire to travel and see a bear, tiger or killer whale in the wild, much less get good photographs of them. It can be a difficult and time-consuming process. So that's the reason for a reference book on wildlife. I'm sharing a large portion of my personal photo library with you! You are free to use parts of the photographs as reference for your paintings as long as you don't copy the whole picture

exactly. The photos included here come from a variety of different places in North America including, but not limited to, Washington, Oregon, Montana, Wyoming, Alaska, California, Kentucky, Florida, British Columbia, Alberta and the Yukon Territory. You will also see photographs from Africa and India. I took all of these photographs, most of which are wild animals in the wild. I am a firm believer in experiencing wildlife in the wild whenever possible, instead of relying on zoo animals.

In addition to the photographs, five demonstrations, by several artists in a variety of media, will show how professional wildlife artists paint from their photographs.

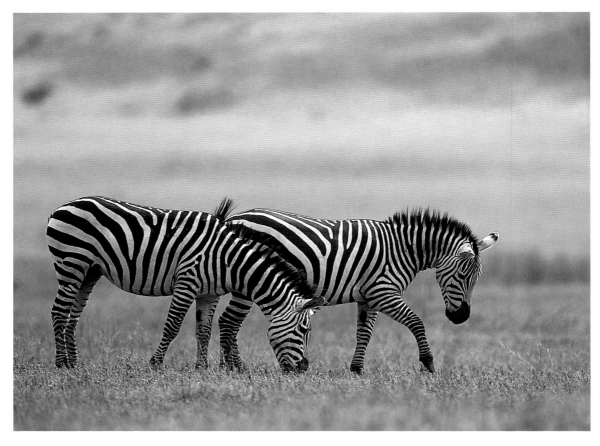

Use the reference photographs in this book to enhance your artwork. Take the pose of an animal from here and put it in your own landscape, or use one of these photos as supplemental reference for the details of fur or eyes. Always keep in mind that the colors in any scene constantly change during the day with different lighting situations. Try to match the situation in your painting with the situation in the reference photographs. For example, if your landscape reference depicts front lighting on a sunny day, then use a reference photograph of your subject front lit on a sunny day rather than on a cloudy day. When trying to match reference photos from different locations, keep in mind that colors in the landscape are often reflected on an animal and affect its appearance. For instance, a deer standing in the grass might have green reflected on its belly, but a deer standing on lightly colored dirt might have a warm glow on its belly.

Try not to copy the photographs in this book exactly, especially if you exhibit your work publicly or sell your work. It is not a copyright infringement to copy a reference photograph if the artwork is not put up for sale, exhibited publicly or claimed to be original art. Instead, take parts of the photographs to enhance your work. Add things, take things out and use the photographs to help build your own vision.

I have done my best to combine my personal knowledge of wildlife with in depth research to give you accurate information about each animal. However, keep in mind that this book was written by an artist, not a professional biologist, so if you should find a mistake, please forgive me. Because this book is primarily visual and room for text was limited, it was sometimes very hard to decide what information to leave in and what to take out. I tried to generalize the distribution ranges of each animal as much as possible, and in some cases, small parts of an animal's range may have been left out because of this.

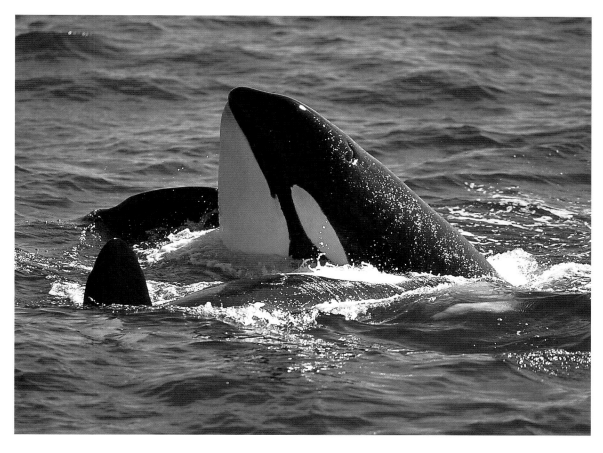

Taking Your Own Reference Photos

Experiencing your subjects in person is an important aspect of the creative process. Photography is a great way to do this. With a camera you can bring back memories to work from so much faster and easier than by drawing or painting on location.

Camera

Buy the best possible equipment you can afford. First you will need a 35mm Single Lens Reflect (SLR) camera; either a manual focus or autofocus camera will do. Make sure that the camera is one that accepts interchangeable lenses. This will give you versatility in how to capture each scene. Avoid the popular 35mm point and shoot cameras, even those with zoom lenses. These models don't give you the control needed to take the best reference pictures.

Many camera brands are sufficient, but be sure to choose a brand that has a large variety of lenses and accessories. Nikon, Canon, Minolta, Olympus and Pentax are the five major 35mm camera companies and they all have quality products. If you are starting from scratch, however, I recommend Nikon or Canon because they are the two brands used most by professionals. These two companies are known for their high quality, a large selection of lenses and a full line of important accessories.

Lenses

The most important part of your photography system is the lens. The lens directly influences the sharpness and quality of your photographs. Try to buy lenses made by the same manufacturer as your camera for the highest in quality and compatibility. Other manufacturers, such as Sigma, Tokina, Vivitar and Tamron make lenses to work with the major 35mm cameras. Lenses made by these companies are usually less expensive, and often lower in quality, but they are sufficient for most artists. If you prefer sharply detailed pictures for your work, consider the high-quality lenses made by the camera makers first. Run a test roll of film with any lens to make sure it lives up to your standards.

To take pictures like those in this book you will need a lens in the 200mm to 500mm focal range. The 200mm to 300mm range is ideal for photographing large animals that are easy to approach, or for including their habitat in the picture. The longer focal lengths of 400mm to 500mm are necessary for smaller wildlife subjects and those that will be difficult to approach. Almost all of the photos shown in this book were taken with a fixed 400mm lens. The most inexpensive and flexible way to cover this range is with a zoom lens. In general, fixed focal length lenses produce sharper photographs than zoom lenses of the same class, but the versatility of a zoom lens is hard to beat for an artist. With a zoom you can take close-up photographs using a long focal length and photos of an animal in its habitat with a shorter focal length, without changing your position. I have always used a fixed 400mm lens to photograph wildlife because of the detailed results, but there are many situations where I wish I had a zoom to frame my subject in different ways. Since zoom lenses tend to produce photographs that aren't as sharp as their fixed focal length siblings, it can pay off to invest in a more expensive zoom with higher quality glass than to buy a cheap one because your photos will probably show the difference.

Another option is to use a fixed focal length lens in tandem with 1.4x and 2x tele-extenders. A popular choice is to use a 300mm lens with these extenders because you can cover most of your ideal focal lengths for wildlife with this combination. Add a 1.4 to the 300mm lens and you have a 420mm, or add the 2x and you get a 600mm lens. Keep in mind that adding a tele-extender

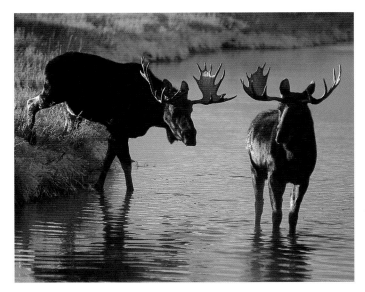

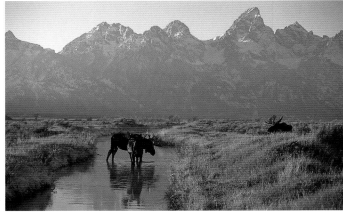

Zoom In and Out

Using a zoom lens is the quickest way to get a variety of photos of your subject from up close and personal, to seeing the animal in its habitat, both of which are important to capture for your artwork.

decreases your maximum aperture and decreases sharpness.

Tripod and Shutter Speed

A tripod is another essential tool for good wildlife photography. A tripod allows you to get the sharpest possible photographs when using a telephoto lens in almost any situation. This is true especially in low lighting situations, when holding the camera by hand doesn't have a chance. A monopod is a useful substitute, but it is not nearly as stable as a tripod. When photographing from a car, use a window mount or a bean bag on the door to support your camera and lens.

Because you can shoot at slower shutter speeds with a tripod, you can also use smaller aperture settings for greater depth of field. This means more of the picture will be in focus from the foreground to the background or from the front of an animal to the back. Depth of field can make the difference between the whole animal being in focus or just a small portion of it. Use the depth of field preview button on your camera to check if all the important details will be in focus before you push the shutter. When shooting for depth of field, the shutter speeds will be slower and a moving subject might turn

out blurry. Telephoto lenses magnify accidental camera movement much more than a smaller lens does. So when taking photographs at slow shutter speeds be sure to use a light touch or use a cable release to reduce movement. You can find a cable release or remote shutter release for your camera at most camera stores.

A few camera companies have come out with image stabilization technology for their lenses. Canon was first to introduce it, and Nikon followed with their own version called vibration reduction. By the time this book is published, other manufacturers probably will have similar technology. The vibration reducers are built into certain lenses to reduce camera shake. This allows you to hand hold a camera with sharp results using slower shutter speeds than ever before. The general rule is that you can shoot at shutter speeds two aperture stops slower than with conventional lenses. For example, the long-time rule of thumb with a regular lens is that you can only hand hold a 300mm lens successfully at shutter speeds over 300th of a second. With image stabilization you can hand hold a 300mm lens at 125th of a second shutter speed. I have one of these vibration reduction lenses and it works very well. It is particularly

useful when shooting from a car or boat or when using a monopod. The technology is great news for those who refuse to use a tripod, but it's still not a substitute for one.

Film

I prefer to use slide film because it is more accurate and detailed than print film. With print film you are partially at the mercy of the film developer as to how the color and contrast turns out in your pictures. With slide film you have more control over the picture.

Slow speed films are sharper than higher speed films. If you use a tripod, you can use films with slow ISO ratings of 50, 64 or 100. If you hand hold, you might have to use 200 or 400 speed film, resulting in less detailed pictures. I prefer 50 to 100 ISO speed films.

Choosing the right film can be very difficult. You can photograph the same scene with a number of different films and get vastly different color results. Some will be closer to reality than others. Today many films are intentionally made to have supersaturated colors that are not accurate, but attractive. Also, some films render certain colors better than others. To find out more about how accurate or supersaturated a film is look for information from the manufacturers

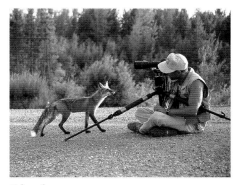

Tripod
For the best results always use a tripod. I prefer one that will allow me to get close to the ground, like with this curious red fox. It should also extend out quickly to eye level for use in a standing position.
Photo by Dave Sellers

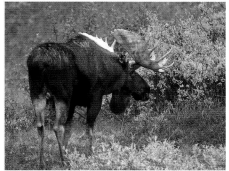

Color Differences in Film
The color renditions in different films can vary drastically. Compare the results of the same moose in the same habitat taken within two minutes of each other, but with different films. The standing moose is from Kodachrome 64 slide film, and the resting moose is from Fujichrome Provia 100 slide film.

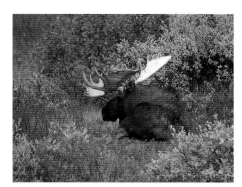

at professional camera stores or call the film company. Several popular photography magazines do annual film comparisons that list film characteristics.

Bracketing

An important technique when using slide film is to bracket your exposures. Bracketing means to intentionally underexpose and overexpose film in addition to taking a photo at the camera's recommended exposure setting. You can achieve this by changing the shutter speed or the aperture or by changing your exposure control dial to -1 or +1, etc. A bracketing of ½ stop or 1 stop increments is sufficient for most scenes. Camera meters are good but not perfect. They tend to be wrong when photographing subjects that are extremely light or dark. A bright sky, backlighting, snow, sand or any animal that is white or black are common problems for camera meters. By bracketing a few extra photos you are more likely to have at least one photo with the correct exposure. Some cameras have special bracketing programs to make the

process even easier. Bracketing is not as important with print film because of its more forgiving nature.

Camera as Composition Tool

In the field, use the camera as a tool to frame the best compositions for your paintings. Try to compose your subject using the same principles as in painting. That way the photos will be more useful to work from. Also look at your wildlife subjects from different angles to find the best vantage point for a painting. Whenever possible take the time to see if your subject looks better with backlighting, sidelighting or frontlighting. Get close-up photos as well as photos from a distance that include habitat.

How to Find Wildlife

Chances are there are opportunities to photograph wildlife near your home. The key to finding wildlife is good habitat. If you know the habitat of an animal, find these areas and look for your subjects there. Dawn and dusk are usually the best times of the day to look for animals, and the lighting is best for

photography then too. Drive down back roads, ask locals where they see wildlife or join a bird watching club. National parks and wildlife refuges are fantastic places to find wildlife. In fact, animals are often much easier to approach in these protected areas because they are safe from hunters and are often familiar with human traffic.

How to Get Close to Wildlife

You often have to think like a hunter to get close enough to photograph wildlife. Even in parks or refuges where wildlife is approachable, you should still be cautious. Approach wildlife slowly. Quick movements are most likely to scare them off. Watch the reactions of an animal as you approach it. An animal's body language often says whether it's comfortable or getting nervous. If an animal is feeding, resting or not paying much attention to you it probably feels at ease with your presence, and you might be able to move in closer. If the animal is staring at you, looks tense or is walking away, you may not be able to get any closer. When an animal gets

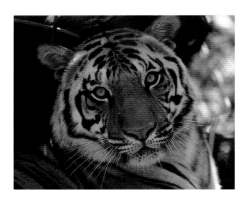

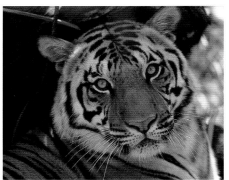

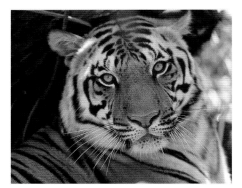

Bracketing Your Photos
Bracket the exposures on your pictures to assure that at least one photo turns out well. Little did I know it, but my camera's meter didn't read this scene correctly. The photos would have all turned out dark if I hadn't bracketed. If you don't bracket, you risk the chance of all your pictures turning out too light or too dark, especially in tricky lighting situations. If you have a camera with a built-in bracketing program, you can take a series of photos quickly without missing the action.

nervous, freeze in your tracks until it calms down enough to approach.

If you take the time to approach an animal slowly and deliberately, you're more likely to succeed. It takes time before animals feel comfortable with a person nearby. For instance, a deer might let you approach within 40 feet after half an hour of slow approach. If you tried to close the same gap after only a few minutes, the deer would surely run off in a flash.

With some animals you must avoid approaching them directly, and staring at them the whole way, because this imitates the way a predator stalks its prey. Instead, pretend that you're not paying attention to the animal. Act as if you have other objectives like picking flowers, and walk in a indirect or zig-zag manner toward the wildlife. Try not to look directly at your subject.

It's best not to stress wild animals for their own well being and yours too. A stressed animal is more likely to attack you than one that is comfortable. Almost any wild animal can become dangerous if you are not careful. Animals such as

bear, bison, elk and moose frequently maul people who get too close to them. During the mating season male animals of many species become particularly aggressive, and a mother animal will fight hard to protect her young. To help avoid getting attacked you should pay close attention to the body language of every animal, never approach a mother with young too closely, stay close to your car when possible and don't ever corner your subject without leaving it an escape route. Finally, use a telephoto lens so that you can photograph from a safe distance.

When you're dealing with animals that are really skittish, use camouflage like a hunter so they will approach closely without knowing you are there. Set up a camouflage blind with openings for your camera and peepholes to survey the area. Even in a blind you will have to be careful. Any movement or sound can scare a critter away. Even the sound of the camera can be enough to spook a wary animal. Your car can make a great blind. If you find an animal near the road, you should stay in your

car and photograph from the window. Animals are more likely to accept the presence of a person in a car than a person on foot. I've also found that wildlife in and around the water are easier to approach in a kayak.

With all this emphasis on getting close, don't forget to take photos from far away to show the animals as part of their habitat. Have patience with your subjects because you never know when something interesting might happen. Be ready at all times!

Photograph From Kayak **Photograph From a Camouflage Blind**

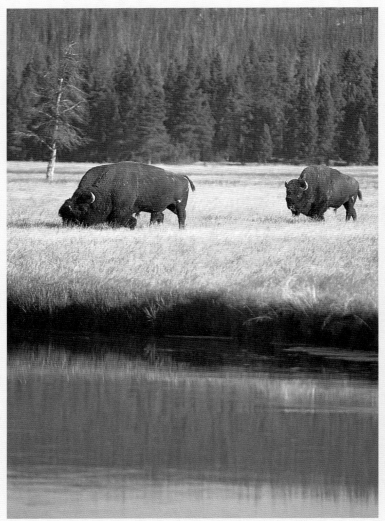
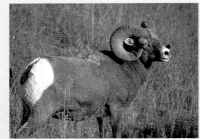
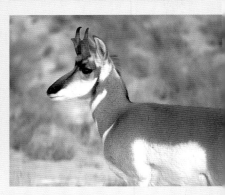
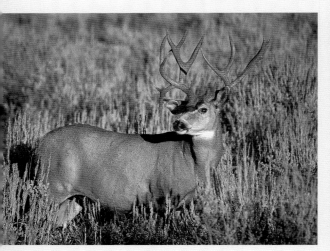
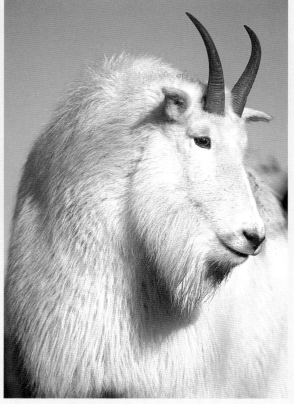

Hooved Mammals

The hooved mammals in this book can be separated into two different groups: those with antlers and those with horns. This chapter covers animals from both groups. Keep in mind that gender, age and season can alter the color and appearance of both the antlers and fur coats of these animals.

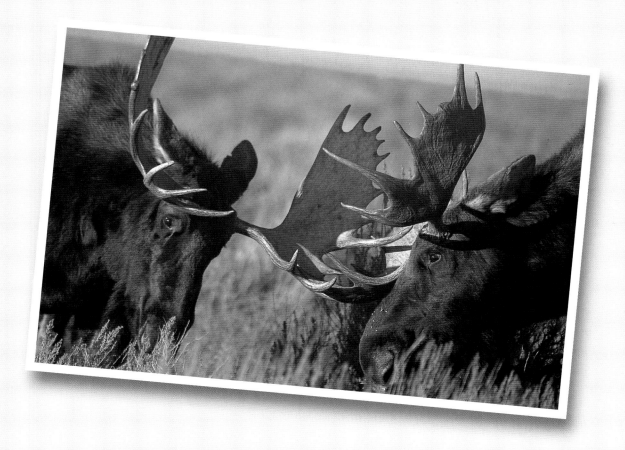

White-Tailed Deer

White-tailed deer range across most of the United States, southern Canada, and south into Mexico, Central America and northern South America. They are absent from the coastal Pacific Northwest areas of Washington and British Columbia and most of the southwestern states. They have also been introduced into Scandinavia and New Zealand.

Their habitat includes heavy forests, forest edges, brushlands, swamps, open prairies and mixed farmlands.

Males (bucks) get larger than females (does). Only bucks grow antlers. When alarmed this deer raises its tail exposing white on the underside.

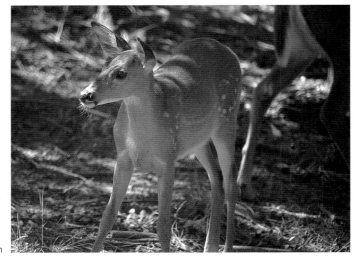

Fawn

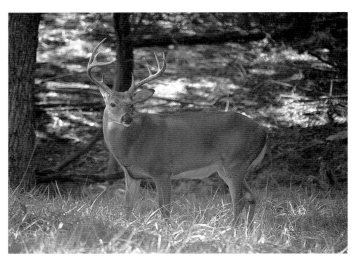

Buck

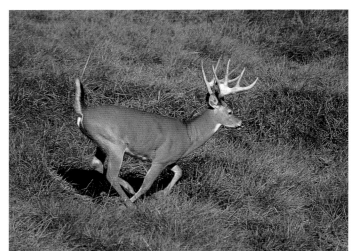

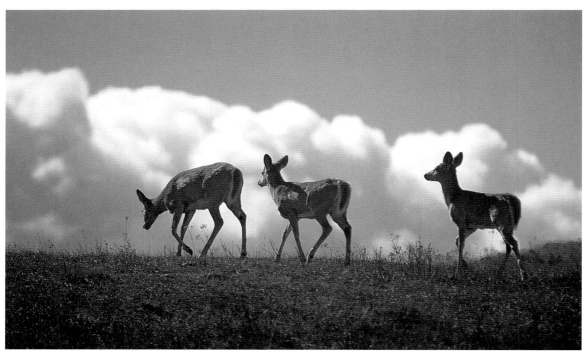

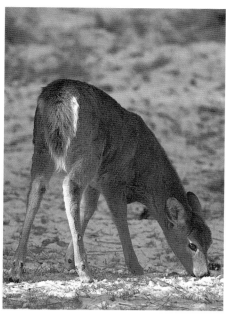 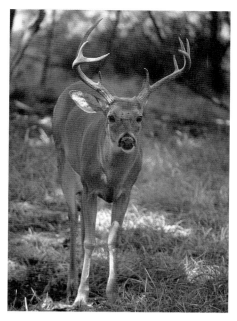 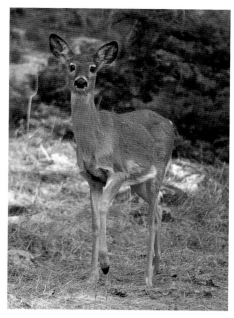

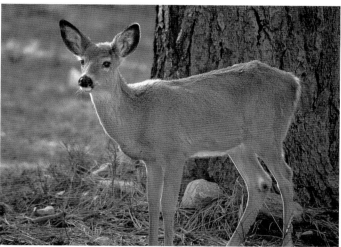 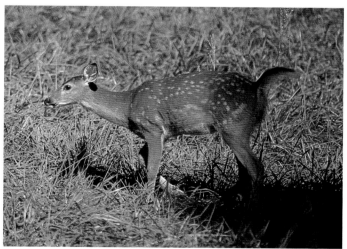

Doe

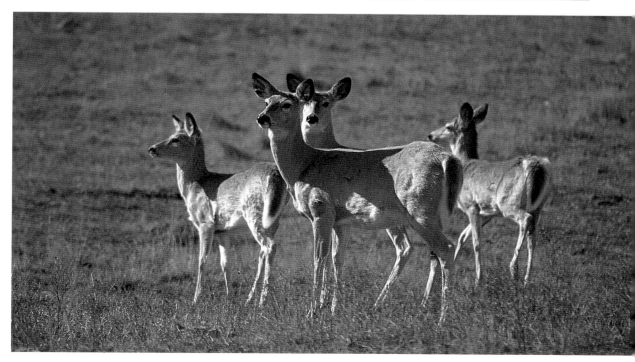

Mule Deer

Mule deer inhabit the western parts of Canada and the United States as far east as Wisconsin and western Texas and south into northern Mexico.

They prefer open forests, sagebrush, brushlands, mountains, prairies and river valleys.

Males (bucks) grow larger than females (does) and only males have antlers. Mule deer and white-tailed deer differ in several ways. The most obvious differences are that mule deer have larger ears, the bucks have forked antlers, and mule deer tails are smaller and colored white with a black tip.

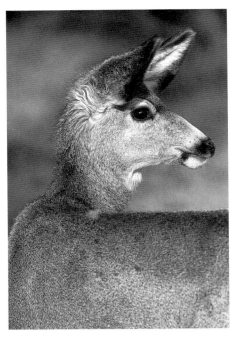

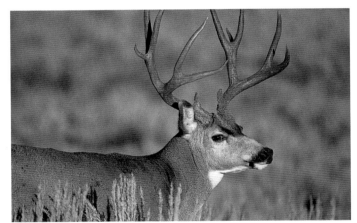

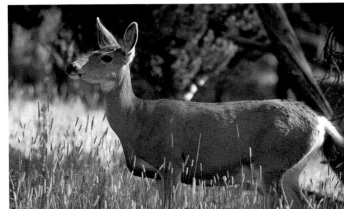

Doe

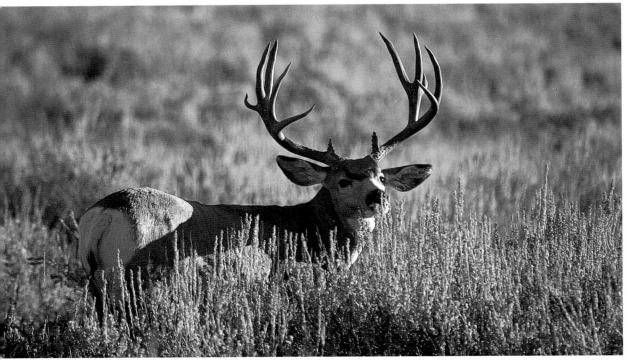

Buck

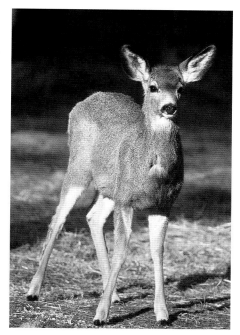

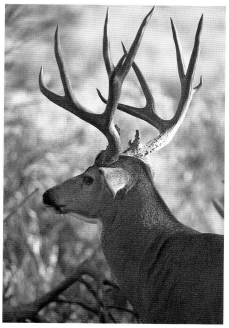

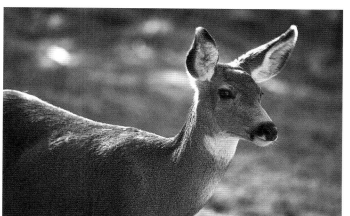

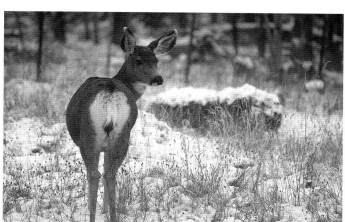

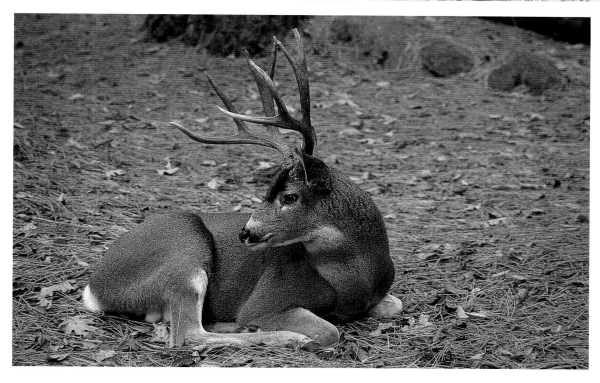

Black-Tailed Deer

Black-tailed deer are a smaller subspecies of the mule deer that inhabit the moist forests of the Pacific coast from northern California to the Alaskan panhandle, west of the Pacific Coast Mountain Range.

The most notable physical differences of this mule deer subspecies are its smaller size, a tail that is completely black on its top side instead of white at the base and no white rump.

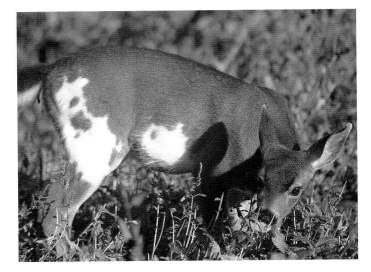

Fawn

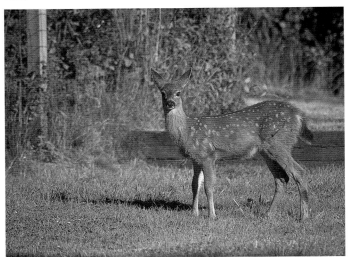

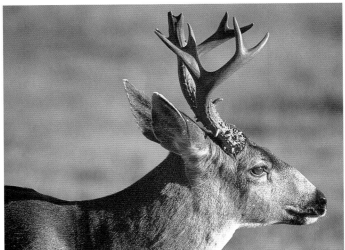

Buck

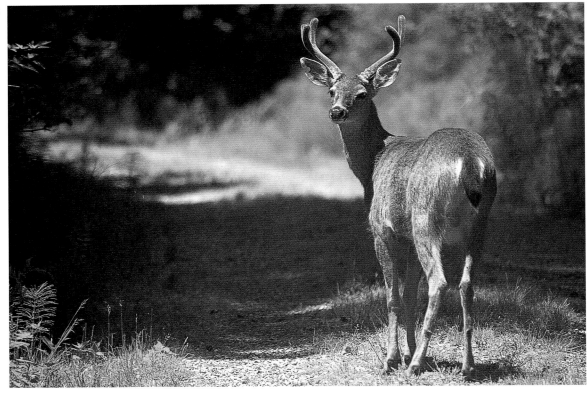

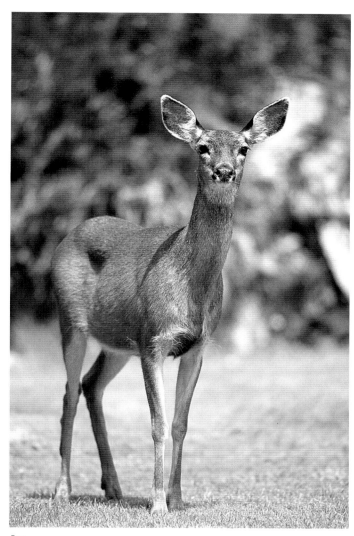

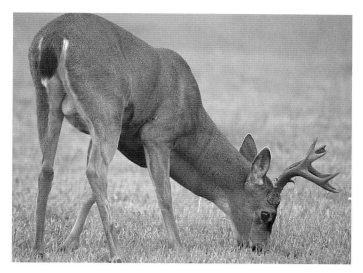

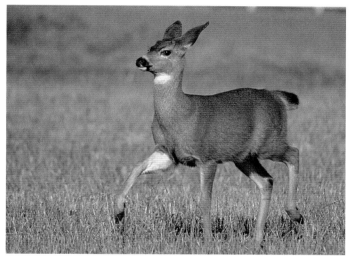

Doe

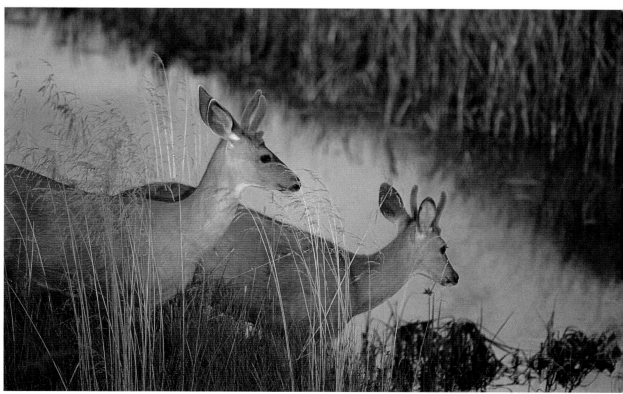

Caribou

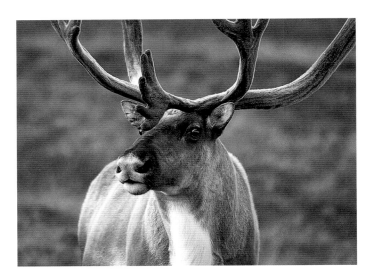

Caribou range throughout most of northern Canada and Alaska. They are also found from Jasper National Park in Alberta and British Columbia south to the panhandle of northern Idaho and in Scandinavia, northern Asia (where they are called reindeer) and Greenland.

Their habitat includes alpine and arctic tundra and nearby taiga forests. They tend to migrate from open habitat in summer to taiga forests in winter.

All caribou and reindeer are of the same species but they include several different subspecies that can vary in color and antler size. (All photos here are of the barren ground caribou subspecies found in Alaska and northern Yukon, whose males grow the largest antlers of all the subspecies.)

Males (bulls) are larger than females (cows). Both sexes develop antlers, but the males' antlers grow much larger than females'.

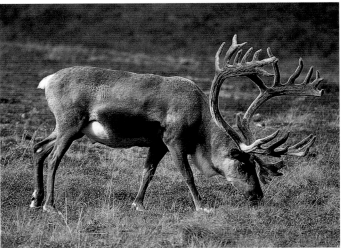

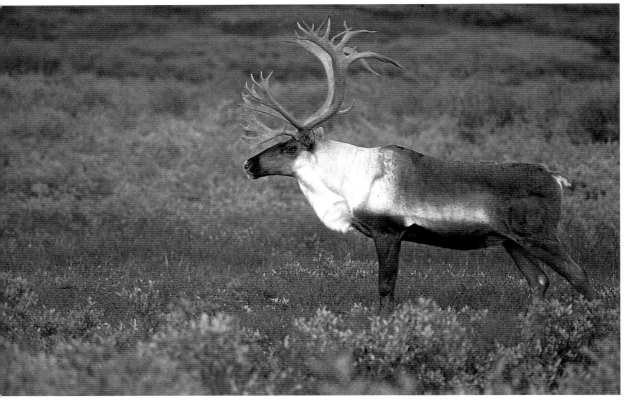

Bull

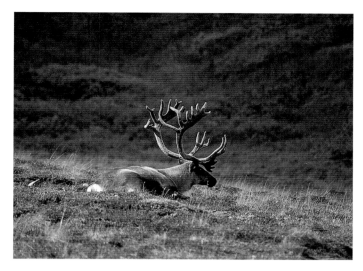 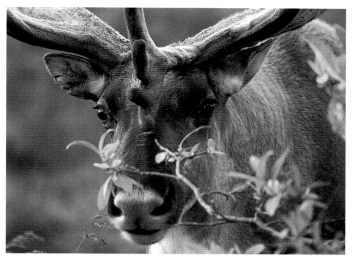

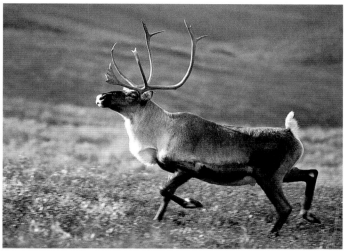 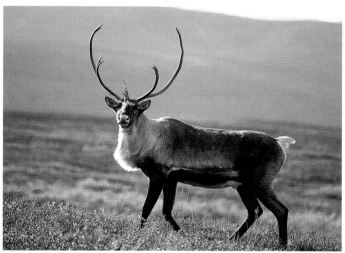

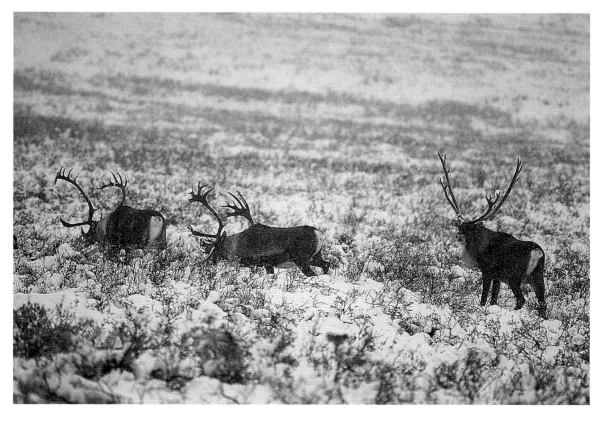

Elk

North America has four subspecies of elk. The Rocky Mountain elk is the most numerous and ranges in and around the Rocky Mountains from northern British Columbia south to New Mexico. The Roosevelt elk, in the Pacific Northwest, is the largest. The tule elk, in west central California, is the smallest. The Manitoba elk originated in central Canada. Other small populations are found in Texas, the Great Plains and, via reintroduction, in some eastern states. Elk migrate downward from mountain meadows and forests in the summer to valleys and flats in the winter.

Many other subspecies of elk occur from Europe to Far Northeast Asia, including eastern China, Manchuria, Mongolia and the Middle East, and they have been introduced into New Zealand.

Only males (bulls) have antlers, and adult males grow larger than females (cows).

Calf

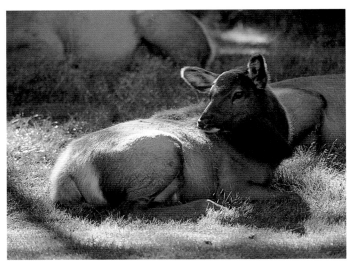

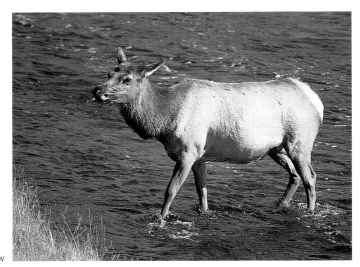

Cow

Bull bugling

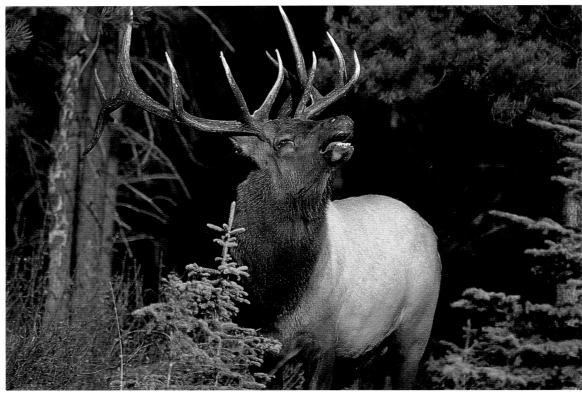

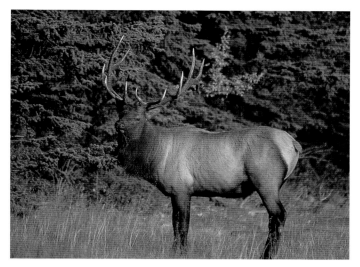
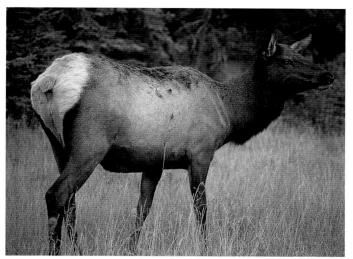
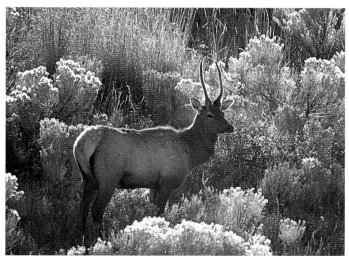
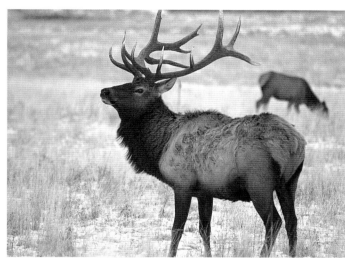

Young Bull

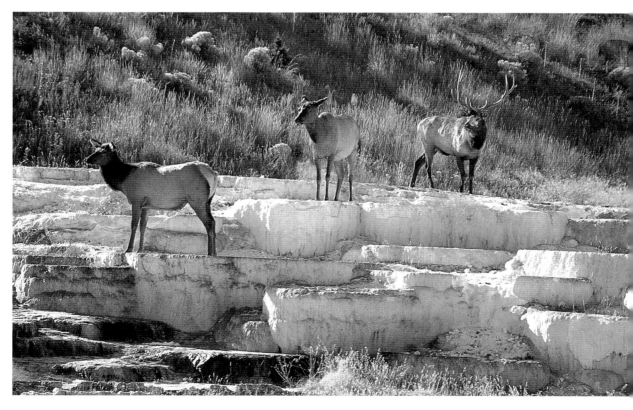

Elk in Acrylic

Materials

Surface
Hardboard panel primed with gesso

Brushes
Filbert no. 8
Flat no. 12
Rounds no. 000, no. 1, no. 3, no. 5

Palette
Golden Acrylic—C.P. Cadmium Yellow Light, Raw Sienna, Raw Umber, Titanium White

Liquitex Acrylic—Burnt Sienna, Ivory Black, Naphthol Red Light, Ultramarine Blue

Other
Water used as a painting medium with each painting mixture

This painting demonstrates how to use several photographs to make an interesting painting. It also shows how to pick out additional reference photographs and use them to fit a subject into a scene with consistent lighting. I took the main reference photographs for this painting in Yellowstone National Park within a few minutes of each other using a 400mm lens and a tripod. Any time you start a painting where you must recreate the lighting on an animal, be sure to find additional reference photos to help pull it off before you get started. To make a painting believable, it is essential to make sure the colors and lighting on an animal are consistent with the background.

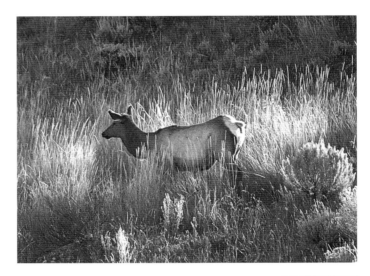

Main Reference Photo
This reference photograph of a cow elk sparked my interest because of its beautiful lighting and nice composition. It serves as the main reference for the background and the cow elk in the painting. Use habitat photographs that include an animal in them as a size reference whenever possible.

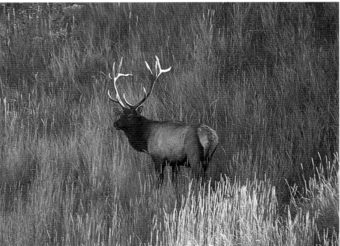

Reference Photo for the Bull Elk
This photograph serves as a great reference to include a bull elk in the scene because it is taken in the same lighting situation as the above photo, although this elk is standing in the shadows.

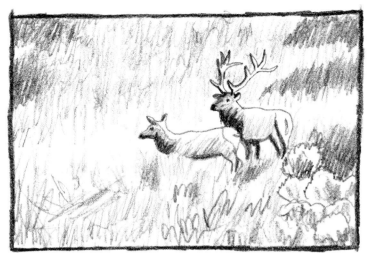

1. Utilize a Thumbnail Sketch

Use thumbnail sketches to work out the composition before starting the drawing. Try to position the bull in various spots around the cow.

2. Complete the Drawing

Draw the elk on scrap paper and work out all the problems before transferring it to the board. Bull elk are larger than cows so make sure to make him larger. For the background just draw in the outlines of the sagebrush.

3. Block in the Background

The first painting step is all about getting approximate colors on the board to help judge later mixtures of paint. Use the no. 12 flat brush and the no. 8 filbert to block in the colors in the background using the middle tones for each area. Make the greens in the foreground and background with a mix of Cadmium Yellow Light, Ultramarine Blue, Raw Umber, Titanium White and Ivory Black. Add more Ultramarine Blue and Ivory Black to the mix for the sagebrush's cooler color.

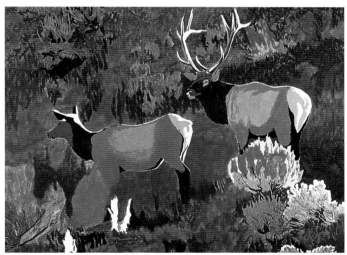

4. Block in the Elk

Use the no. 12 flat brush to block in the sides of the elk with a mixture of Raw Sienna, Titanium White, Raw Umber and Ultramarine Blue. Use less white for the darker areas indicated in the photo. Use the no. 5 round to paint the neck with a dark mixture of Raw Umber, Ivory Black and Titanium White. At this point don't worry about blending. For the rump use a mix of Ultramarine Blue, Naphthol Red Light, Titanium White and a touch of Raw Umber. Leave the highlights white for now. Continue to darken the green colors in the habitat with the same mixtures as in the previous step.

5. Begin the Details

For the background, work from dark to light in areas where dark dominates and from light to dark in areas where light dominates. Refer to the reference photos closely. Use the no. 3 round for some of the darkest details in the head, neck and body of the elk. Blend the edges where applicable using a scumbling technique. For the skinny highlights on the backs of the elk, use your no. 1 and no. 000 round brushes to paint a thin layer of Raw Sienna and Titanium White. Add Burnt Sienna to this mix for the highlight on the back of the cow elk. Keep highlight mixes thin so the white beneath can show through the color and make it glow.

For the details in the habitat, paint the shapes and details that jump out at you first. These will help you find your place in the photo for other details later. Afterward use a combination of painting exactly what you see and improvising. Grass can make you cross-eyed if you try to paint every blade exactly. Start to paint a few of the highlights in the grasses behind and in front of the elk so you know how dark to make the background in comparison. Mix Titanium White and Raw Sienna for the grass highlights.

6. Define the Elk

Work in some of the middle tone details on the elk with a combination of scumbling and glazing using the no. 3 and no. 1 rounds. Glaze a mix of Ultramarine Blue, Naphthol Red Light, Raw Sienna and Titanium White on the back of the elk using the reference photo as a guide. The blue shade is a reflection of the sky. For the rumps, paint in some of the darker shadow details, and glaze on some warm reflections with a mix of Raw Sienna, Titanium White, Ultramarine Blue and Naphthol Red Light. Finish the antlers, paying special attention to the subtle warm and cool tones shown in the photo. Much of the bright highlight on the elk has a slight

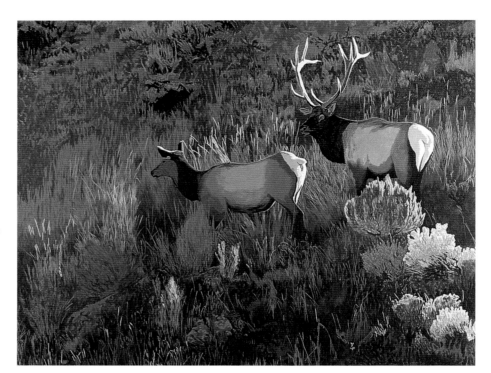

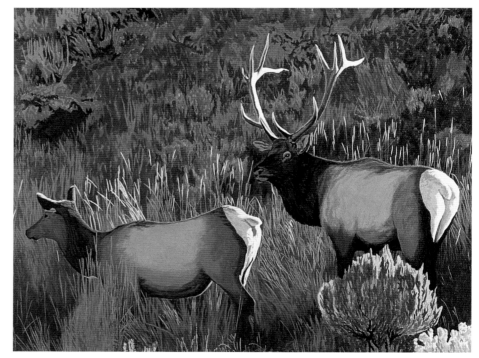

warm tone. Glaze it on with a mix of Titanium White and Raw Sienna.

Continue to refine the tones and details in the habitat with many different brushes and a variety of similar mixtures. Step back and focus on what areas need to be lightened or darkened.

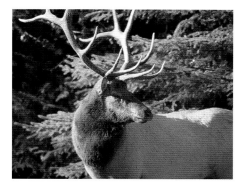

Lighting Guide
Use this photograph as a guide to make up the lighting on the bull's head. In a situation like this, try to find a photo with the head in a similar position and estimate what the path of light will look like.

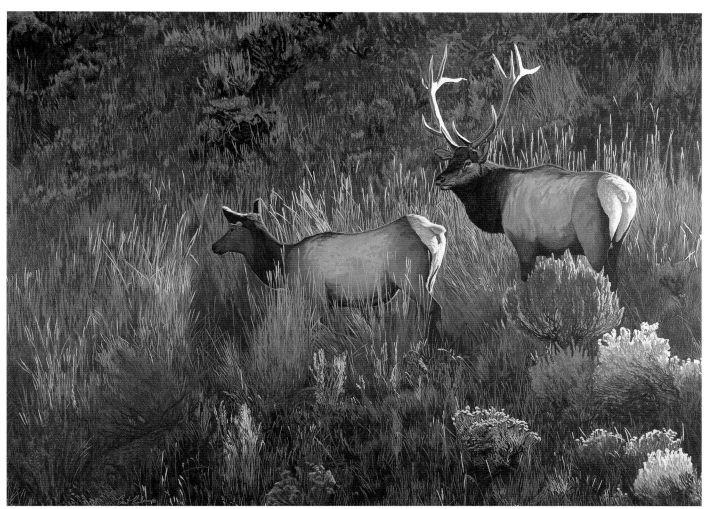

7. Finishing Touches
Finish up the details of the elk, being careful to blend with a scumbling technique to avoid hard edges. Refine the blending of the blue cast from the sky and warm reflections from the grasses on the bellies of the elk. Add light to the bull's face to make him consistent with his new lighting situation. When the cow elk is finished, you can add the grasses in front of her belly. Finish all the highlights from the grasses caught by light. Dull down the rock and the dead bush on the left side with glazes of Raw Umber, Raw Sienna and Ivory Black. To reduce the sharp edges in the background and make it recede, blend the colors with a scumbling and glazing technique. Scumble the dark colors into the light ones, and glaze the light colors into the dark. This helps add to the illusion of depth.

Into the Light
Bart Rulon
22" x 28" (56cm x 71cm)
Acrylic on hardboard panel

Moose

Moose range across most of Canada and Alaska, northern New England, the upper Midwest, and the northern Rocky Mountains. North America has four subspecies of moose. The largest is the Alaska moose. In northern Eurasia moose range from Scandinavia to eastern Siberia. The European moose has smaller antlers than the North American moose. The European moose is also more uniformly dark all over its body than the North American moose, which tends to have a light saddle marking over its back.

Moose habitat includes forests, swamps, the shores of lakes and streams, willow thickets, tundra and sagebrush flats.

Males (bulls) get larger than females (cows), and only males grow antlers.

Calf

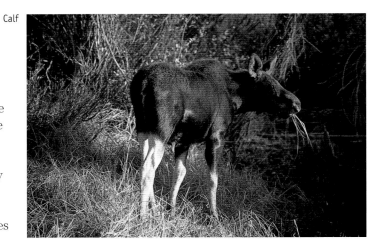

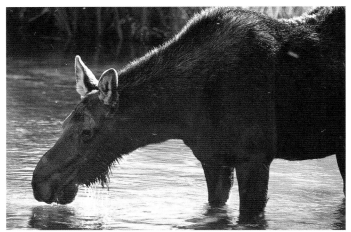

Cow

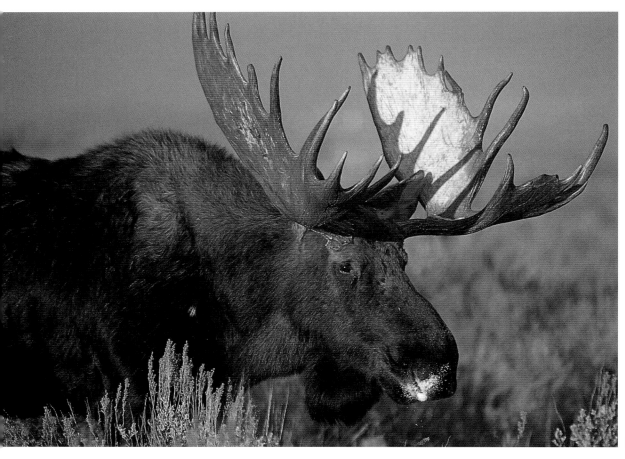

Bull

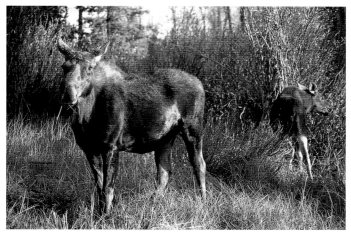

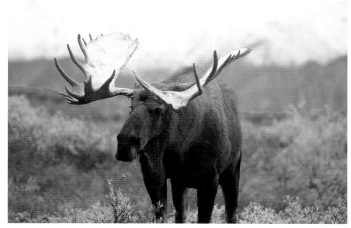

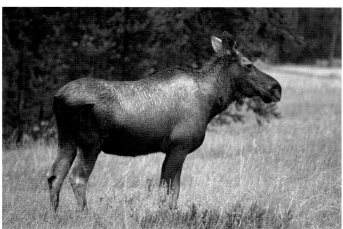

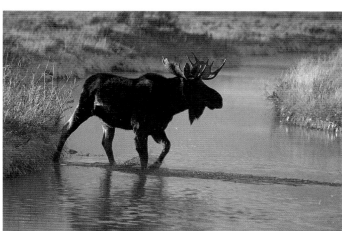

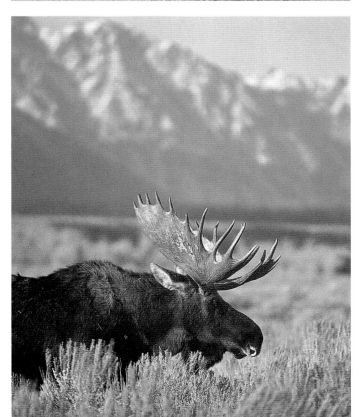

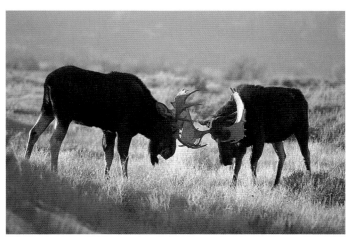

Bulls fighting

Bison

Today bison are only found in scattered populations in the western United States, western Canada and Alaska. Some of these areas include Yellowstone and Grand Teton National Parks, Wood Buffalo Provincial Park and the National Bison Range.

Their habitat includes arid prairies and plains and open forests.

Males (bulls) can grow much larger than females (cows), but both sexes have horns.

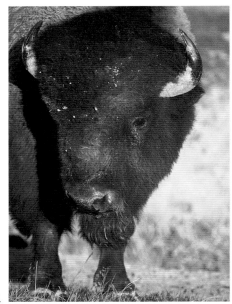

Bull

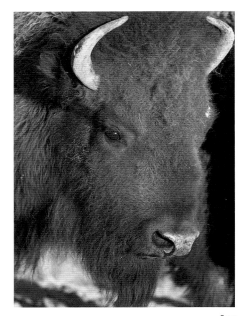

Cow

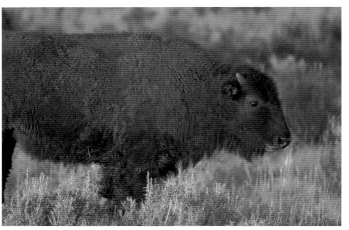

Calf

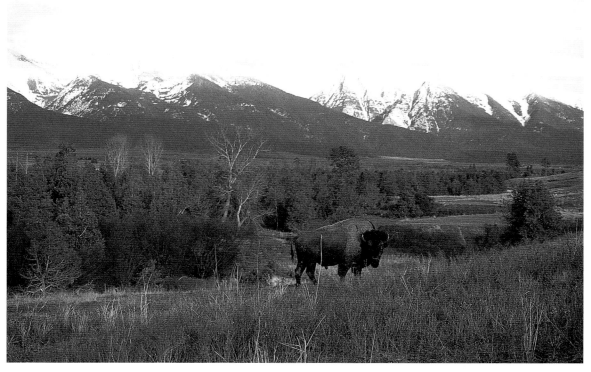

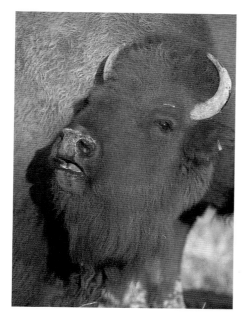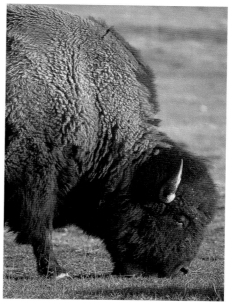

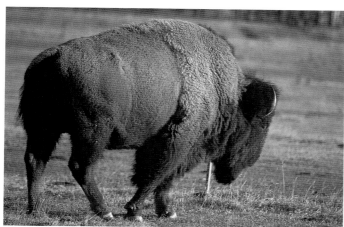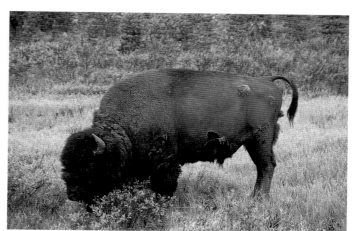

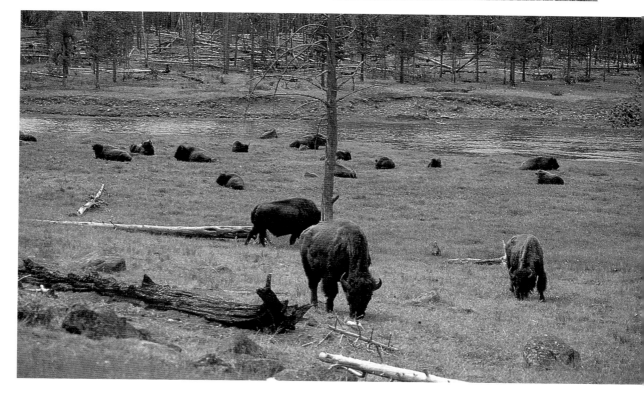

Mountain Goat

Kid

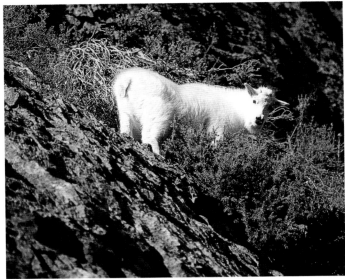

Mountain goats range from Wyoming to the Yukon Territory in the Rocky Mountain range, and from Washington to southern Alaska in the coastal mountain ranges. There are also populations in the mountains of Colorado, Nevada, Utah, Idaho and South Dakota.

Their main habitat is rugged mountains, steep rocky slopes, grassy slopes and alpine meadows.

The sexes look very similar, but males (billies) can get larger than females (nannies). Both males and females have black horns, but the males' can get a little thicker at the base and tend to curve back all the way from the base to the tip. Males have a black crescent-shaped gland at the base of each horn that gets more prominent during the mating season.

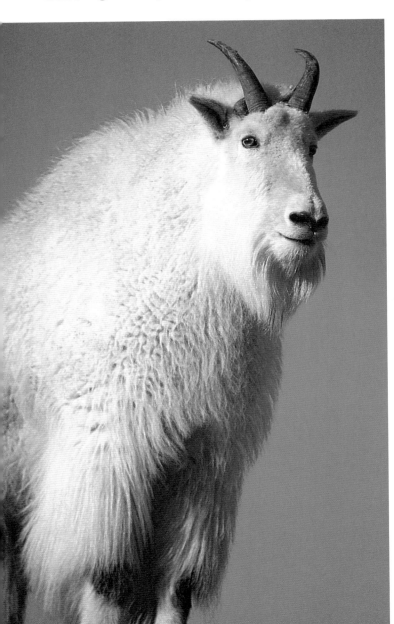

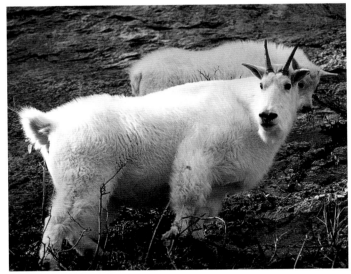

Nanny and kid

Billy

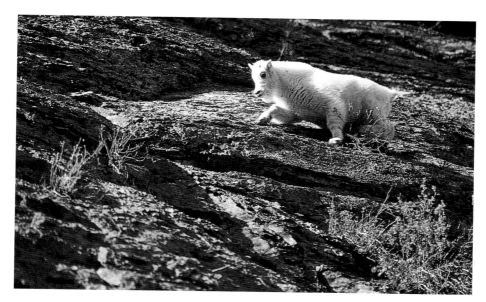

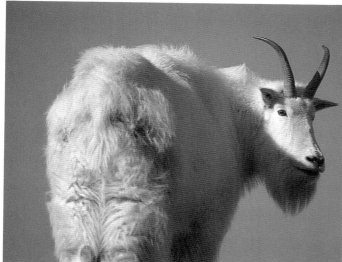

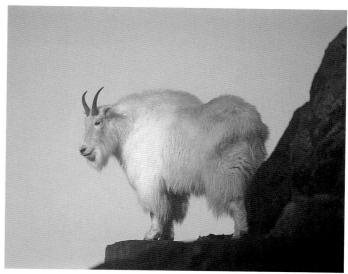

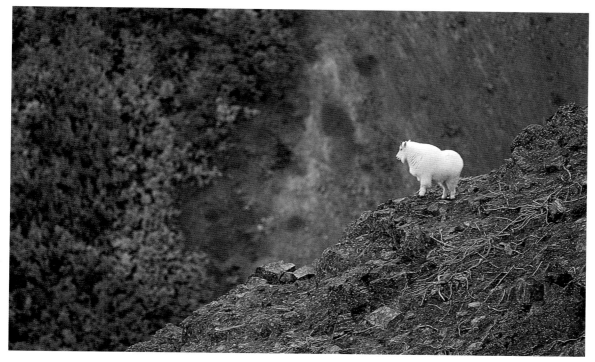

Pronghorn

Pronghorns are found in the western United States from the east side of the Pacific Coast Mountain Range across to Texas and up to southern Canada. They also range southward into Mexico.

Their habitat includes arid plains, prairies and brushlands.

Males (bucks) are slightly larger than females (does). All males and some females grow horns, but the males horns grow larger and forked. Their horns have a unique sheath that is shed each year after the mating season, leaving a small pointed base on the animal. Bucks have more black on their faces than does. Only bucks have a black patch on both sides of their neck behind the cheeks.

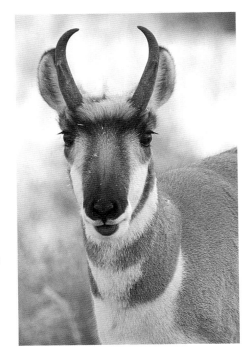

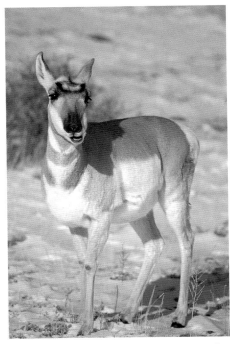

Doe

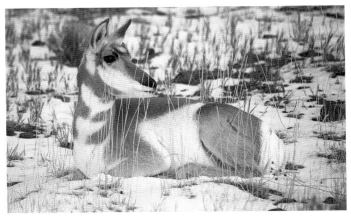

Buck

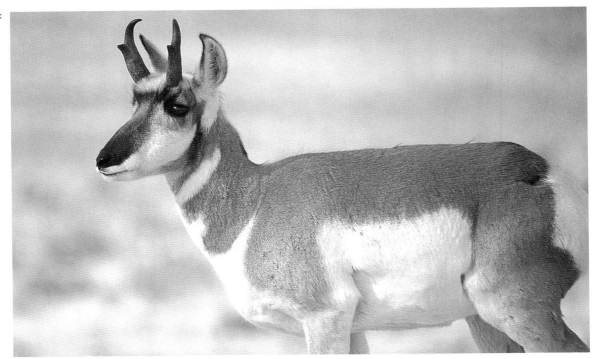

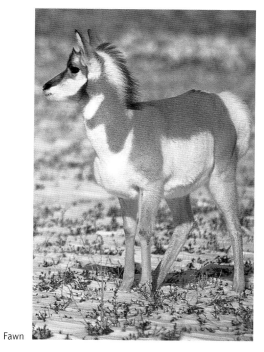

Fawn

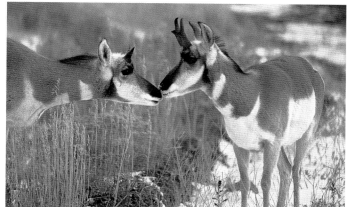

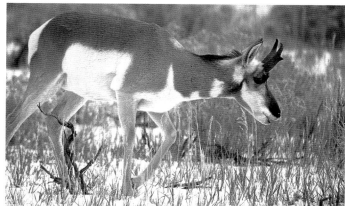

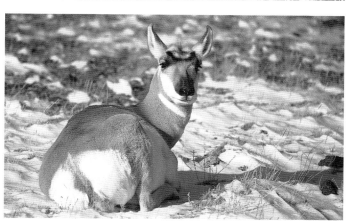

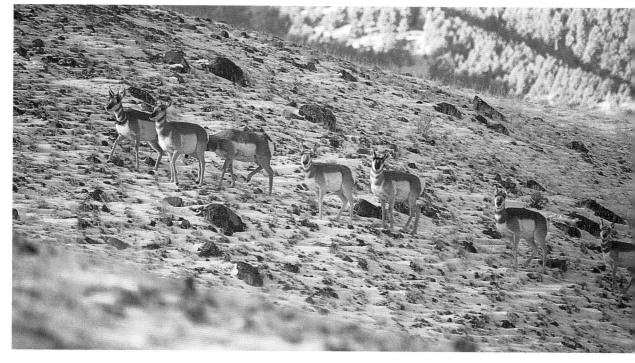

Bighorn Sheep

Bighorn sheep range throughout the Rocky Mountains and outlying ranges from British Columbia and Alberta down to Mexico and also in the Badlands of South Dakota.

They prefer rugged rocky mountains and alpine meadows, but they often roam down to open prairies and meadows to feed if cliffs are close at hand.

Males (rams) grow larger than females (ewes). Both rams and ewes have horns, but the horns of ewes are much smaller and do not make a full curl.

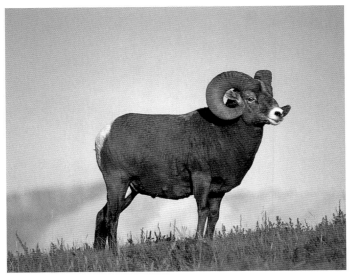

Ram

Ewes
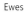

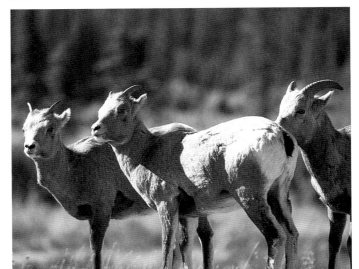

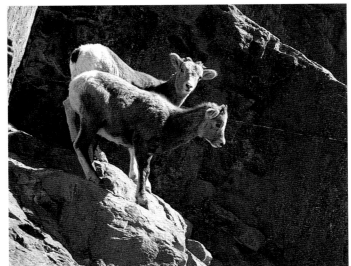

Lambs

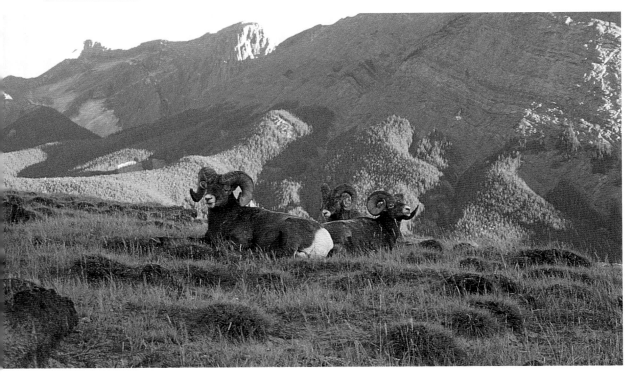

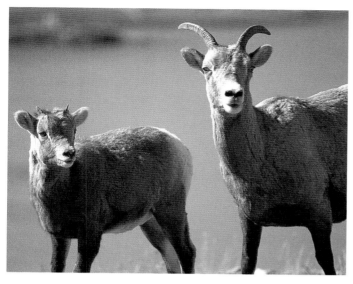
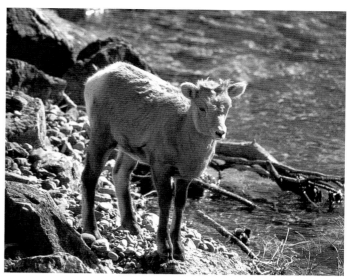
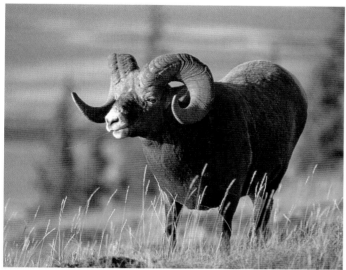
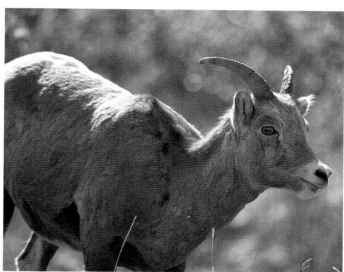
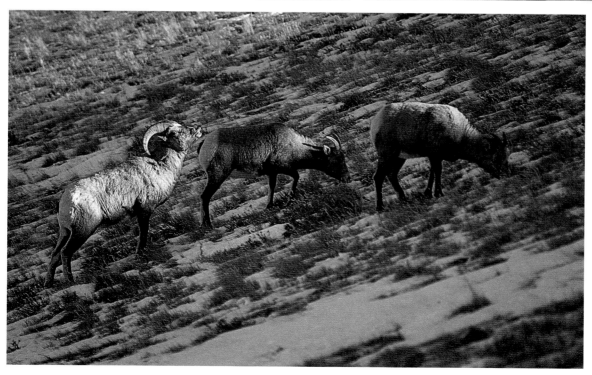

Dall's Sheep

Dall's sheep range from the Brooks Range in Alaska south to the Pelly Mountains in southern Yukon Territory.

Their habitat includes mountainous areas with cliffs, open meadows and alpine ridges.

The adult males (rams) grow larger than females (ewes). Both sexes have horns, but the ewes' horns are much shorter and smaller, and they do not make a full curl as in rams.

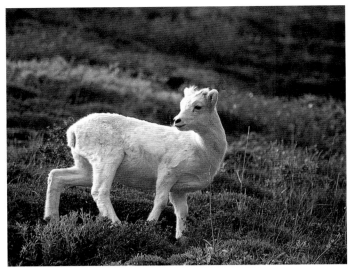

Lamb

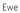
Ewe

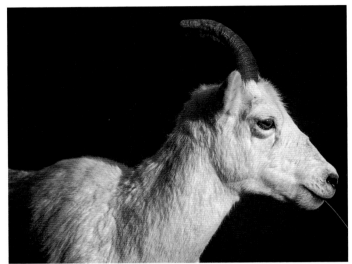

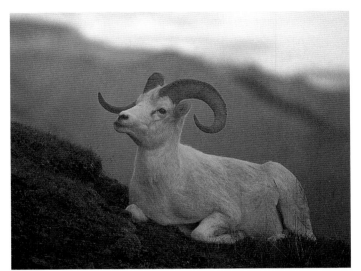

Ram

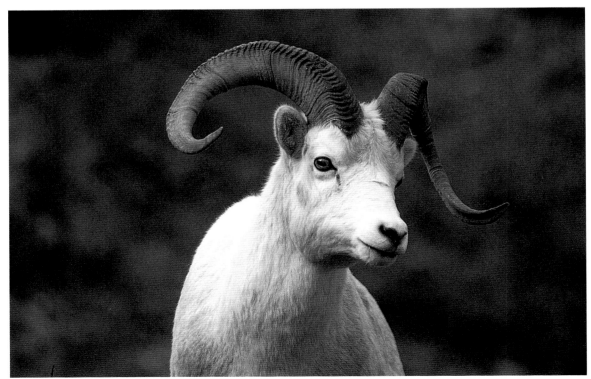

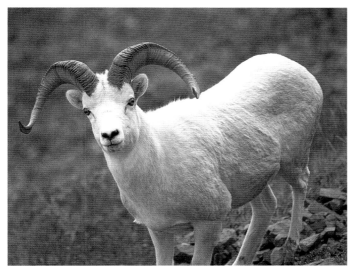 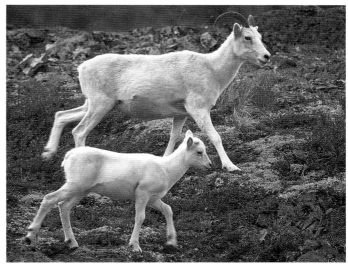

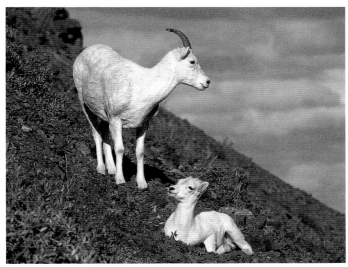 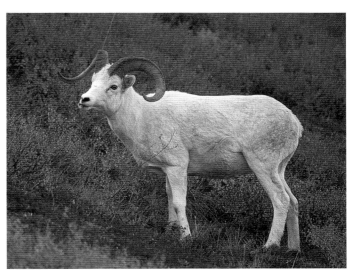

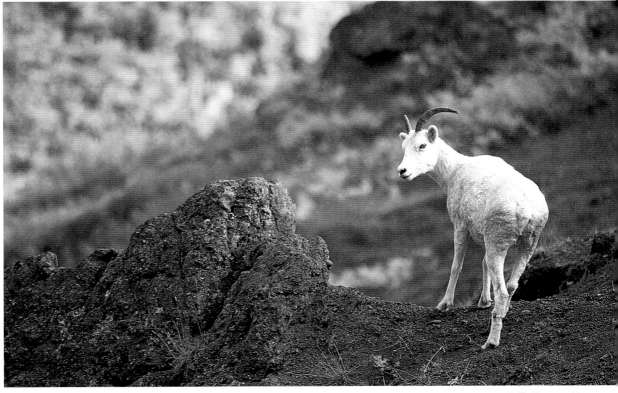

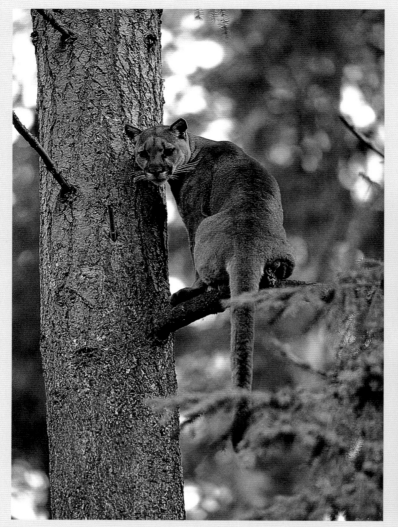
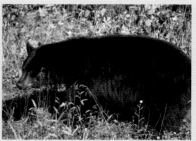
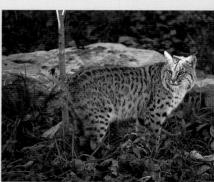
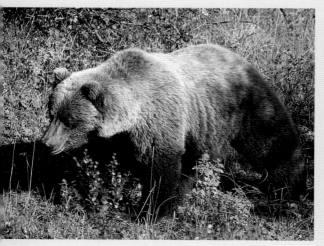
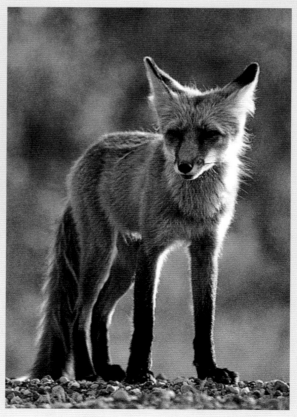

Predators

The cats and dogs in this chapter rely almost solely on catching prey animals for food. Bears, while classified and capable as carnivores, actually eat mostly vegetation and have more of an omnivorous diet.

Like many other mammals that live in cold climates many of these predators grow a thick fur coat for the cold of winter and have a thinner coat during summertime. Except for the wolf, and in some cases the coyote, most of the carnivores in this chapter are loners unless it's a time when they are mating or raising young.

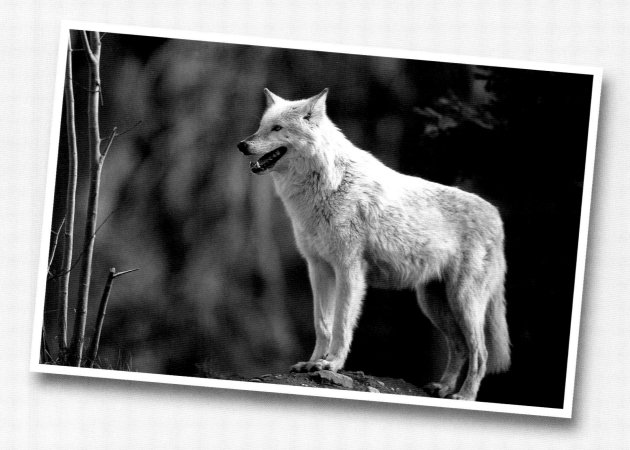

Brown Bear (Grizzly Bear)

Brown bears, also called grizzly bears, range all over Alaska, western Canada, northern Canada and south into Montana, Wyoming, Washington and Idaho. They are widespread throughout much of north Asia, from eastern Europe and the Middle East all the way across to Japan, and there are localized populations in western Europe.

Their habitat includes forests, tundra, mountains, alpine meadows, thickets with berries, along coastlines and salmon streams.

Brown bears' coloring varies from pale silver to dark brown. The name *grizzly bear* usually refers to interior populations in North America because they often have silvery-tipped hair that gives a "grizzled" appearance. Males get larger than females.

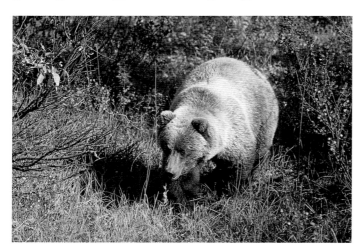
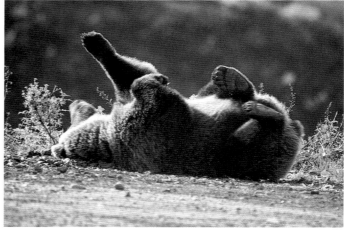

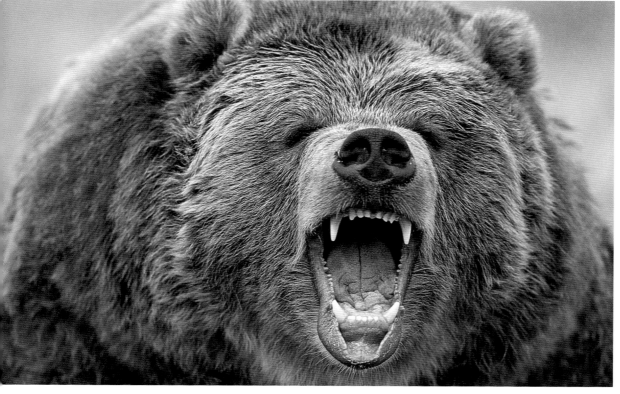

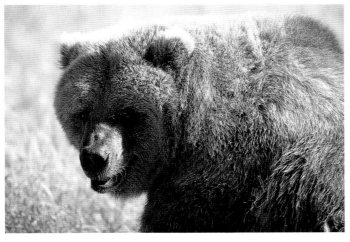
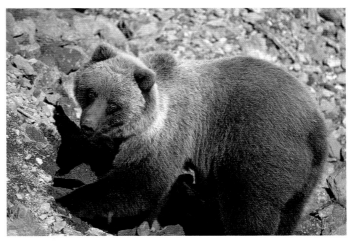
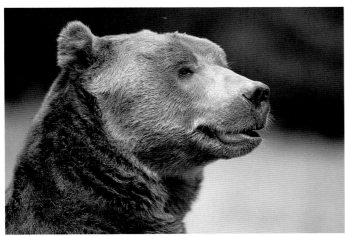
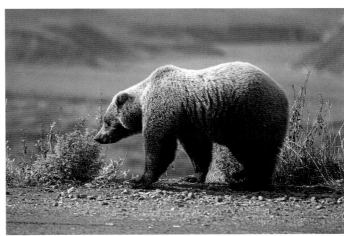
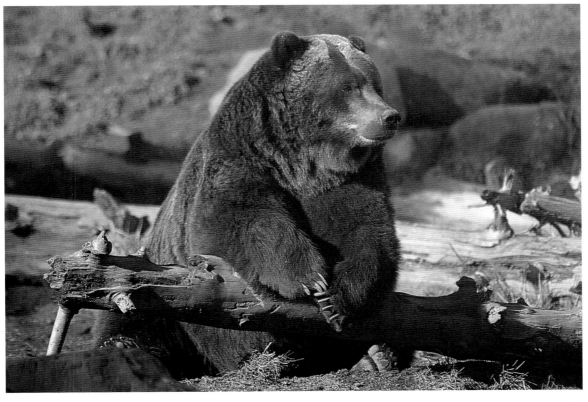

Black Bear

The American black bear ranges throughout most of Canada, Alaska, the Northwest and Northeast United States, the Rocky Mountain states, as well as several southeastern states, and into parts of northern Mexico.

Black bears prefer forests, but are also found in swamps, marshes, mountain areas, alpine tundra, thickets and near salmon streams.

Their color can range from black to cinnamon, and they sometimes have a white patch on their chest. Males grow larger than females.

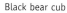

Black bear cub

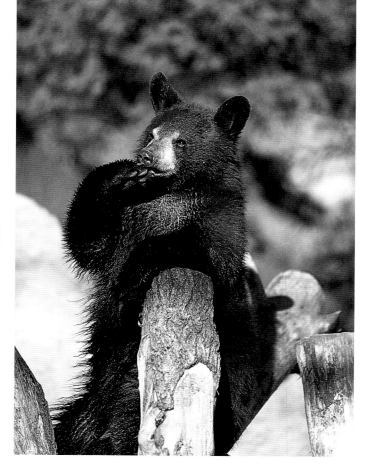

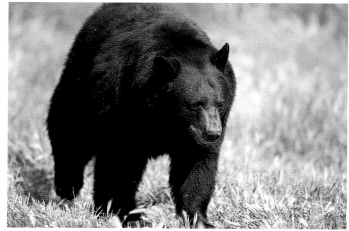

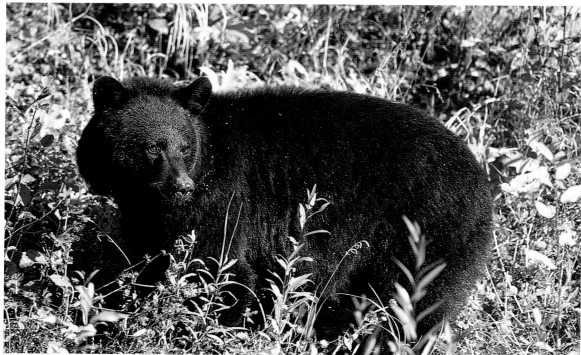

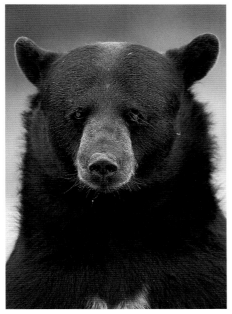
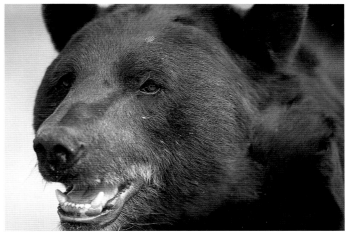
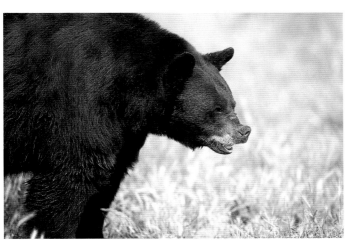
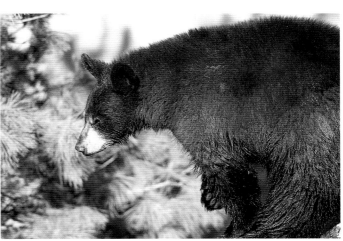
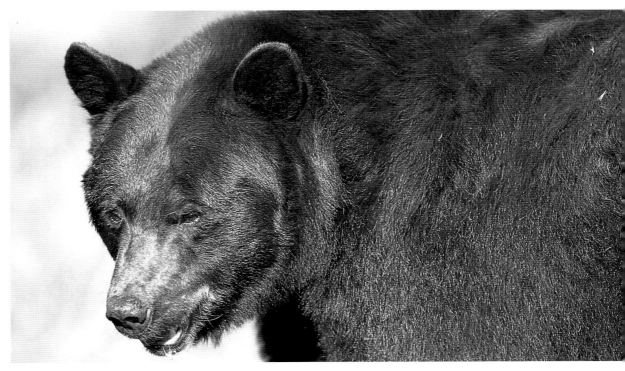

Gray Wolf

Gray wolves range throughout Canada and Alaska, with limited presence in the lower forty-eight states in places like Minnesota and Yellowstone National Park. Other subspecies of gray wolves range throughout much of Asia, the Middle East, and there are a few remaining populations in Europe.

Their habitat ranges from northern forests and forest edges, to arctic tundra.

Wolves are very social and have a highly structured social order. Most live in packs led by a dominant (alpha) male. Wolf coats are usually gray, but can vary to black or white (in the arctic).

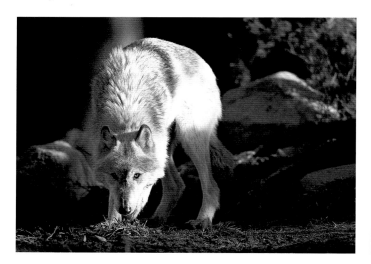
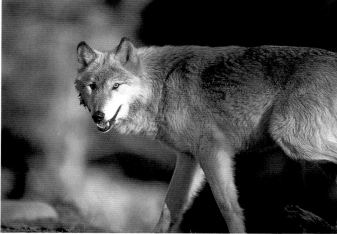

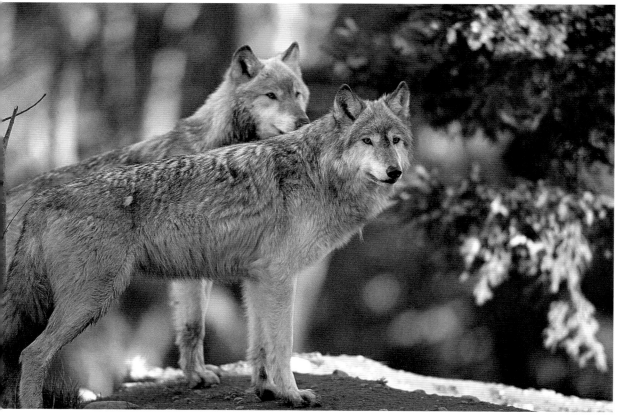

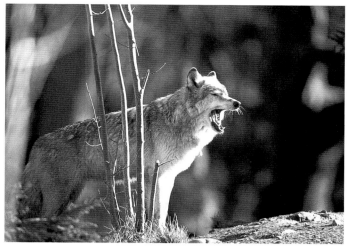

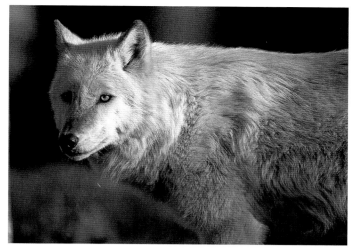

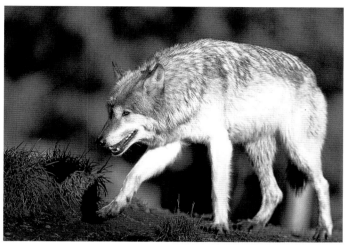

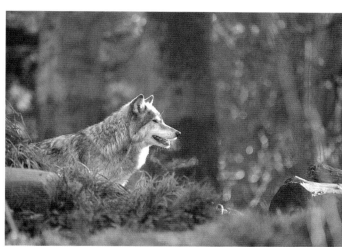

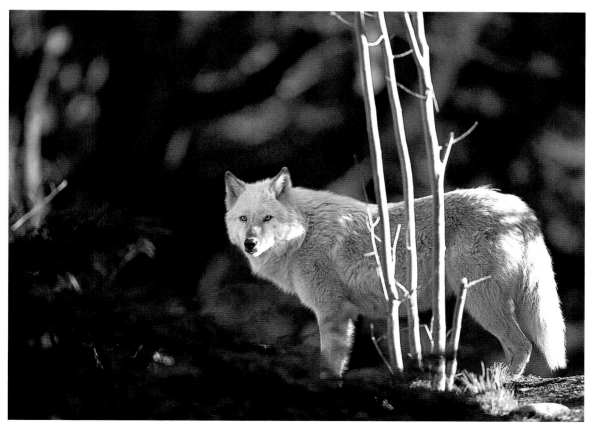

Coyote

Coyotes range throughout the United States southward through Mexico into Central America, and north to southern Canada, through British Columbia, the southwest corner of the Yukon and into Alaska.

Coyote habitat includes open prairies and grasslands, brushy areas, open forests, forest edges and farmlands. Coyotes hunt alone or in packs depending on the area and their main prey species.

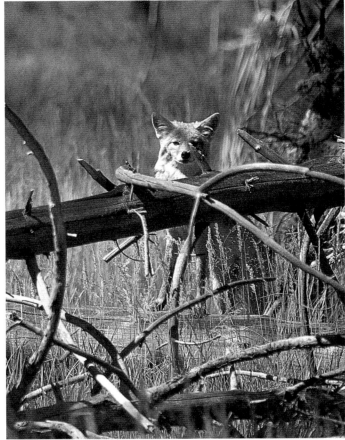

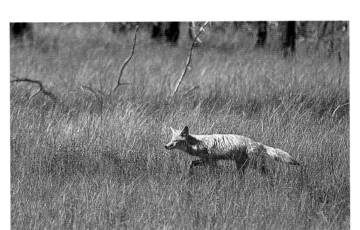

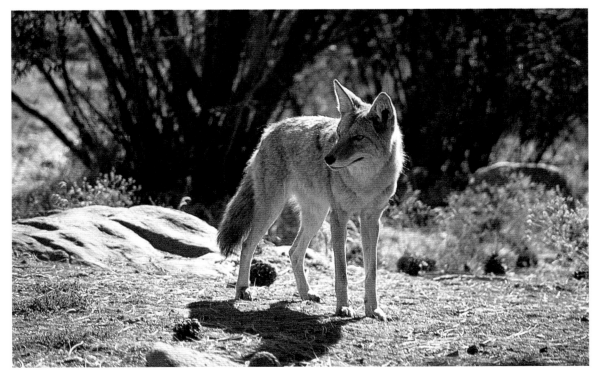

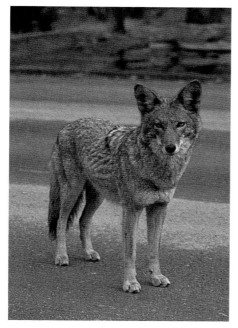

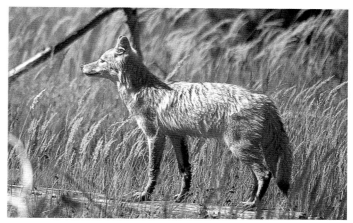

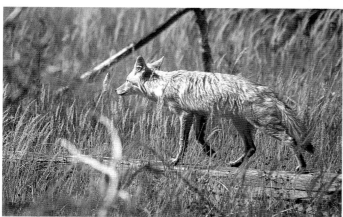

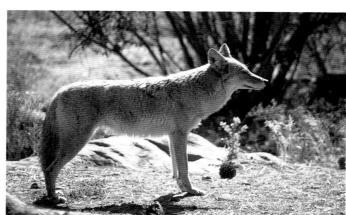

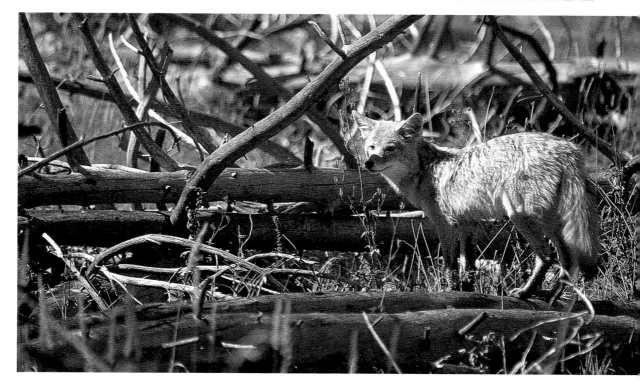

Red Fox

Red foxes are found almost all over North America except some desert and dry plains areas, the southern Pacific coast and much of the Rockies. They also range over most of Europe and Asia, and as far south as North Africa.

Their habitat includes open country such as meadows, farms, brushlands, prairies, alpine and arctic tundra, meadows, semi-open forests, fencerows and stream borders.

Their color varies from red to silver, black or a combination of red and black, but the tip of the tail is always white.

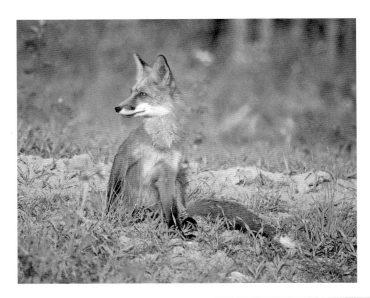

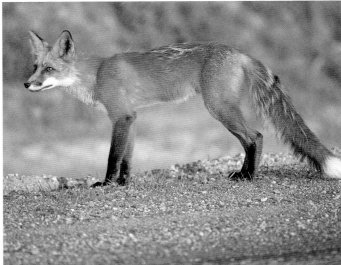

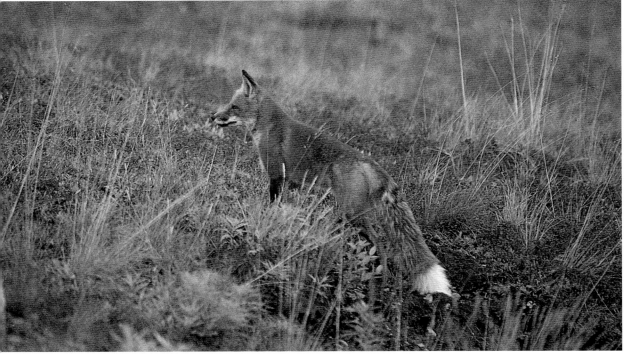

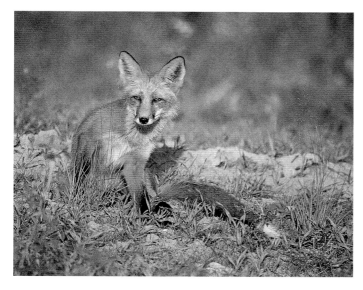

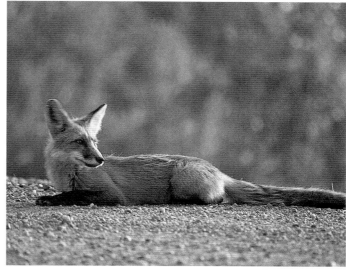

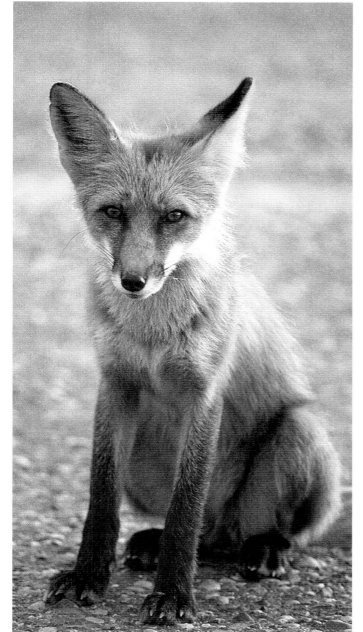

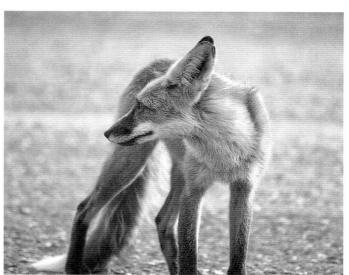

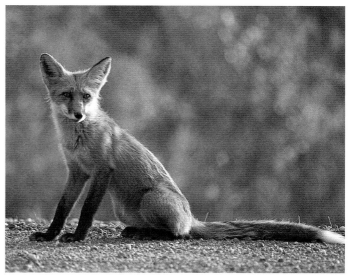

Bobcat

Bobcats range from British Columbia and the Canadian border south through most of the United States and into Mexico. In the United States they are absent only from the Midwest and part of California and Colorado.

Bobcat habitat includes forests, swamps, farmlands, thickets, semi-deserts and rocky hillsides. They prefer rocky ledges for den sights.

A bobcat's coat varies geographically and by time of the year, with the tendency for a gray winter coat and a warmer brownish coat in summer.

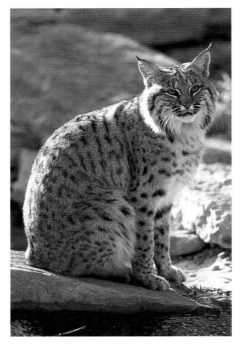
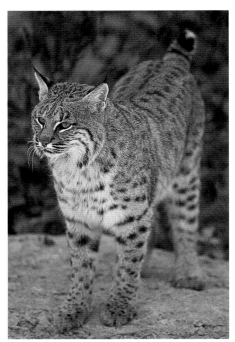

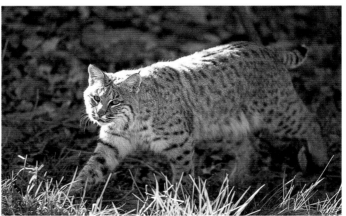

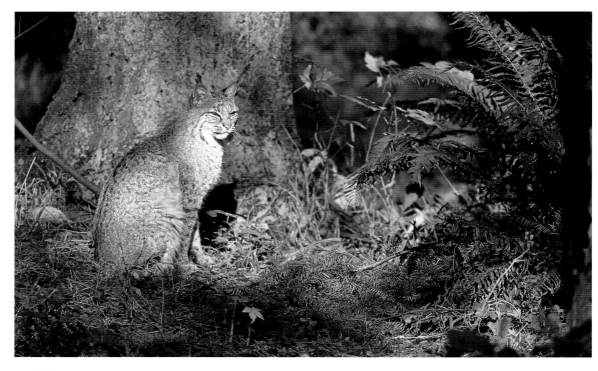

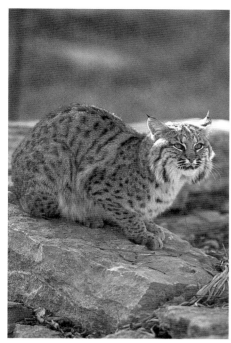

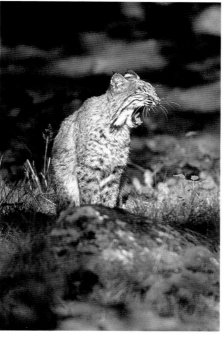

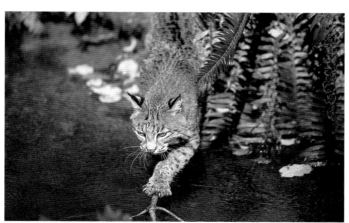

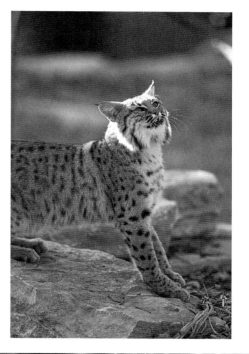

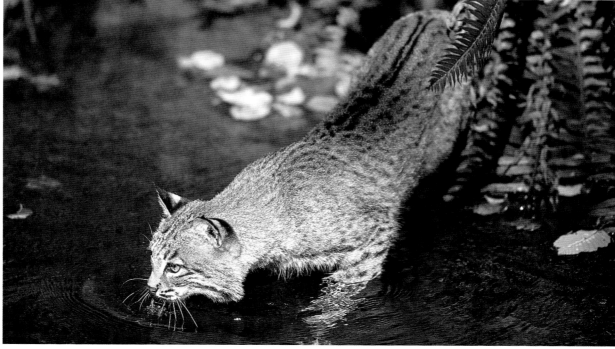

Cougar

The range of cougars extends all the way from the Yukon down to Tierra del Fuego, including western Canada, the western United States, Mexico, Central America and most of South America. There is also a small population in the Florida Everglades.

Cougars inhabit a variety of habitats but seem to require some forest cover in areas with abundant prey (especially deer) and few people. They are found in forests, swamps, thickets, semi-arid areas, as well as, rainforests, mountains, grasslands and river valleys.

Their color normally ranges from shades of reddish brown to gray. Males grow larger than females.

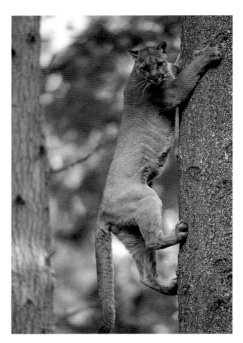

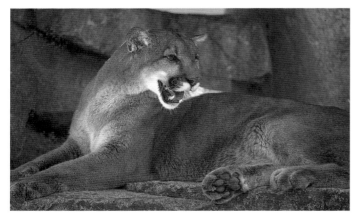

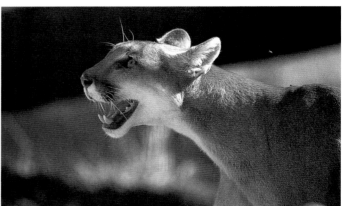

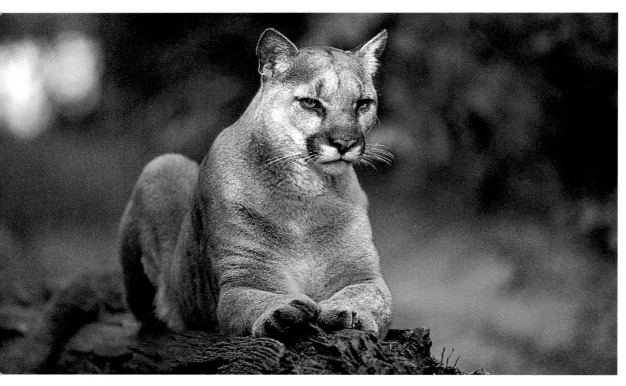

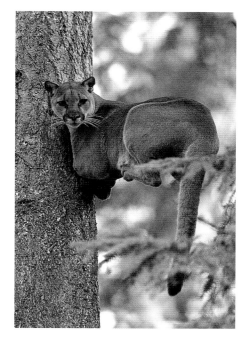

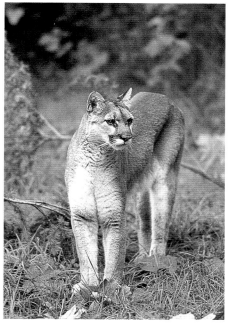

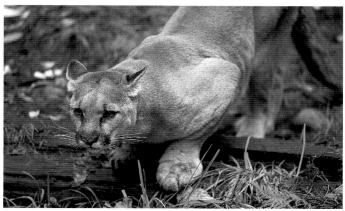

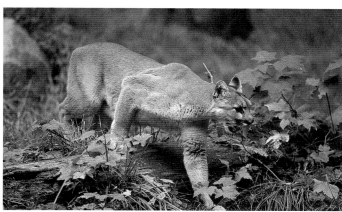

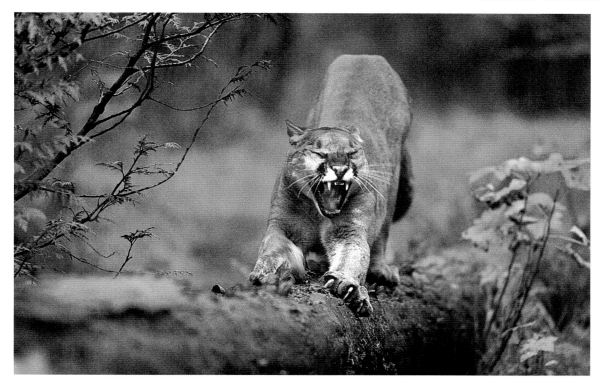

Cougar in Oil

Materials

Surface
RayMar panel

Brushes
Flat sables no. 3, no. 5, no. 6, no. 8, no. 10, no. 12
Round no. 1

Palette

Winsor & Newton Artist's Oils—
Alizarin Crimson, Burnt Sienna, Burnt Umber, Cadmium Lemon, Cadmium Orange, Cadmium Red, Cadmium Yellow, Cerulean Blue, Lemon Yellow, Naples Yellow, Permanent Green, Permanent Mauve, Raw Sienna, Raw Umber, Sap Green, Titanium White, Ultramarine Blue, Ultramarine Violet, Viridian, Yellow Ochre

Other
Gray gesso
HB charcoal pencil
Ingres green gray charcoal paper
Liquin
Krylon Crystal Clear Spray Coating
Stabilo aquarellable pencil
White charcoal

This demonstration will teach you some unique oil painting techniques and how to combine several different reference photographs to form one cohesive painting. You'll combine trees from one landscape photograph with a different landscape and then add cougars from a photo taken at the zoo. Kalon goes the extra mile to photograph his subjects in the wild, but some animals are almost impossible to find in their natural habitat, let alone photograph. He frequently photographs and sketches zoo animals that are difficult to view in nature.

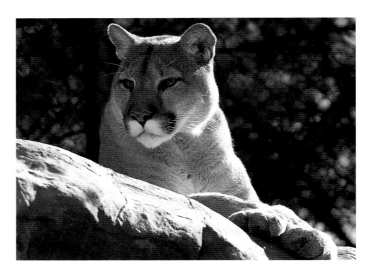

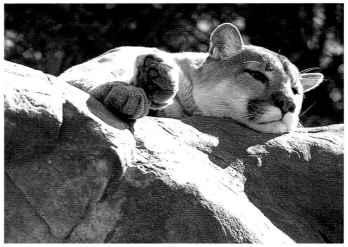

Cougar Reference Photos
Kalon took these cougar reference photographs at the Minnesota Zoo with a 35mm camera using a 300mm lens and 100 speed film. Although the positioning of the cougar is different in each photograph, it is the same cougar. The challenge of using two reference photographs of the same animal in different poses is to try and make the animal appear as two separate individuals in the painting. The benefit is that by using photos taken at the same time of the same animal, the angle and lighting conditions are consistent.

Landscape Reference Photos

Kalon used two camera formats, 35mm and medium format, for taking these landscape reference photographs. The medium format camera, which has a much larger negative, captures details much better (above). The down side to using medium format is that it's cumbersome to use in the field, and the film and developing is much more expensive. The landscape photos Kalon used for this painting were both taken in Yellowstone National Park. Both photos were chosen for the compatibility of the light source and subject matter.

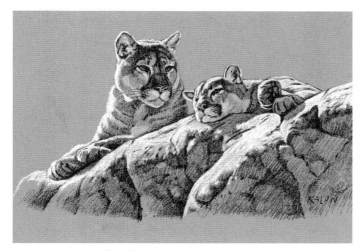

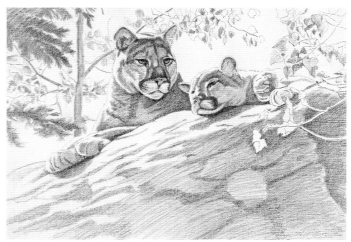

1. Create a Drawing Study

Complete a drawing study to be used as a blueprint for your painting. Use an HB charcoal pencil and white charcoal pencil on green gray Ingres charcoal paper. Take great care in this step to make sure the cougar's anatomy is correct, and the integration of different reference photos appears natural. Plan for the placement of the main focal point (the cougar heads). Create a diagonal across the painting surface with the animals' bodies to enhance the interest level of the composition. Place the feet of the cats at the ends of the diagonal to create a visual balance with their head placement. Create visual tension by focusing the cougars' gazes outside of the painting.

2. Transfer the Drawing

Transfer the drawing study to the painting surface. Prepare a RayMar panel with gray gesso and draw with the Stabilo aquarellable pencil. Fix the drawing onto the gessoed panel using Krylon Crystal Clear Spray Coating before the painting process starts. This allows the drawing to remain on the panel without being smudged by paint.

3. Underpaint the Cougars

The main objective here is to put in the shapes and shades that will be the building blocks of your painting. Block in your light values first using a no. 10 or a no. 12 flat sable brush. This way you don't muddy your lights with the darker values underneath. Then choose your warm medium values and block them in.

Use three grays when painting the cougars. The first is a warm gray composed of Cadmium Lemon and Permanent Mauve. The second is a cool gray that is a mixture of Viridian and Alizarin Crimson. And the third is an orange gray made up of Cadmium Orange and Ultramarine Violet. All of these grays can be lightened and dulled down with Titanium White. The other main colors are Raw Sienna, Cadmium Yellow, Cadmium Orange, Ultramarine Blue and Titanium White.

Note the strong backlighting of the ears and the side and top of the head. Use Titanium White and a touch of Cadmium Yellow to create the effect of light hitting these areas. Create the pinkish color in the ear by using a combination of Cadmium Red and Cadmium Orange mixed with Titanium White. The rest of the areas in the ear are gray tones heavily saturated with Titanium White.

The lighter areas in the muzzle are comprised of very muted shades of gray mixed with Titanium White and a touch of Cadmium Yellow and Cadmium Orange. The orange color in the nose is predominantly Cadmium Orange, with a touch of Cadmium Red, Burnt Sienna, Cadmium Yellow and Titanium White. The darker areas around the muzzle are Burnt Umber mixed with various shades of gray. Use a no. 8 and a no. 6 flat brush to detail the nose. To prevent colors from getting muddy, avoid mixing warm and cool tones.

4. Underpaint the Rock and Sky

Premix two colors for the sky. For the lighter color of the sky, that appears lower in the painting, use Titanium White, Cerulean Blue, Ultramarine Blue, and Naples Yellow with a touch of Burnt Sienna. For the darker part of the sky

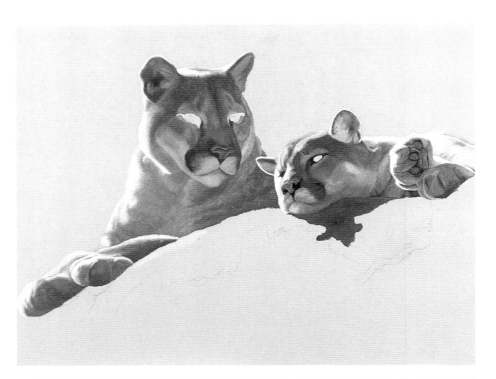

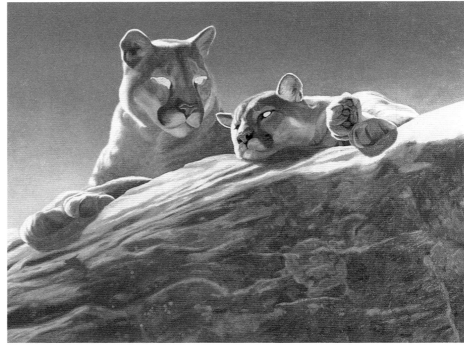

use Ultramarine Blue, Cerulean Blue, Alizarin Crimson and Titanium White. Use a large no. 12 flat sable brush and apply the lighter color first. Then gradate the color up into the blue by mixing the paint directly on the panel, ending with the pure darker blue mixture at the top.

Next, block in the colors of the rock using grays similar to those premixed for the bodies of the cougars. Use colors for the highlighted part of the rock that are similar to the highlighted parts of the cougars and a similar contrast of warm and cool shades of gray as in the lower shadowed portion of the rock.

However, add more Cadmium Orange and Alizarin Crimson to the orangish color used for the lichens. Use a no. 10 flat sable brush for blocking in the main colors of the rock and reduce the size of the brush to a no. 6 as you begin filling in more detailed areas of the rock, such as the lichens and highlights.

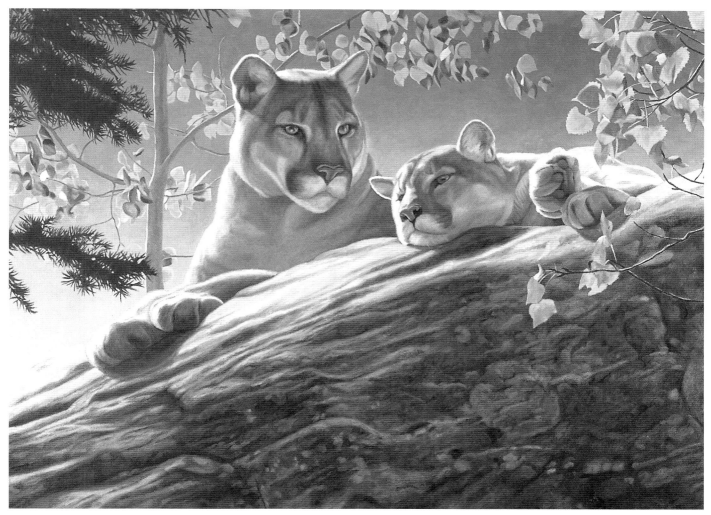

5. Finish the Underpainting

For the underpainting of the eyes, use the Viridian-Alizarin Crimson gray mixed for the cooler or bluer areas of the fur around the eyes and in the iris. Use the Cadmium Lemon-Permanent Mauve gray mixed occasionally with Raw Sienna, Cadmium Yellow and Cadmium Orange for the warmer areas, including those in the iris. The darker areas, such as the eyelid and the vertical line on the forehead, are a mixture of Burnt Umber and Raw Umber. Use a no. 3 and a no. 5 flat brush for these areas, while being careful not to mix the cool and warm colors.

Separate the foliage into two main parts on the basis of their color. The aspens are primarily yellowish orange, and the evergreen has a brownish green tint. The aspen leaves have a variety of yellow colors in them such as Lemon Yellow, Naples Yellow, Cadmium Yellow, Yellow Ochre, and Cadmium Orange. Tone down all shades of yellow with Titanium White. Also you can use a dash of a complementary color in each mixture to tone down the color's intensity. Use Sap Green in the area that has greenish tints. Paint the aspen tree trunk and smaller branches with light shades of the same gray used in the cougars and the rock. This helps keep the painting uniform.

Mix the evergreen colors using Sap Green, Ultramarine Blue and a touch of Cadmium Orange, then add a small amount of Titanium White to soften the color. Block in the aspen and evergreen foliage with a no. 6 flat sable brush, and use a no. 3 flat sable brush for the details and highlighted areas.

Once the underpainting is completely dry, apply a clear coat of Liquin and allow it to dry. This prepares the painting surface for the technique of drybrushing.

6. Drybrush the Cougars

Drybrushing involves loading a brush with just enough paint to rub on the painting surface; the more pressure you apply, the more opaque the layer will be. With less pressure, you will allow the underpainting to show through while enhancing the image with the overlying detail.

Now is the time to create the amount of texture and detail that you desire in your painting. This will transform your painting rather rapidly. All of the texture created will be created by drybrushing with just three dark colors. Raw Umber is the primary color to use. For warmer textured areas, add Burnt Umber, and for the cooler areas, including your darkest blacks, add Ultramarine Blue.

First use the dry-brush technique to darken all of your darks and to create the various textures in the fur surrounding the eyes. After the dry-brushed areas are dry, go back into the iris with Permanent Green on a no. 1 round brush and very carefully dab in some color, as cougars tend to have a brownish-green hue to their eyes. Also use lighter values and a no. 1 round brush to touch up the highlights, including the light spots in the eyes.

Then use the dry-brush technique to develop the texture in the fur around the ears. To create the mottled look of the inside of the ear, darken the area that is most in shadow in the center of the ear with Raw Umber. Also use Raw Umber to create the irregular spots in the ear. For the wispy, lighter hairs, use softer drybrush strokes, laying down less paint. Develop the rim of the ear with irregular, darker strokes, being careful not to boldly outline the rim.

Finally use combinations of Burnt Umber and Raw Umber to drybrush the textures of the fur over the underpainting. On the nose, drybrush irregular marks to give the cat's nose character. Finally, add the whiskers and the highlights on the jowls by using a no. 1 round brush with a dab of Titanium White and Cadmium Yellow, adding a light blue-gray on the whiskers that are in shadow.

7. Drybrush the Evergreen

Use long, needle-like strokes for the evergreen pine needles, varying the pattern now and then to avoid visual monotony. Use more Ultramarine Blue on your brush, occasionally adding a touch of Burnt Umber, as pine needles tend to reflect the colors of the sky. Highlight some of the edges with a mixture of Titanium White, Cadmium Orange and Cadmium Yellow.

8. Drybrush the Aspen

For the aspen leaves, tree trunk and limbs, use a brownish mixture for drybrushing and alternate back and forth from Burnt Umber to Raw Sienna for variety. Vary the brushstrokes to indicate the individual character of the limbs, leaves, veins, bug holes in the leaves and dark irregular protrusions on the bark. Use a mixture of Titanium White and Cadmium Yellow to add highlights and to variegate the edges of the leaves that are glowing with backlighting from the sun.

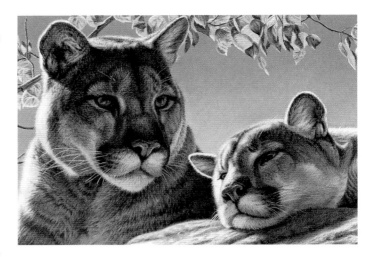

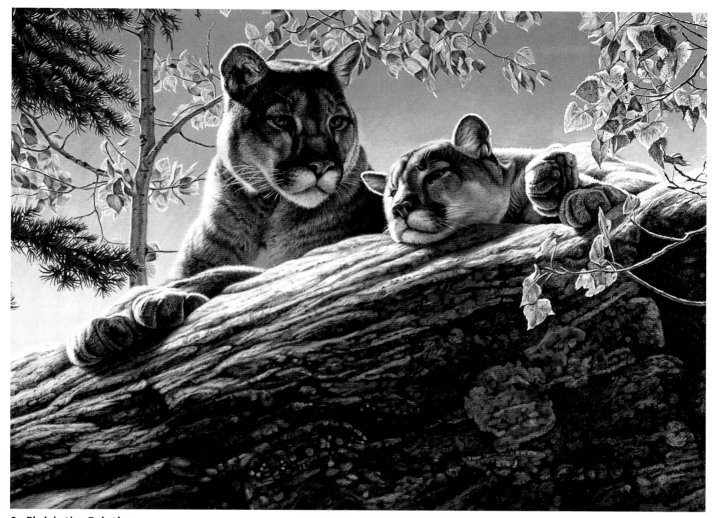

9. Finish the Painting

Last but not least, drybrush the rock to add texture. These are rocks with a large variety of lichen, deep fissure-like cracks and an uneven surface. To add interest use the full range of drybrushing colors, from warm to cool. Then use a mixture of Titanium White, Cadmium Yellow and Cadmium Orange to emphasize the backlighting on top of the rock and all its small imperfections.

The intense backlighting in this image creates a strong sense of three-dimensionality and warmth. The lyrical branches of the aspen and the bright colors of the leaves soften the masculinity of the painting, in contrast to the solid mass of rock on which the cougar rests. A strength of this painting is the integration of trees and rocks indigenous to the cougar's habitat. This is key to a successful portrayal of nature.

Contentment
Kalon Baughan
16" x 24" (41cm x 61cm)
Oil on RayMar panel
Collection of Warren and Nina Maurer

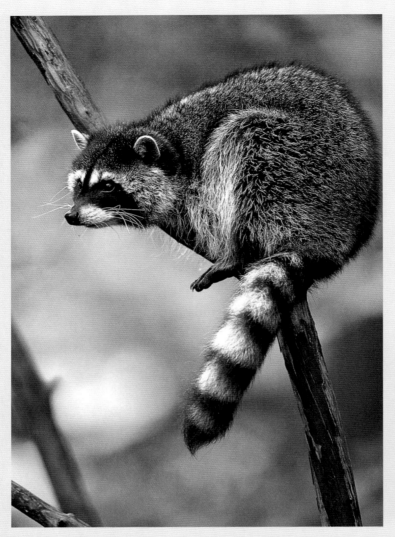

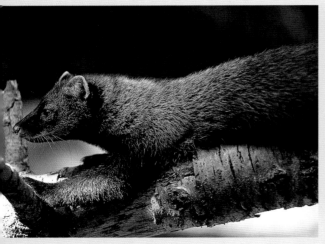

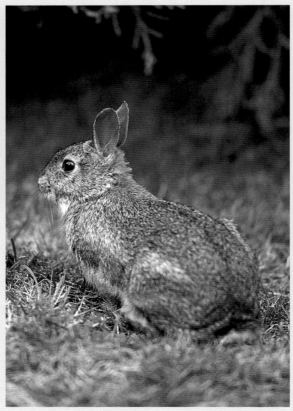

Small Mammals

Most of the small mammals included in this chapter are common near human dwellings. They often live in our backyards and come to feed at bird feeders or in the garbage. However, the fisher, by contrast, prefers to live far away from humans and is rarely seen.

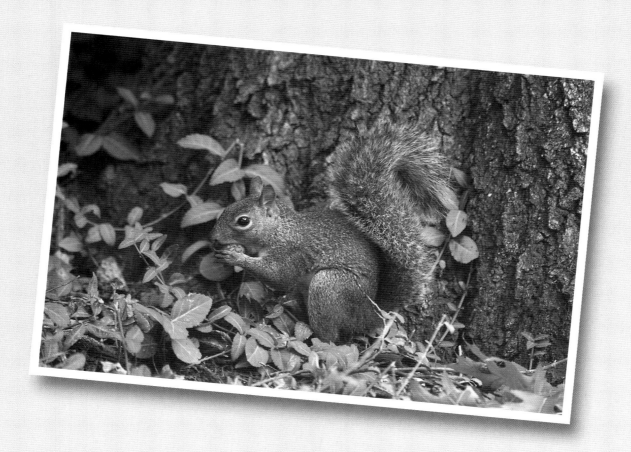

Eastern Gray Squirrel

The gray squirrel is widespread throughout the eastern United States.

The gray squirrel's habitat includes eastern hardwood forests or mixed forests with nut bearing trees like walnut, oak, hickory or beech. This squirrel is also found near streamsides, suburbs, city parks with nut bearing trees, and backyard bird feeders.

Males and females look alike.

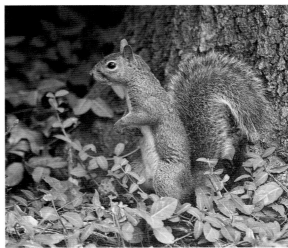

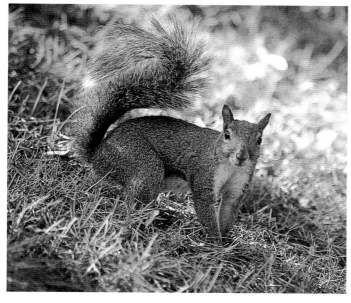

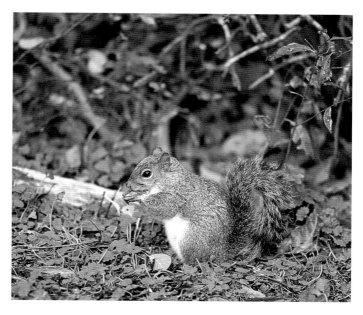

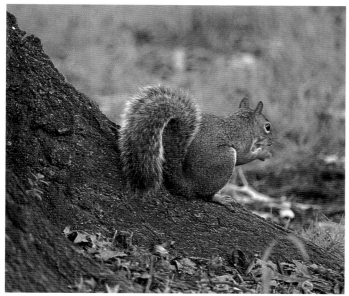

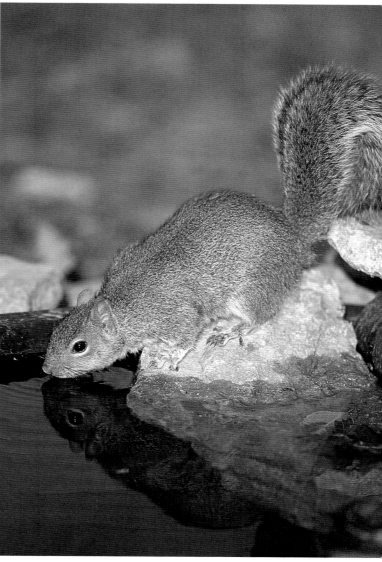

Townsend's Chipmunk

These chipmunks live in the Pacific Northwest including British Columbia, Washington and Oregon.

Their habitat is the dense coniferous forests of the Pacific Coast and thick brushy areas, but they are also common in backyards and at bird feeders.

Males and females look alike.

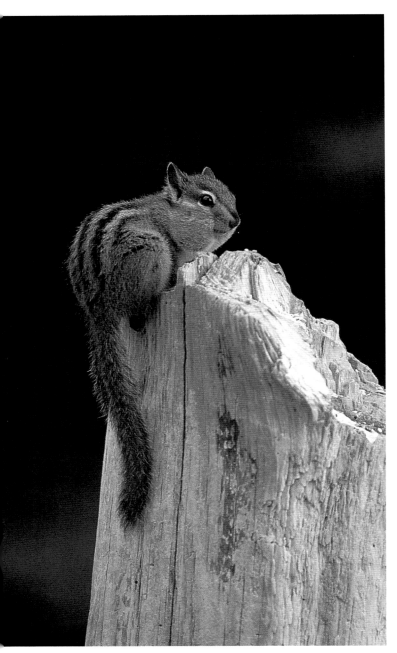

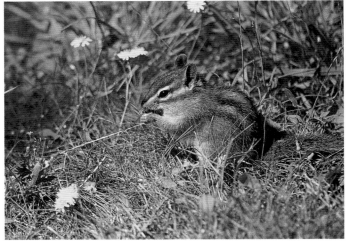

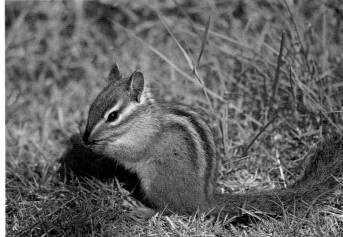

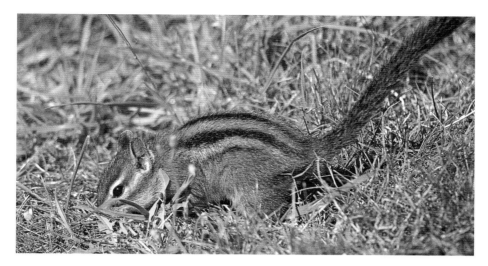

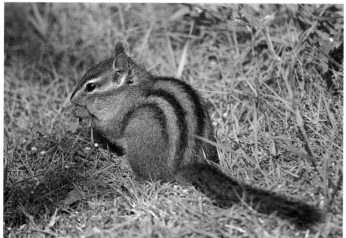

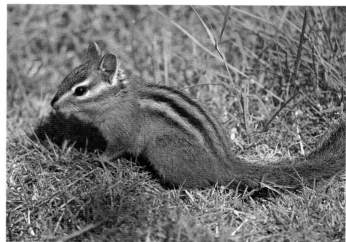

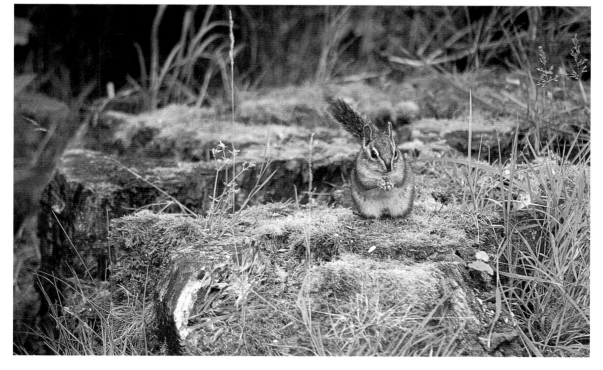

Raccoon

Raccoons are widespread throughout the United States and southern Canada, except in some desert areas and the Rockies. Their range extends southward into Mexico and Central America, and they have been introduced in parts of Europe and Asia.

Their habitat includes woodlands, the banks of rivers and streams, brushlands, rural areas, suburbs and even cities. They prefer habitat near water where they feel around for aquatic prey such as crayfish.

Chiefly nocturnal, raccoons are more likely to be seen at dawn or dusk than in the middle of the day. Males and females look alike.

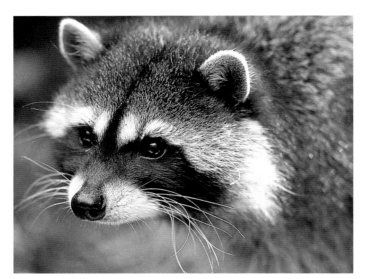 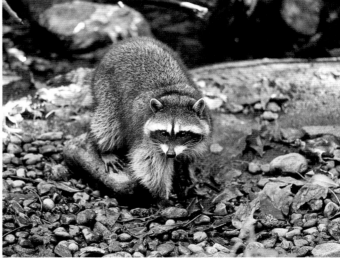

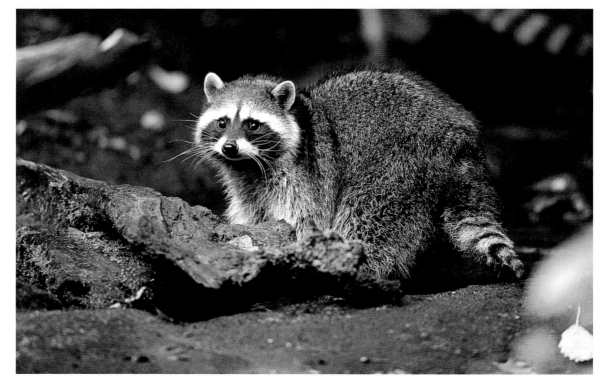

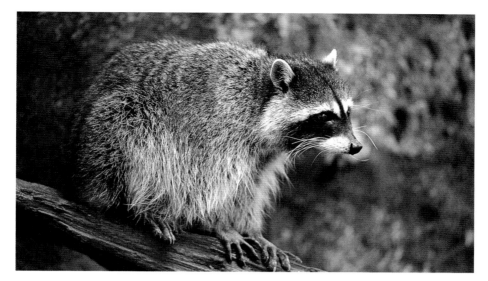

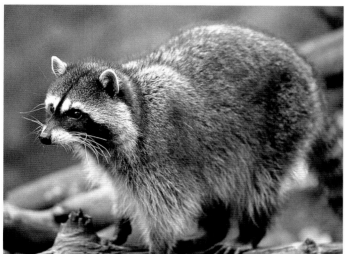

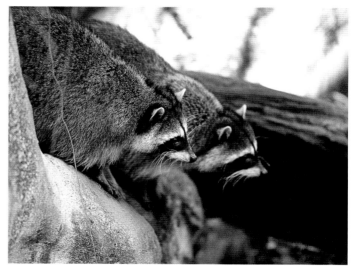

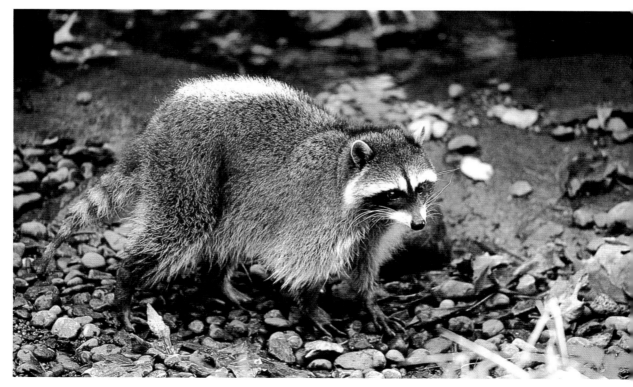

Fisher

Fishers range throughout most of central and southern Canada, southward into the Pacific Northwest as far as California, the northern Rocky Mountain states, the Midwest and New England.

They prefer northern forests, especially pine forests. Fishers spend their mostly solitary lives both in trees and on land, away from humans.

Fishers prey on small animals of all types, even porcupines.

Males and females look alike except that males can grow to twice the size of females.

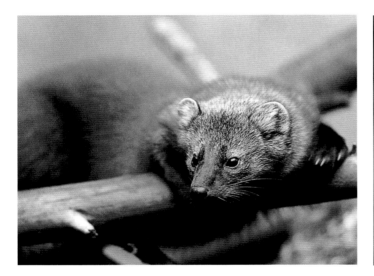

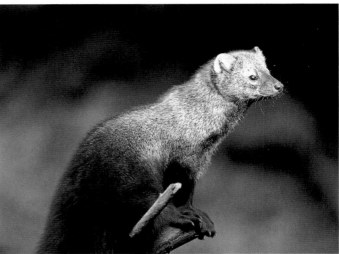

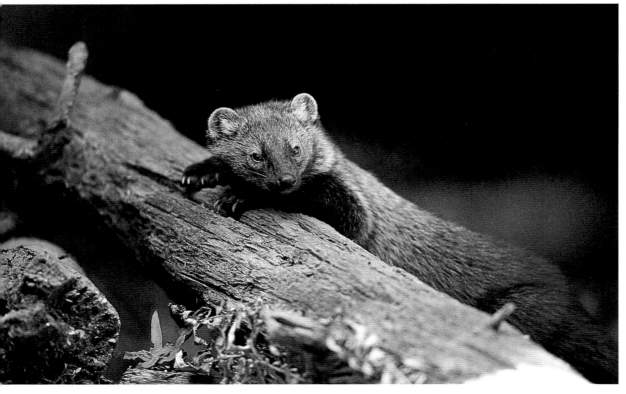

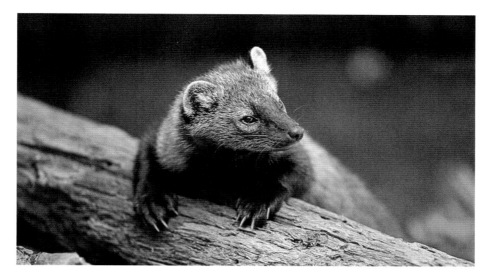

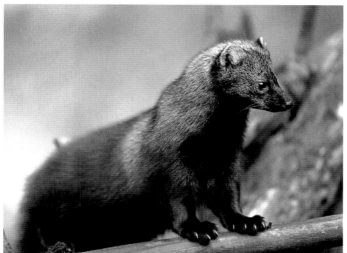

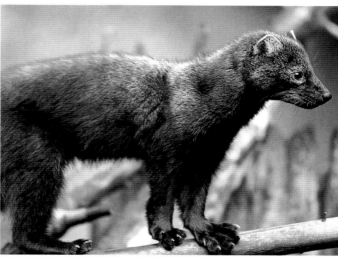

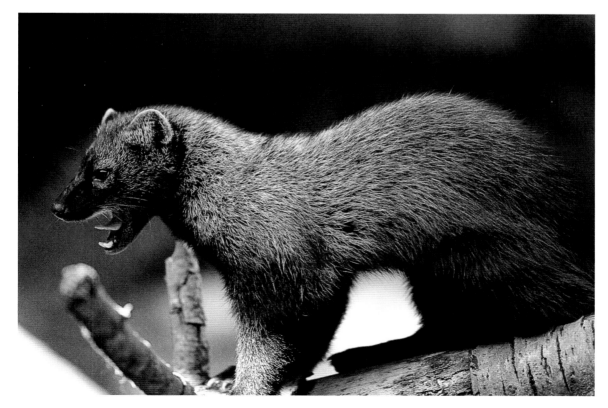

Eastern Cottontail

The eastern cottontail is widespread throughout the eastern United States and is also found in Washington, Arizona and south into Mexico.

Cottontail habitat includes heavy brush, grassy fields, weed patches, meadows, fencerows, forest and swamp edges. They prefer meadows with second growth areas nearby for cover.

Males and females look alike.

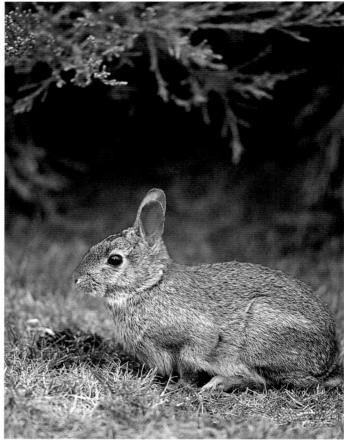

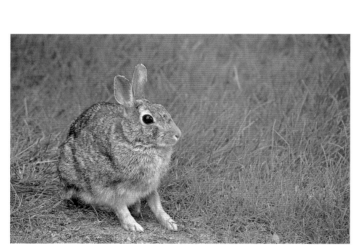

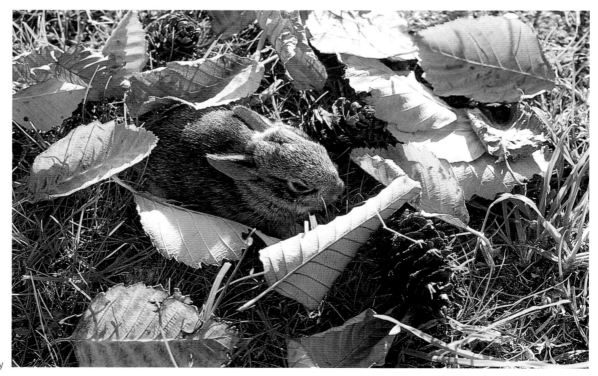

Baby

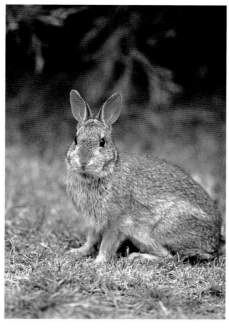

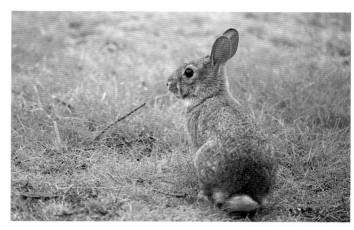

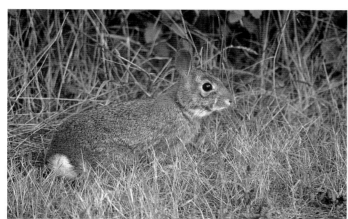

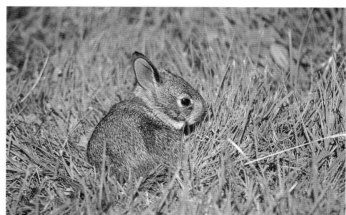

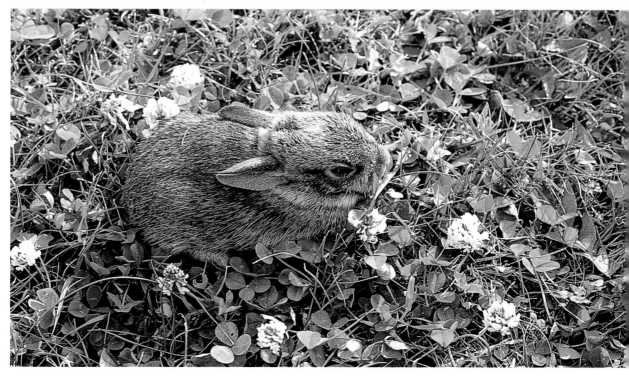

Cottontail in Mixed Media

Materials

Surface
Arches 140-lb. (300gsm) hot-pressed watercolor paper

Ink Brushes
Rounds no. 0, no. 5

Watercolor Brushes
Rounds no. 0, no. 5, no. 10

Watercolor
Winsor & Newton—Aureolin, Burnt Sienna, Burnt Umber, Charcoal Gray, French Ultramarine, Hooker's Green, New Gamboge, Payne's Gray, Quinacridone Gold, Raw Umber, Rose Doré, Sap Green, Sepia

Acrylic
Neutral Grey Value 5

Colored Pencils
Sanford Prismacolor—Apple Green, Black, Burnt Ochre, French Gray 10%, Goldenrod, Jade Green, Light Umber, Olive Green, Orange, Sand, Sepia, Slate Gray, White

Other
Drawing pen
FW Acrylic Artist's Black India Ink
HB pencil

Sueellen has developed a very unique way of painting with mixed media that produces beautiful results. Her stepwise approach to painting makes her artwork ideal for teaching demonstrations. For this painting Sueellen started with photographs of a desert cottontail she found on a trip to Tucson, Arizona. The photograph of the marigolds came from the same spot as the cottontail.

1. Complete the Drawing and Lay the Shadows
Do a detailed and complete pencil drawing of the rabbit and the background. Pay attention to the flowers and leaves that protrude in front of the hidden rabbit, and where their shadows fall on the ground and on the rabbit. Draw in the texture of the rabbit's fur, the petals and centers of the flowers, even the stones in the dirt and their shadows.

Decide where your darkest values are and fill them in with waterproof India ink. To avoid inking the wrong areas, indicate the darkest values with an ink dot first. Then outline each area with a pen filled with waterproof ink. Fill in larger areas with a brush, smaller ones with your drawing pen.

Cottontail Reference

Habitat Reference

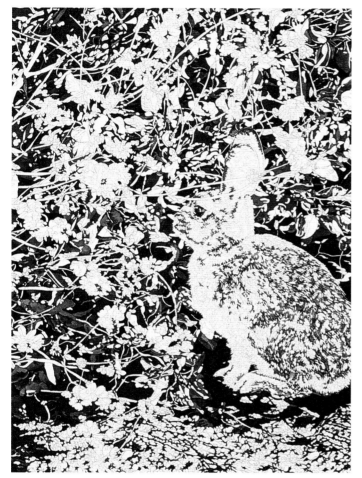

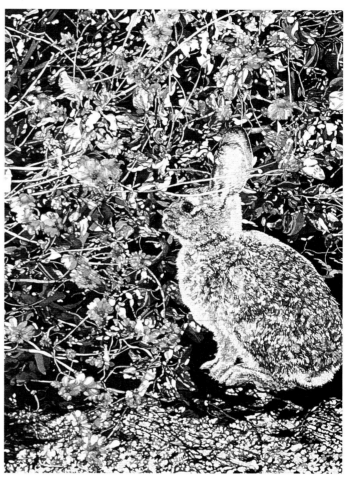

2. Start Adding Watercolor

Move around the painting with watercolor going from dark to light.

In the vegetation, mix Hooker's Green with Sepia for your darkest green. Add a bit of Sap Green to the mixture, and paint in your second-darkest green. Use Sepia for your darkest brown.

For the dirt, put in your darkest shadows with a mixture of French Ultramarine and Burnt Sienna.

Paint the darkest fur on the rabbit with Charcoal Gray. Use Sepia for the eye.

3. Add More Color

Continue painting with watercolor going from dark to light.

For your third-darkest green in the vegetation areas, add Payne's Gray and water to your green mixture. Then, for your fourth-darkest green, add more Payne's Gray and water.

For the dirt, add more Burnt Sienna and water to your shadow mixture for warmer, paler areas.

Start on the flowers using straight Quinacridone Gold for your darkest yellow. For your second-darkest yellow, add water to your paint. For your third-darkest yellow, add Aureolin to the gold. (To avoid color contamination, postpone painting the flowers in front by the rabbit's ears.)

Switch from your Charcoal Gray watercolor to Neutral Gray Value 5 for the warmer, paler gray in the rabbit. Then add more water to the acrylic for your next-lighter gray.

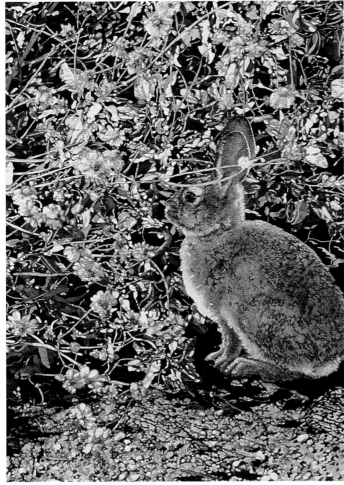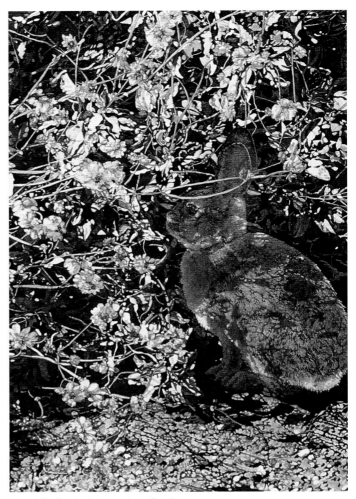

4. Complete Main Colors and Details With Watercolor

In the vegetation, paint the palest greens with straight Payne's Gray. Paint in dead leaves with Raw Umber. Stems get Sap Green mixed with Aureolin.

Protect the white stones by masking them with White Prismacolor pencil. Then paint in your final pale shadows in the dirt with a watered-down mix of French Ultramarine and Burnt Sienna. Add even more water to this mixture, and do a wash over all the dirt.

Paint the lightest yellow on your flowers with straight Aureolin.

Paint in the final rabbit fur details with pale Neutral Gray acrylic. Then do a pale wash of the same acrylic over the whole rabbit, avoiding the eye. This will blend the colors. Now protect the palest areas of fur by masking them with White Prismacolor pencil. Then paint a warm flesh color into the ears with a mix of Raw Umber and Rose Doré. Paint the rest of the body with a pale wash of Burnt Umber, and paint brighter gold areas of the fur with a mixture of Burnt Sienna and New Gamboge.

5. Add Final Watercolor Shadows

Erase all graphite and White pencil on your background and subject.

Add a mixture of French Ultramarine and Burnt Sienna to some of the leaves to put them in deeper shadows.

Paint in the flowers in front of the rabbit's ears using the same colors from steps three and four.

Using the shapes of the shadows from your background reference photo and the same shadow color you used on the leaves, paint the shadows made by the flowers onto the rabbit's body. (Adjust the shapes to conform to the rabbit's anatomy.) Soften the shadow edges with a damp brush.

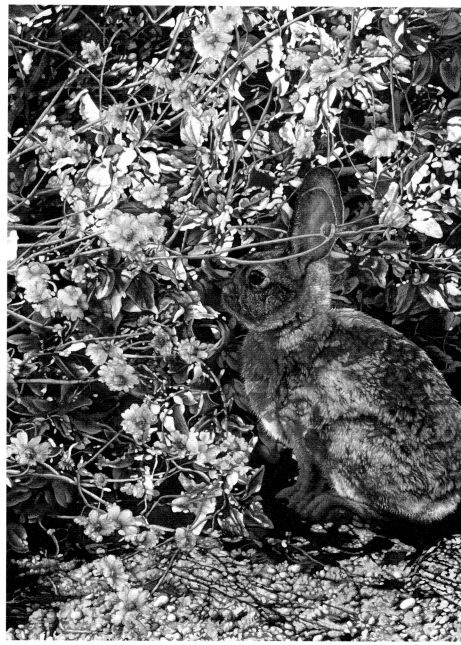

Desert Cottontail in Desert Marigolds

Sueellen Ross

13" x 9" (33cm x 23cm)

*Graphite, ink, watercolor and colored pencil on 140-lb.
(300gsm) hot-pressed watercolor paper*

6. Add Lights, Brights and Details With Colored Pencil

Highlight the darker leaves with Slate Gray. Blend the darker greens with Olive
Green pencil and the paler greens with Jade Green. Use Black pencil to sharpen
edges, deepen center veins and deepen shadows on the leaves. Edge the stems with
Burnt Ochre pencil.

Put in additional white stones with White pencil. Soften the edges of the ink shadows and add shadows to the stones with Sepia.

Deepen the shadows in the flower centers and petals with Goldenrod and Apple
Green pencils. Add final details and sharpen petal edges with Burnt Ochre pencil.

Where the sun hits the rabbit, highlight the fur at the tips with White pencil.
Where the rabbit is in shadow, highlight the tips of the fur with French Gray 10%.
To warm up the color on the back of the neck and in the ears, use Burnt Ochre in
the darker areas, Orange in the medium areas and Sand in the light areas. Blend and
soften the fur edges that are in full sun with Light Umber pencil, and use Sepia pencil to blend and soften the fur in the shadows. Use Black pencil to deepen shadows
and to sharpen details on the rabbit.

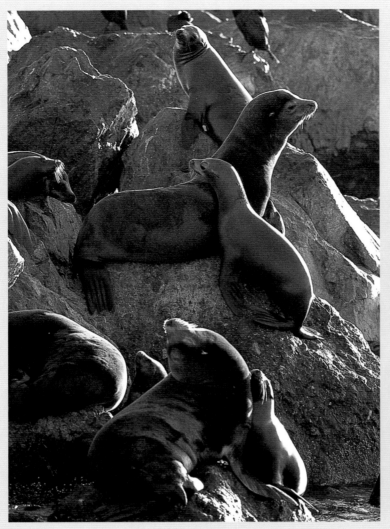
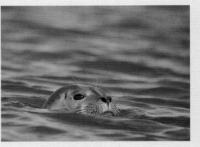
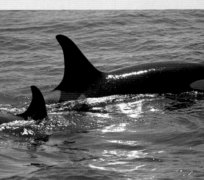
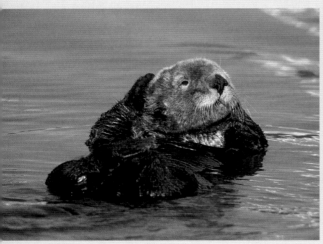
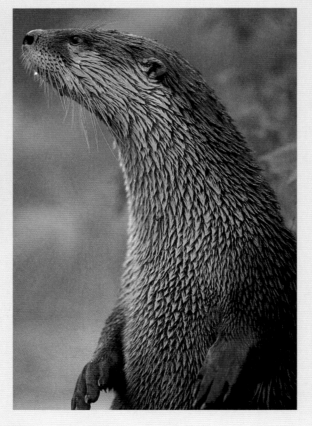

Aquatic Wildlife

This chapter covers animals that live most or all of their lives in fresh or salt water. All the animals included here are mammals except the American alligator, which is a reptile. They are also all predatory animals, which prey on a wide variety of aquatic life.

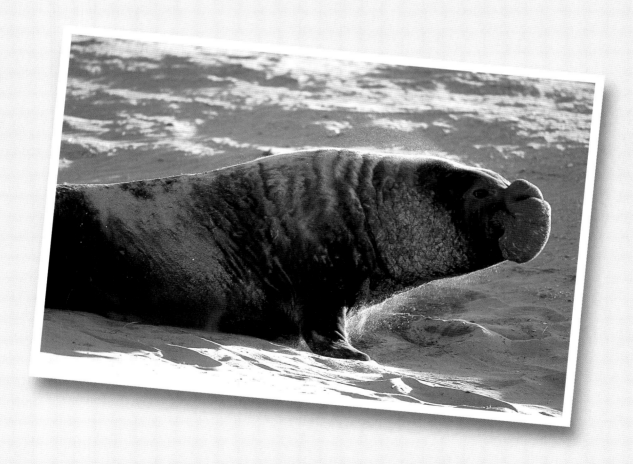

American Alligator

American alligators inhabit the southeastern United States from North Carolina south to Florida and as far west as Texas.

Their habitat includes swamps, marshes, rivers, lakes, ponds, bayous and sometimes even brackish water.

Males and females look alike except that males grow significantly larger than females. Young alligators are black with yellow stripes on their sides, but the yellow disappears as the animal matures.

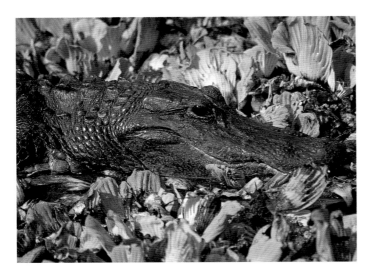

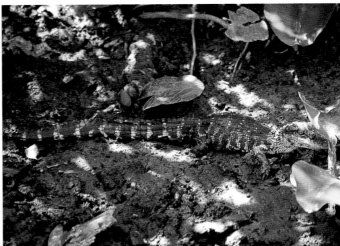

Baby alligator

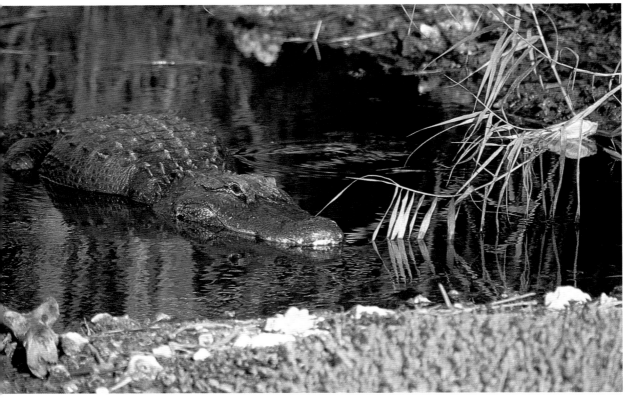

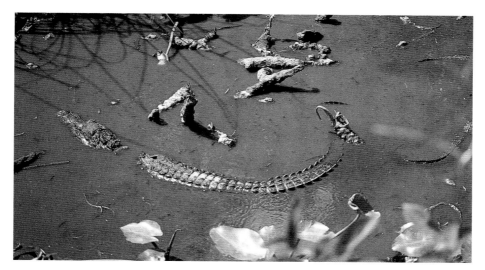

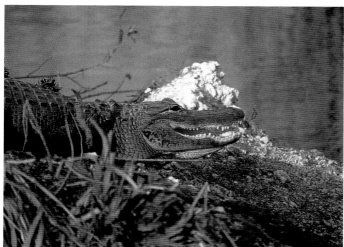

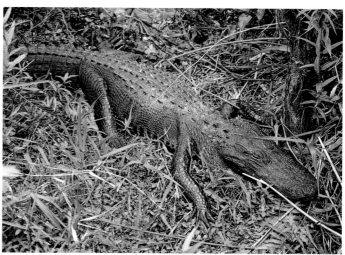

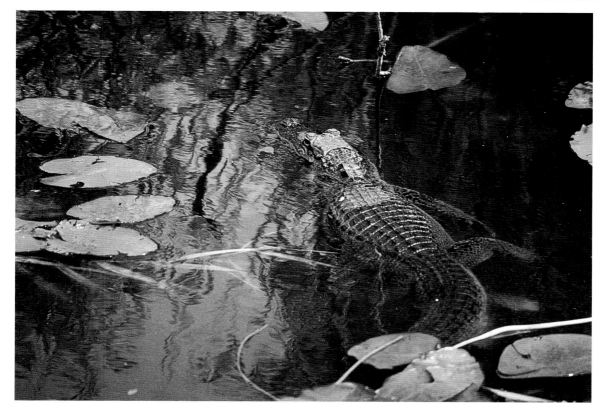

Killer Whale (Orca)

Killer whales live in all the oceans but are more common in cooler waters than tropical and more often near coastlines than the open ocean. They are most common in certain areas such as the coasts of Washington and British Columbia, Alaska, Norway, Iceland, Antarctica, Argentina and north Japan among others.

Adult males are larger than females and have a taller dorsal fin.

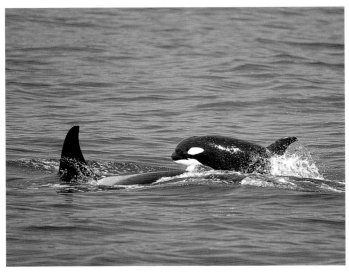

Calf with mother

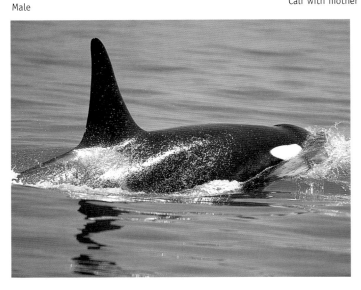

Male

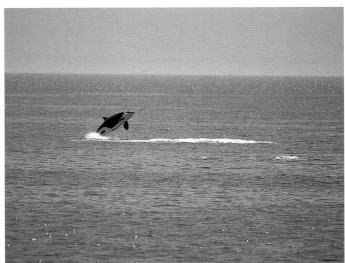

Female

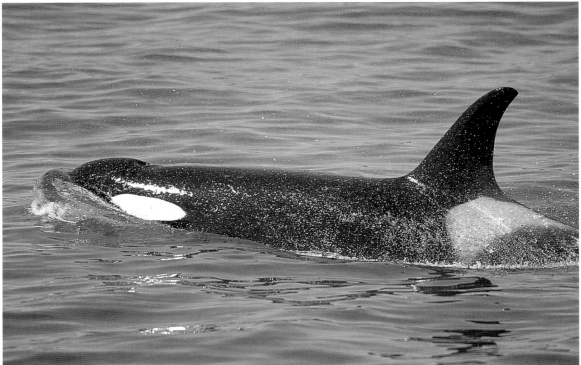

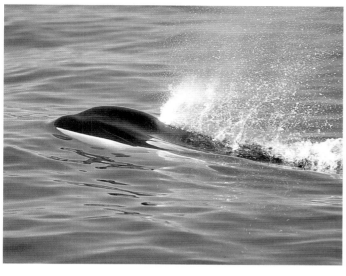

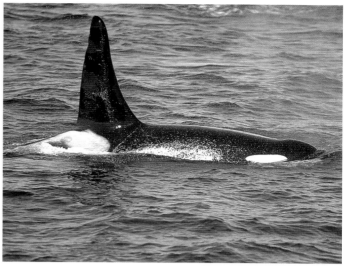

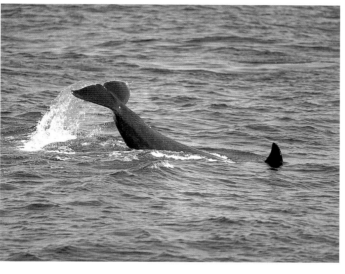

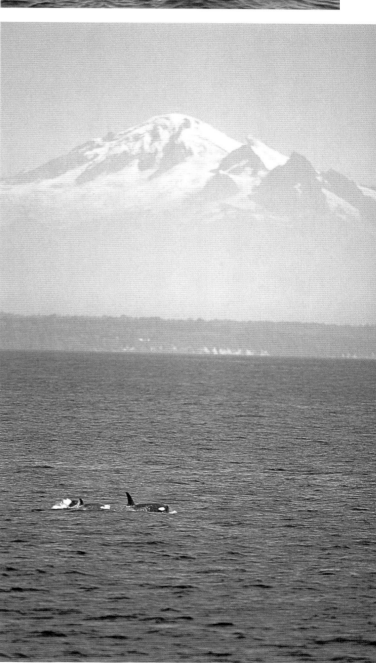

California Sea Lion

California sea lions range from Mexico to Baja California and up the Pacific coast of North America to British Columbia. Females remain near their breeding grounds, from Santa Barbara, California, south to Mexico, with their young year round.

They are most common near coastlines or islands, and they haul out on rocky coasts or sandy beaches, particularly at low tide.

Males grow larger than females and have a more pronounced bump on their forehead. Sea lions' fur coats appear dark when wet but become paler when dry.

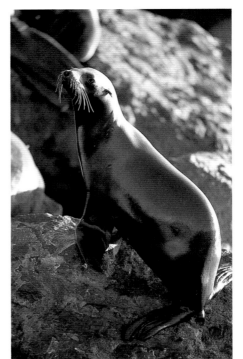

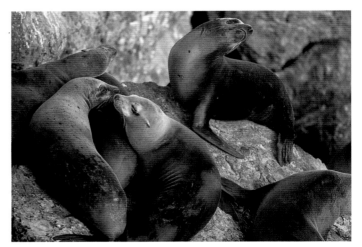

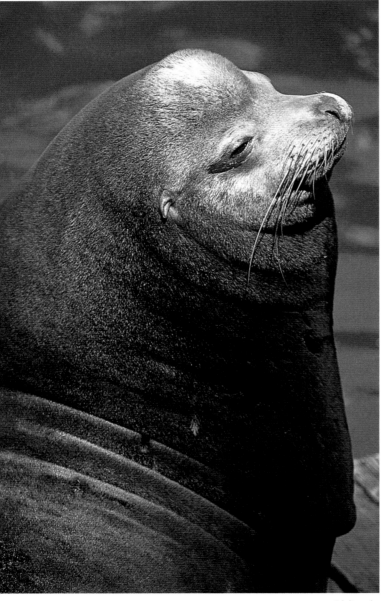

Adult male

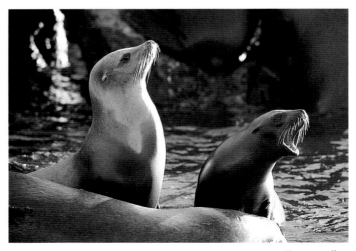

Young sea lion

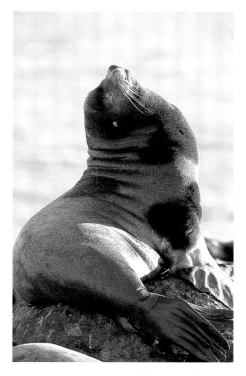

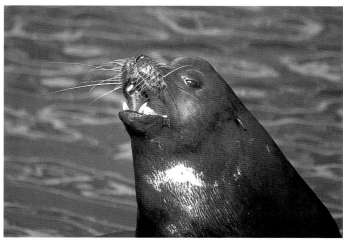

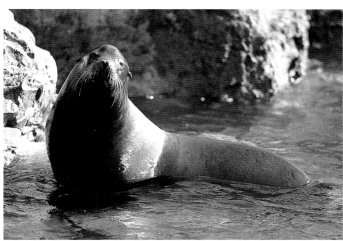

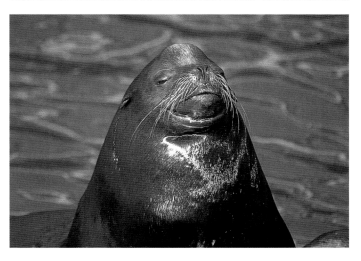

Harbor Seal

Harbor seals have a circumpolar distribution including several different subspecies. In the Pacific Ocean they range all the way from Baja California up to Alaska, across the Bering Sea to the east coast of Russia and north Japan. In the Atlantic Ocean they range along the coast of northeastern North America from Hudson Bay and Newfoundland as far south as New Jersey. They also live along the coasts of southern Greenland, southern Iceland, Norway, Denmark, Germany and the British Isles.

Their habitat includes ocean coasts, bays, harbors and estuaries.

Their coloration varies between light silver or tan, to black with white spots. They tend to appear darker when wet and paler when dry. The sexes basically look alike except that males are slightly larger.

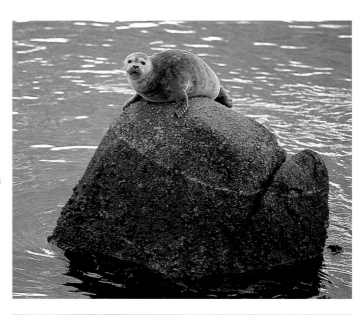

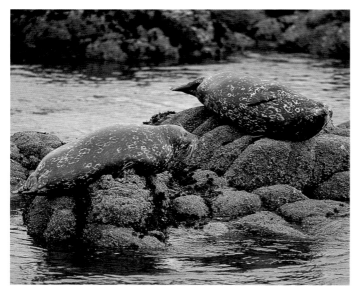

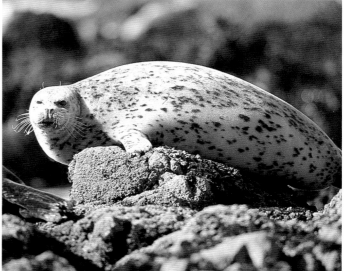

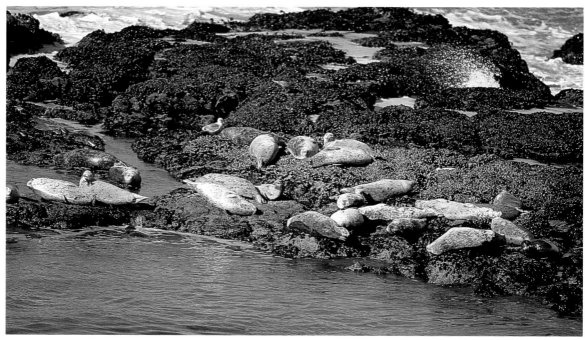

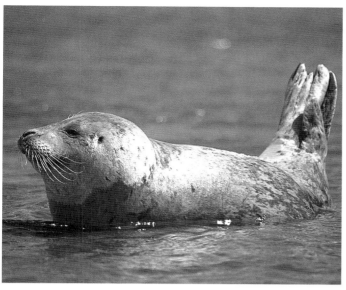
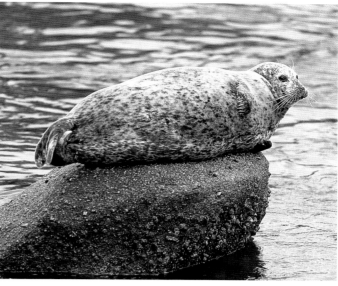
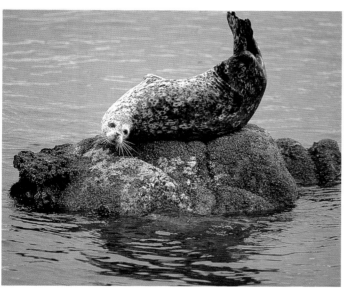
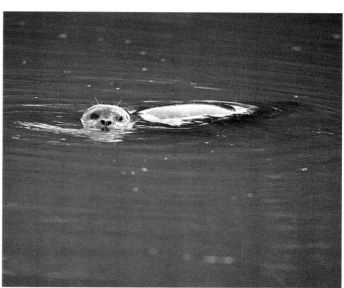
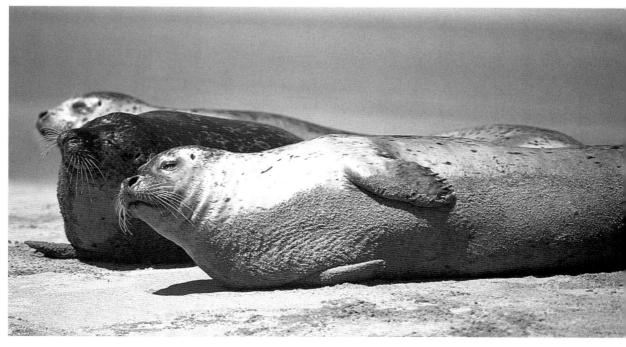

Northern Elephant Seal

Northern elephant seals live on the pacific coast of North America from Baja California to Alaska.

During the breeding season they spend much of their time on open sandy beaches between San Francisco and Baja California. Afterward they tend to move out to sea (especially the males), and some migrate into northern waters.

Adult males are considerably larger than females. Males have a large fleshy proboscis not found on the females.

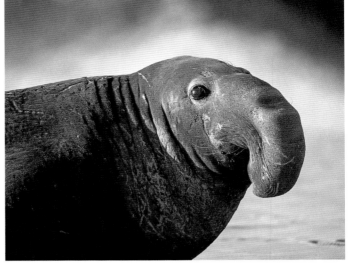
Male

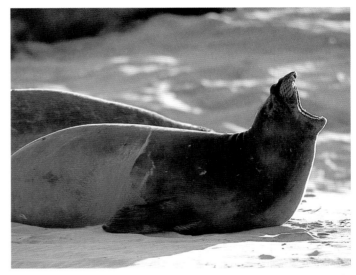
Female

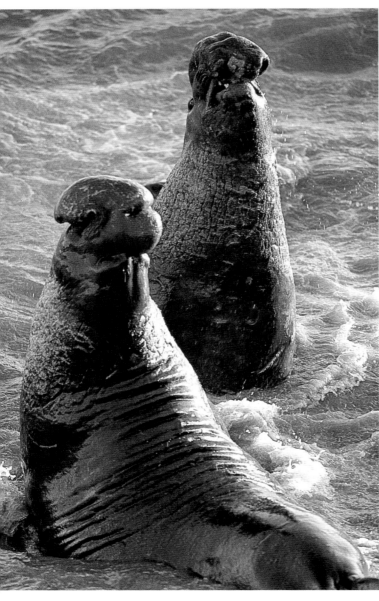
Males fighting

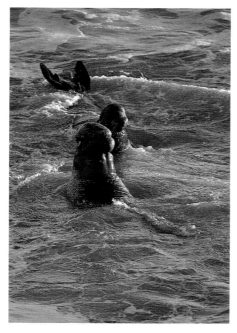

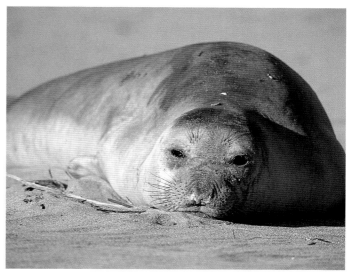

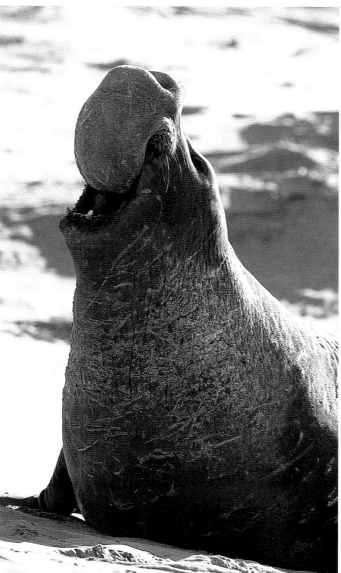

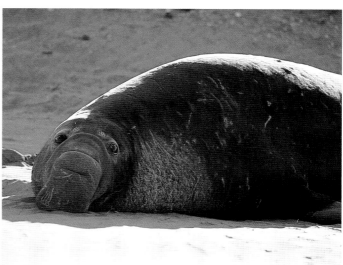

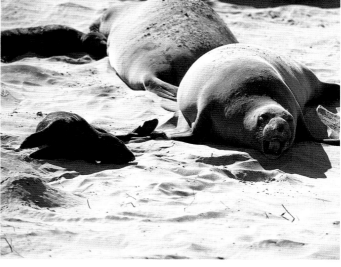

Female and young

Sea Otter

Sea otters range up the Pacific coast from California to the Aleutian Islands of Alaska across the Bering Sea to the Commander Islands and Kamchatka, then south to the Kuril Islands off eastern Russia. Within North America their populations are patchy and occur mostly off the coasts of central California, Washington, Vancouver Island, the Alaskan panhandle and from Prince William Sound to the Aleutian Islands in Alaska.

Sea otters rarely crawl out of the water yet they never wander more than a half mile from shore. They like shallow ocean waters near the shore with rocks, shellfish and seaweed.

The sexes look alike, but males are generally larger than females.

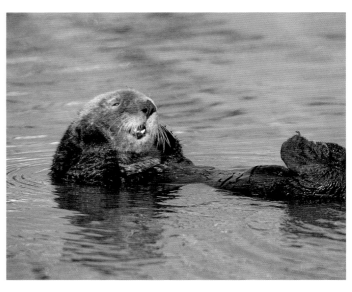

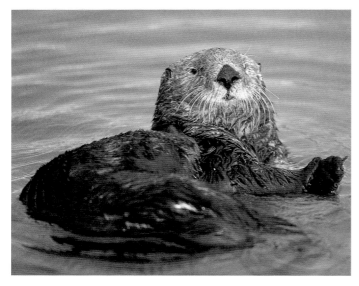

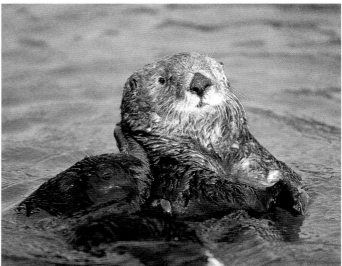

Cracking open a shellfish

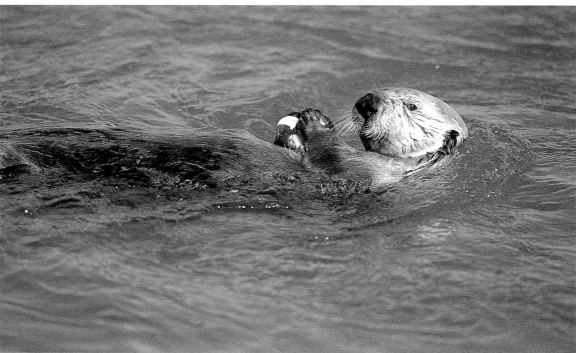

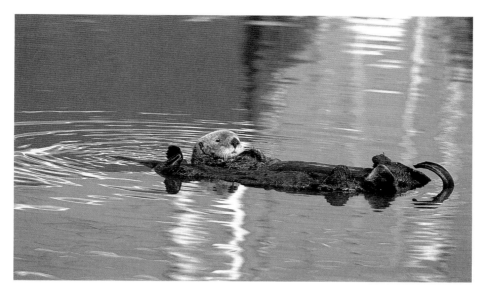

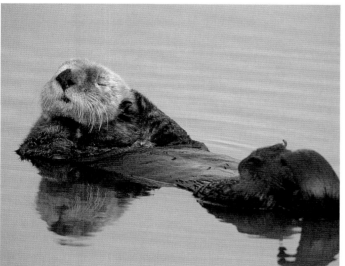

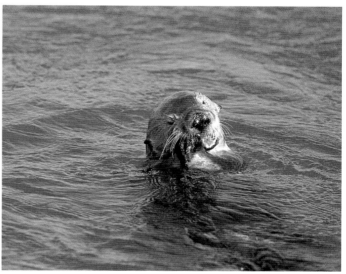

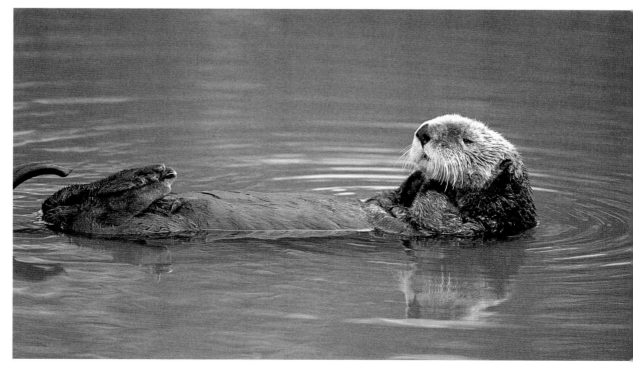

Sea Otters in Acrylic

Materials

Surface
Hardboard panel primed with gesso

Brushes
Flat no. 12
Rounds no. 000, no. 1, no. 3, no. 5

Palette
Golden Acrylic—C.P. Cadmium Yellow Light, Raw Sienna, Raw Umber, Titanium White

Liquitex Acrylic—Burnt Sienna, Ivory Black, Naphthol Red Light, Ultramarine Blue

Other
Empty film canister
Sketching paper
Water used as a painting medium with each painting mixture

In this demonstration you will learn how to create a realistic painting of a pair of sea otters by combining two reference photographs. You will also learn how to paint the soft, fine fur of a sea otter and make it look both dry and wet. I took the reference photographs of these wild sea otters at Moss Landing on the California coast. I was careful to select reference photographs that had consistent lighting and that work together to make a good composition. It helps that these photos were taken within a few seconds of each other from the same camera angle.

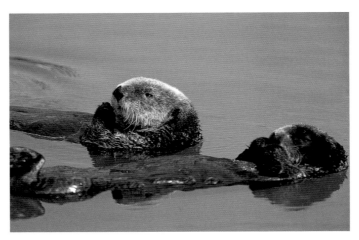

Main Reference Photograph
This photograph sparks a good idea for a painting because it has placement of two otters in a good composition already.

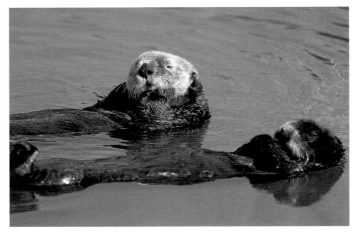

Reference Photograph
Use the otter on the top of this photograph to change the pose and details of the otter in the foreground of the main reference photo. Keep the approximate placement of the otters shown in the main photo.

1. Utilize a Thumbnail Sketch
Draw a thumbnail sketch to see if the composition will work.

2. Complete the Drawing
Fine-tune the drawing on a piece of scrap paper. Transfer the drawing to the board by tracing the lines on the reverse side of the paper, then place the drawing right side up on the board, and retrace, with hard pressure, over the lines again.

3. Block in the Entire Painting
Block in the water with a mix of Ultramarine Blue, Titanium White, Cadmium Yellow Light and Naphthol Red Light using the no. 12 flat and no. 5 round brushes. Save the extra paint for use in later steps.

Block in the eyes, noses and mouths with a mix of Ivory Black and Raw Umber using the no. 3 brush. Add more Raw Umber and block in the dark fur on the otters' necks.

Paint the otters' reflections in the water with a no. 5 round and a mix of Raw Sienna, Cadmium Yellow Light, Ultramarine Blue and Titanium White.

Block in the belly with a mixture of Raw Umber, Burnt Sienna, Ivory Black and Titanium White using the no. 12 flat and no. 5 round brushes.

Paint the lighter brown colors on the neck with the no. 5, no. 3 and no. 1 brushes and mixes of Raw Umber, Raw Sienna, Titanium White and Ivory Black.

Paint the shadow side of the faces with the no. 5 and no. 3 brushes and a mix of Raw Sienna, Titanium White, Naphthol Red Light and Ultramarine Blue.

Block in the nose of the otter on the right side with a mix of Ultramarine Blue, Naphthol Red Light, Titanium White, Raw Umber and Ivory Black.

4. Add More Colors

This step bridges the gap between the basic block in of colors and the really detailed work. Paint the dark blue hues on the bellies of the otters with a mix of Ultramarine Blue, Naphthol Red Light, Raw Umber, Ivory Black and Titanium White.

Take some of the water mixture saved in the previous step, and add more Ultramarine Blue. Use the no. 3 and no. 1 brushes to paint the lightest blue highlights on the bellies, caused by puddles of water and reflections of the sky.

Paint a mix of Raw Sienna and Titanium White on the faces of the otters with the no. 5 and no. 3 brushes.

Start some of the most obvious fur details in the shadows of the faces using the no. 3, no. 1 and no. 000 brushes and a variety of mixtures of Raw Umber, Raw Sienna, Ivory Black Ultramarine Blue, Naphthol Red Light and Titanium White.

5. Get Detailed

Paint the fur on the otters' faces by pre-mixing six different mixtures of brown ranging from the lightest brown to the darkest brown (see list of mixtures in the box below). Paint each color detail where you can see it in the photograph using the no. 3, no. 1 and no. 000 brushes. You will have to make intermediate mixtures from these six piles of paint to catch all the subtle differences in the fur. Where the fur is soft in the photograph, use more water and less pigment as you brush it on. Work back and forth between dark and light to help keep the fur looking soft.

Paint the dark textures on the nose with a dark mix of Ivory Black, Ultramarine Blue, Naphthol Red Light and Titanium White using the no. 1 brush and a stipple-like technique ("dotty" application of paint). Paint the highlights on the nose with the no. 1 brush and Titanium White mixed with a touch of the previous mix.

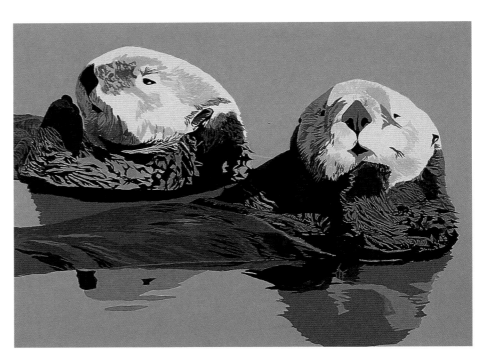

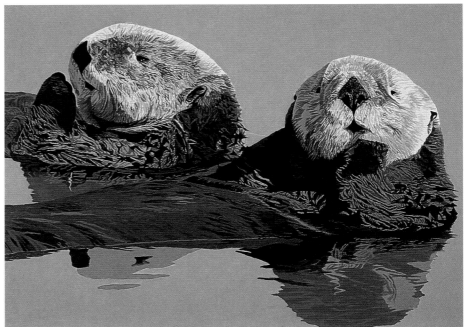

Work back and forth on the fur details of the neck and shoulders with mixes of Raw Umber, Raw Sienna, Ivory Black, Titanium White and Burnt Sienna.

Paint the reflection of the otters with mixtures of Raw Umber, Raw Sienna, Cadmium Yellow Light, Ultramarine Blue, Titanium White and Ivory Black.

Paint Mixtures for the Otters' Faces

• Raw Sienna and Titanium White
• Raw Sienna, Raw Umber and Titanium White
• Same as the above mix but with more Titanium White added
• Raw Umber, Ivory Black and Titanium White
• Same as the above mix but with more Titanium White added
• Raw Sienna, Burnt Sienna, Raw Umber and Titanium White

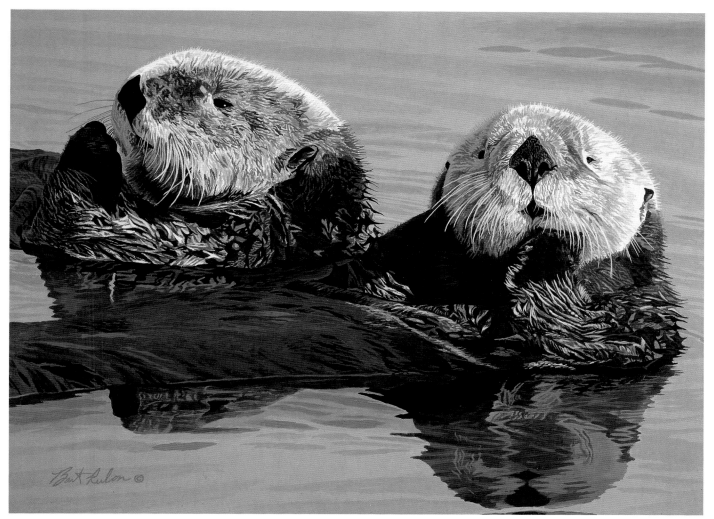

6. Finish With the Highlights and Water

Add the fur highlights with the no. 1 and no. 000 brushes and mixtures of Titanium White, Raw Sienna and Raw Umber (vary the amount of white added). Go back and forth between the highlights and the darkest darks to refine the details of the fur, blending colors where needed wet into wet.

Add a little more Ultramarine Blue and Naphthol Red Light to the water mixture from step three and with the no. 5, no. 3 and no. 1 brushes, paint this as the subtle ripples in the water and as the darker shade of blue, indicating the otters' bodies under the water's surface. To help balance the composition, add a green reflection in the top right hand corner of the background with a combination of the blue water mix plus more Ultramarine Blue, Cadmium Yellow Light, Raw Umber and Raw Sienna. Continue to refine the details in the otters' reflections using the same mixtures as in step five.

After the water is finished, paint the soft edges of fur around the profile of the otters' heads. Take the no. 000 brush, a mix of Titanium White and Raw Sienna, and use quick, light brushstrokes to keep the lines thin, transparent and soft. For the darker fur of the bodies' profile, use mixes of Ivory Black, Raw Umber and Titanium White, and make the brushstrokes longer. Finally mix Titanium White with touches of Raw Sienna and Cadmium Yellow Light, and paint the otters' whiskers with the no. 000 brush. In some areas, where the background is too bright, you might need to underpaint the whiskers with pure Titanium White then glaze the whisker mix on top so it stands out enough. Paint the whiskers on the shadow side of the otter on the left with a mix of Raw Sienna, Raw Umber and Titanium White. When the scene looks believable from a distance of three to five feet away, the painting is finished.

Sea Otters
Bart Rulon
9" x 12" (23cm x 30cm)
Acrylic on hardboard panel

River Otter

River otters range throughout most of Canada, Alaska, the northwestern United States, the southeastern United States and in isolated populations in other states.

Their habitat includes rivers, streams, lakes and marshes, but they can also inhabit saltwater habitats, where they are frequently confused with the sea otter.

River otters are considerably smaller than sea otters. They spend most of their time in the water, but unlike the sea otter, they also spend time on land to den, forage waterside and travel. They are very social and playful animals.

The sexes look alike, but males grow larger than females.

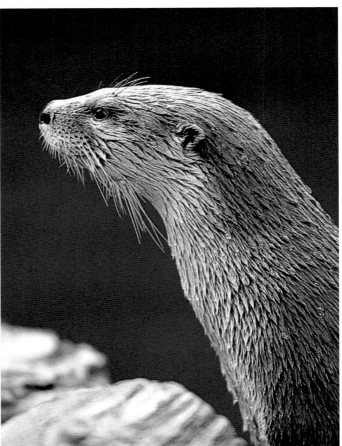

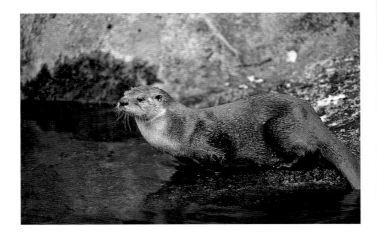

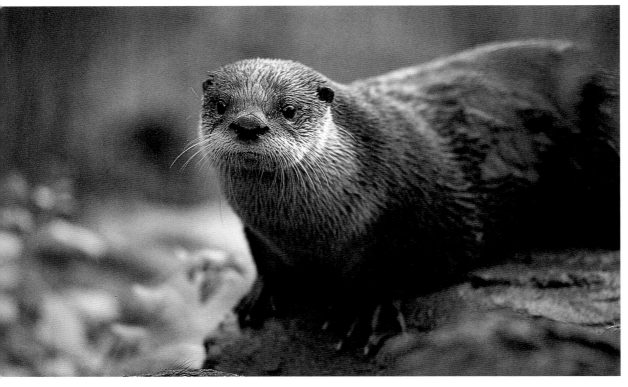

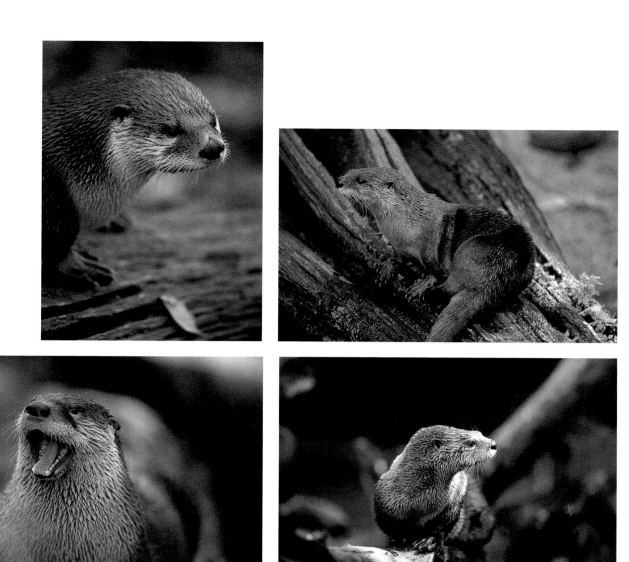

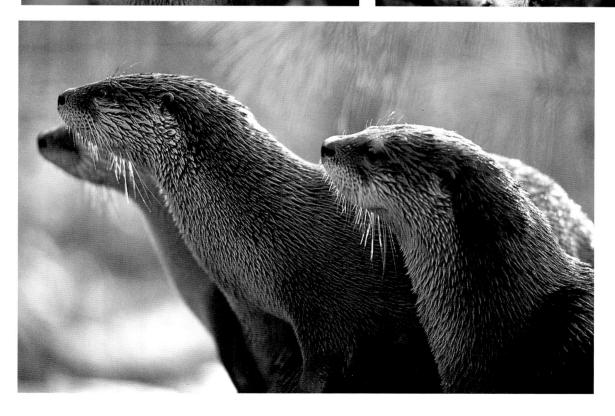

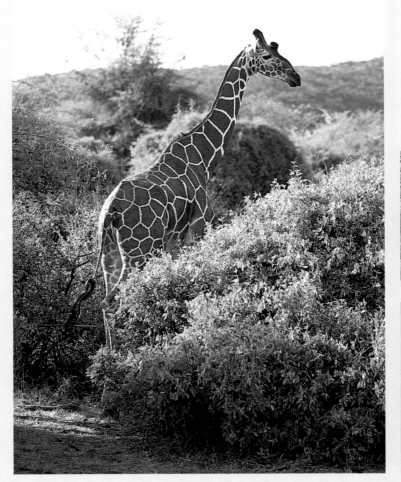
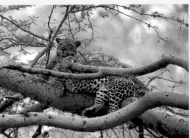
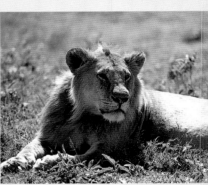
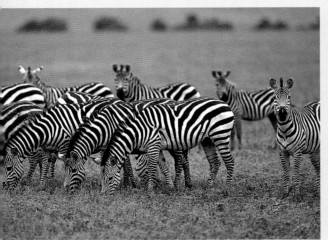
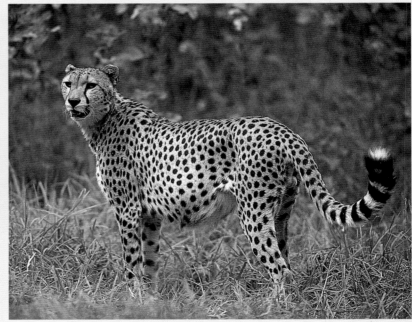

Wildlife in Africa

It's hard to come up with the right words to describe how magical Africa is for wildlife viewing. There is no doubt that Africa is the ultimate destination for any wildlife artist. It has such a great variety of different animals that are readily accessible in national parks and conservation areas. Africa is the best place in the world to see wild cats in their natural habitat and the drama of the predator and prey relationship.

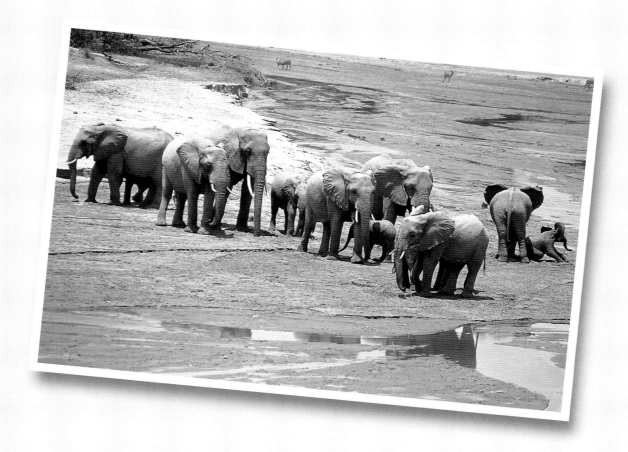

Lion

Lions live in fragmented distribution, south of the Sahara desert, in east and central Africa, and the northern part of southern Africa. There is also an isolated population of lions located in the Gir forest in northwest India.

Lions utilize a wide range of different habitats including grassy plains, desert edges and open forests.

Only males grow a mane, and they grow considerably larger than females (lionesses).

Lions are very social cats. A basic family unit (pride) consists of related females, dependent young and usually a group of two or more adult males.

Female

Male

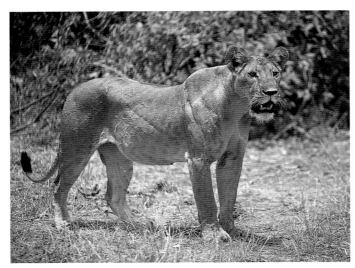
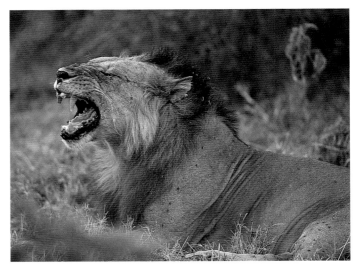

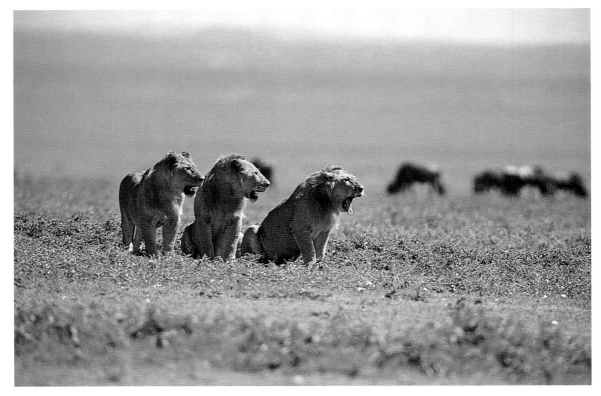

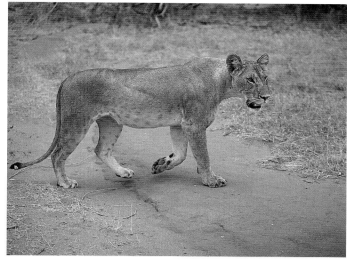

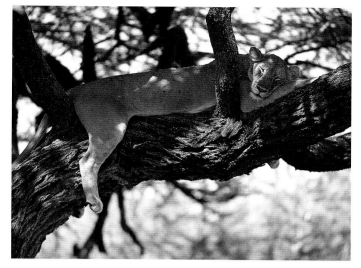

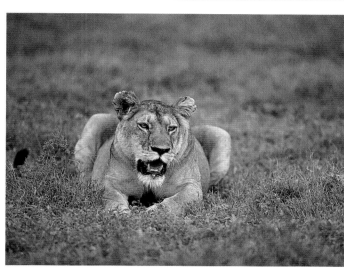

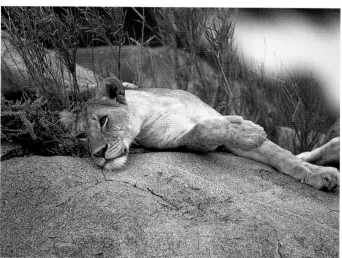

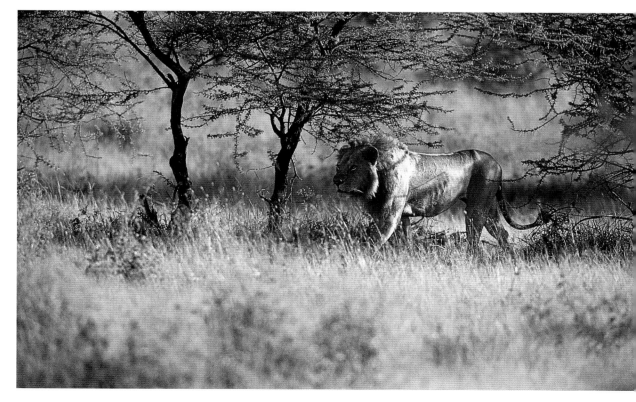

Leopard

Leopards have a fairly wide distribution in Africa south of the Sahara desert but are absent from part of southern Africa. An isolated population exists in Morocco in northern Africa. Leopards are also widespread from the Middle East across southern Asia and into China.

They utilize a wide range of habitats including forests, grassy plains, mountains, semi-deserts and tropical rainforests.

Males grow larger than females. Leopards are mostly solitary and are most active at night.

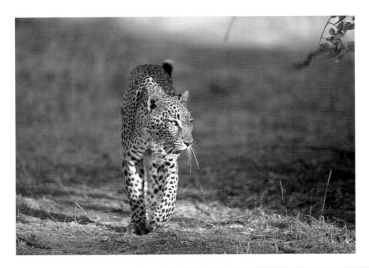

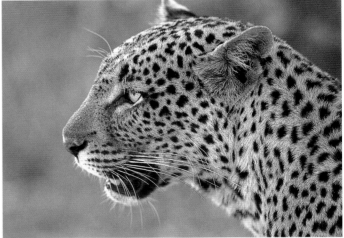

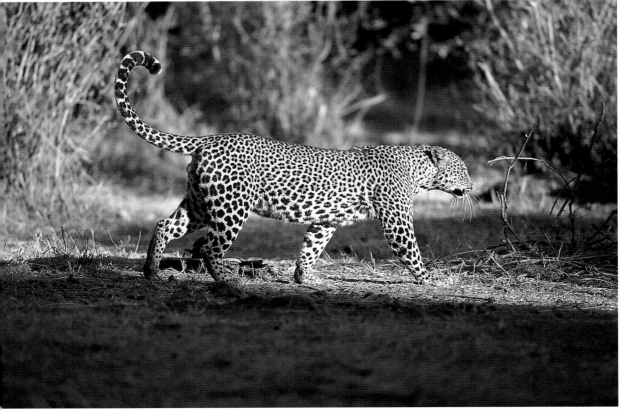

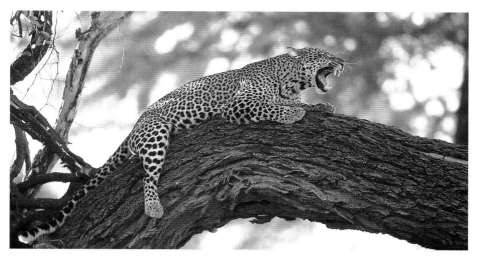

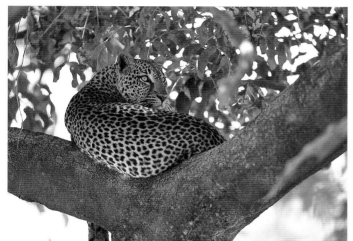

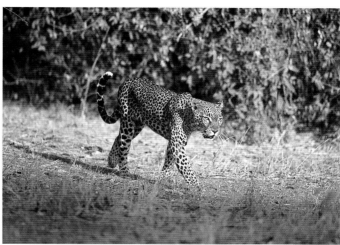

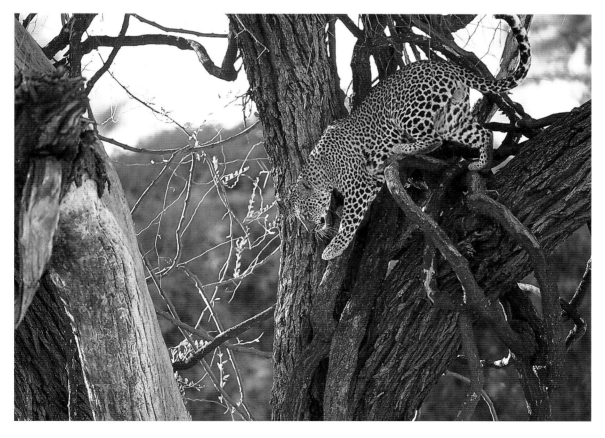

Cheetah

Cheetahs have a fairly widespread distribution south of the Sahara desert in Africa. Their strongest populations are in east Africa and the northern part of southern Africa, but they are also found in central Africa and in isolated parts of the Sahara. Cheetahs also live in parts of the Middle East, particularly Iran.

Their habitat includes mostly open country such as grassy plains, desert plains, semi-deserts and wooded grasslands.

Males average larger than females.

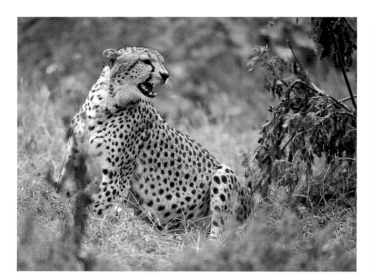

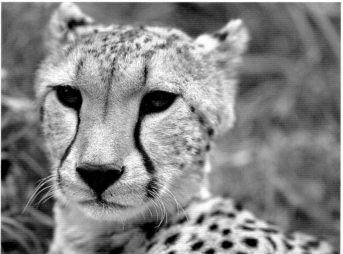

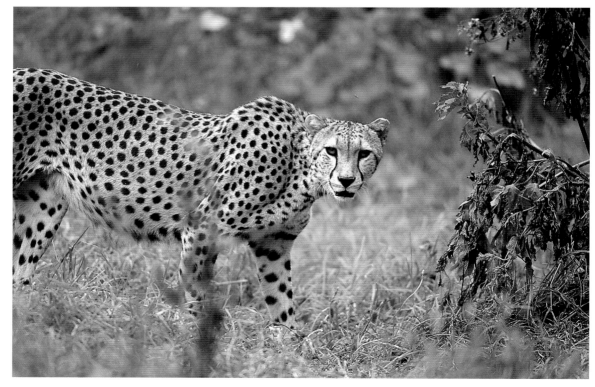

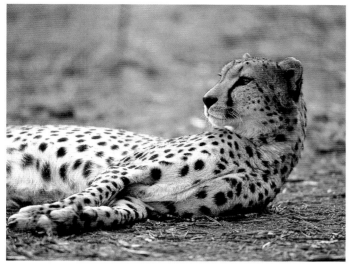

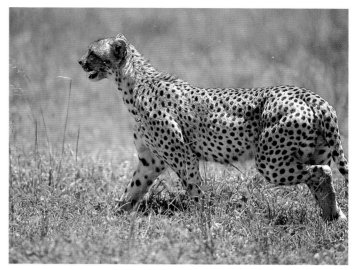

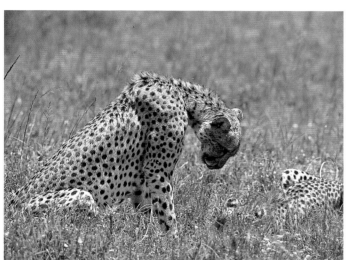

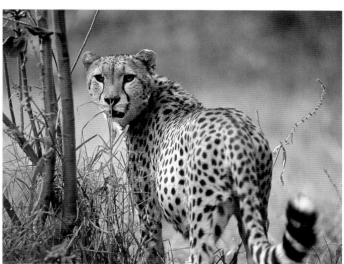

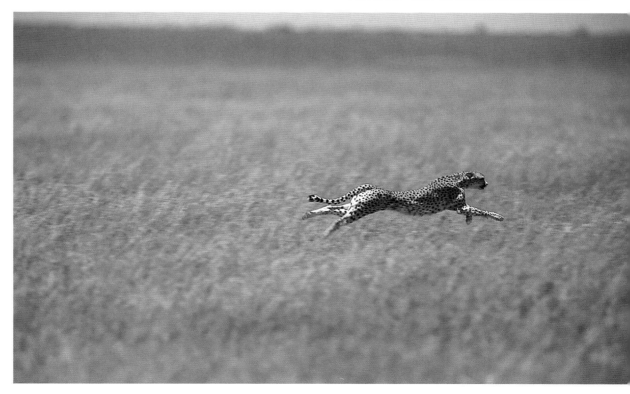

Giraffe

Giraffes are found south of the Sahara desert in fragmented populations in central, eastern and southern Africa.

Their habitat includes grassy plains, dry wooded grasslands and semi-deserts.

Males grow larger than females, but both sexes grow a pair of horns that are covered with skin. The tops of the horns are tufted with hair in females and bald in males. Males in particular sometimes grow extra knobs on their foreheads in front of the pair of horns. The lattice pattern on the coat of a giraffe varies according to the subspecies.

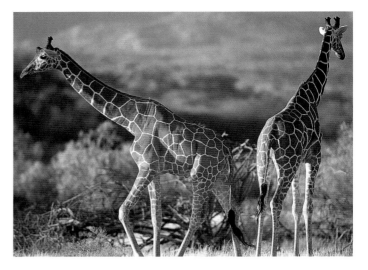

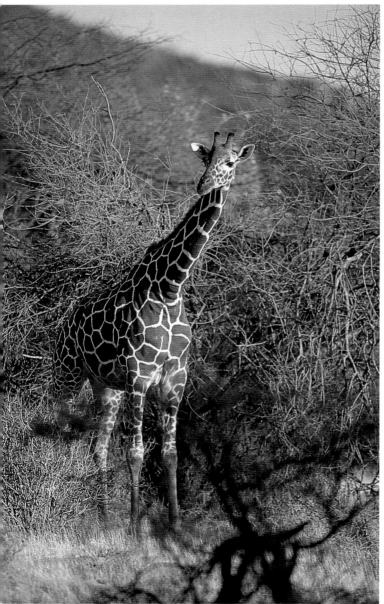

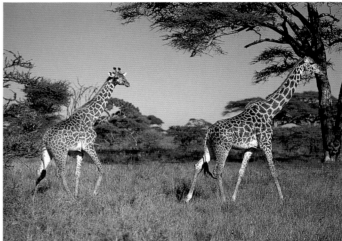

Female with young (Masai or Kenyan subspecies)

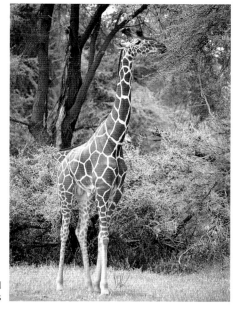

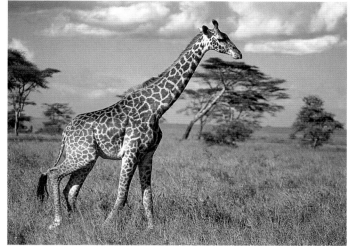

Male Reticulated
subspecies

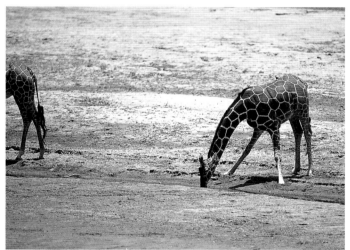

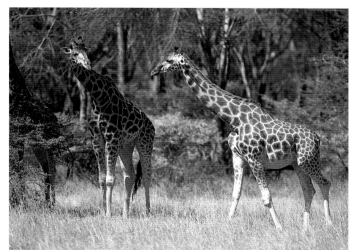

African Elephant

Elephants are found in Africa south of the Sahara desert in patchy distribution. The largest concentrations live in central Africa, eastern Africa and the northern parts of southern Africa. In West Africa there are only small isolated populations.

Elephants use a wide range of different habitats including grassy plains, forests, swamps, semi-deserts and river valleys.

Males grow noticeably larger than females, but both sexes grow tusks, although some don't. They are highly social and live in small family herds comprised of an older cow and her offspring and can include several generations. Adult males live alone or in bachelor herds.

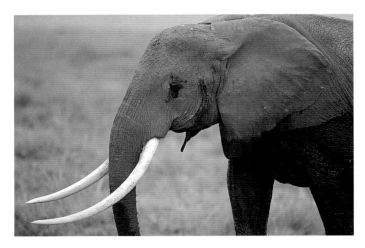

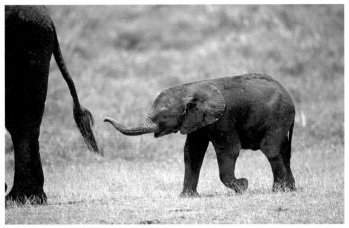

Baby

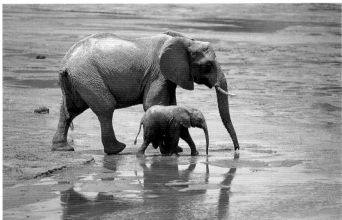

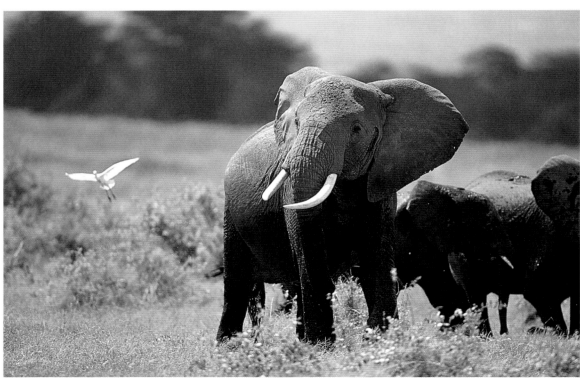

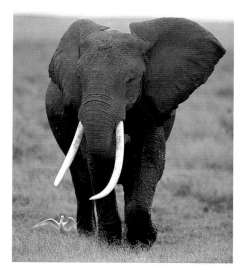

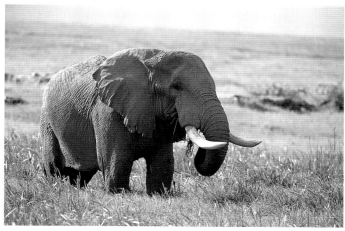

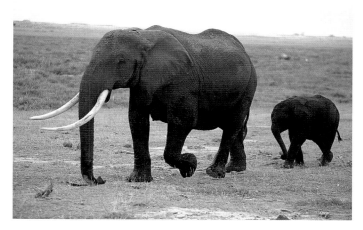

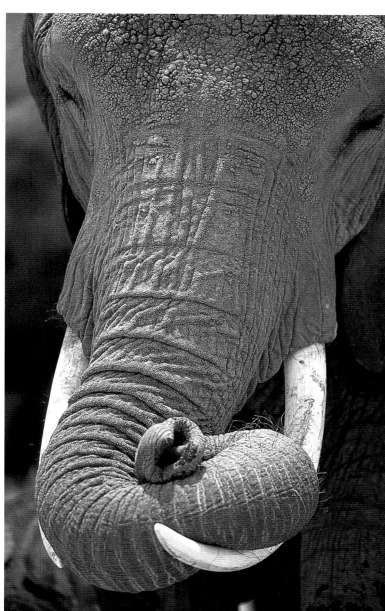

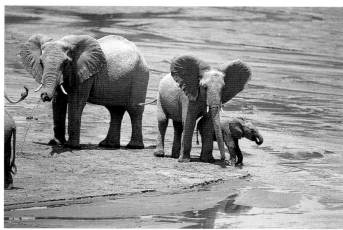

Cape Buffalo

Cape buffalo have a wide distribution south of the Sahara desert, in western, eastern and central Africa. They are absent from the southernmost part of Africa.

Their habitat includes open plains and open woodlands, and forests.

Bulls grow larger than cows. Both sexes have horns, but the bulls' horns grow larger and wider with a heavy boss where the two horns meet.

Cape buffalo are typically found in herds, but bachelor herds are often apart from the main herd and old bulls are sometimes loners.

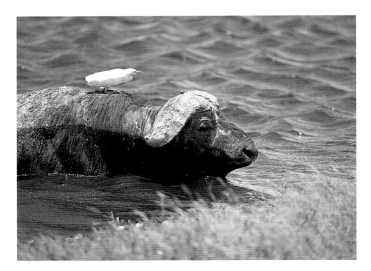

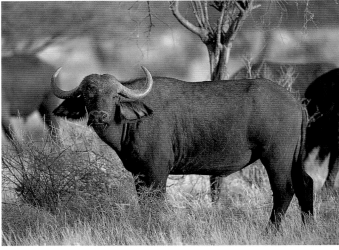

Cow

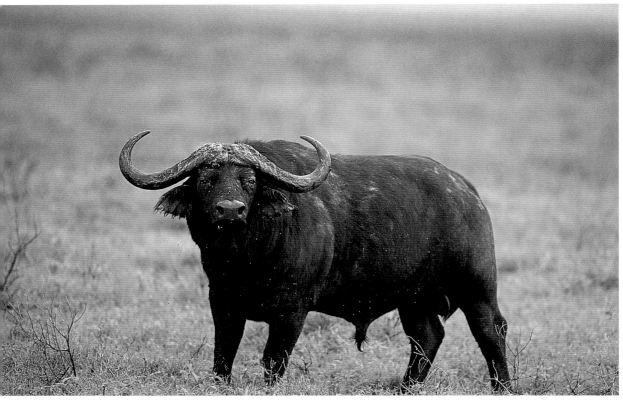

Bull

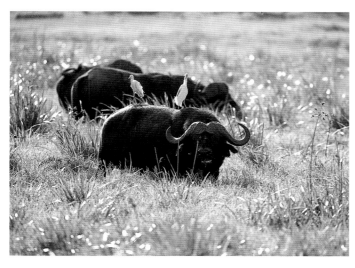

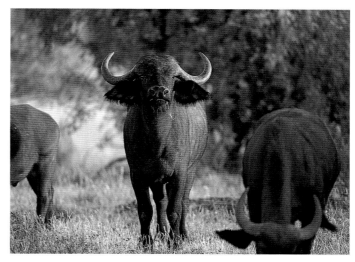

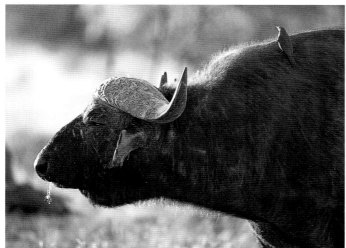

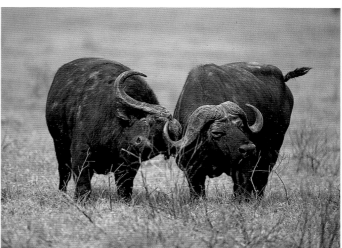

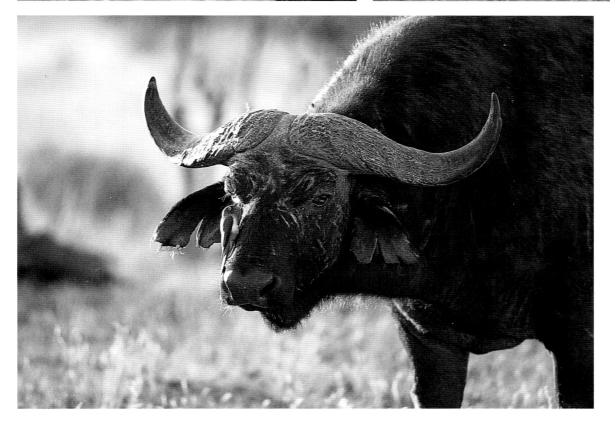

White Rhinoceros

The white rhinoceros is found in isolated populations in South Africa, Botswana, Zimbabwe, Zaire and Kenya.

Because they are grazers, they prefer a short grass savanna habitat with open woodlands, brush and water nearby.

Males grow larger than females, and both sexes have horns.

Female and baby

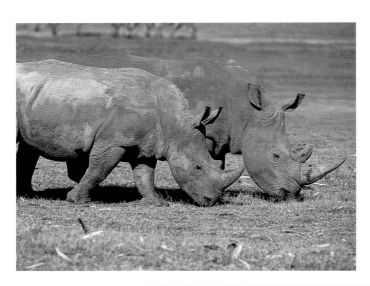

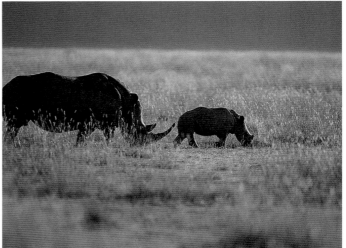

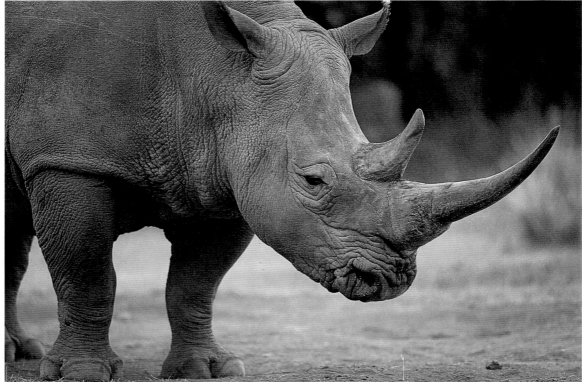

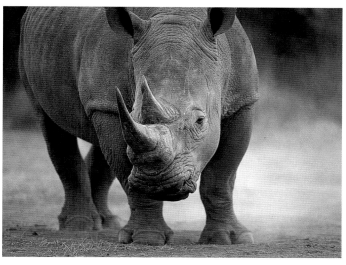
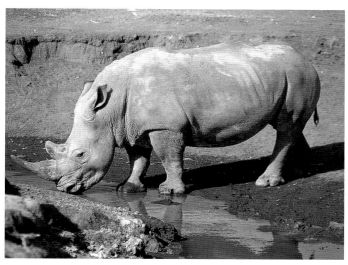
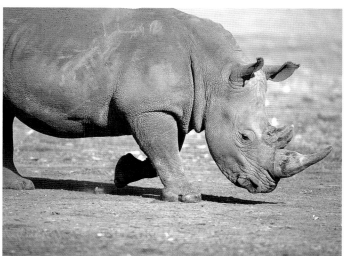
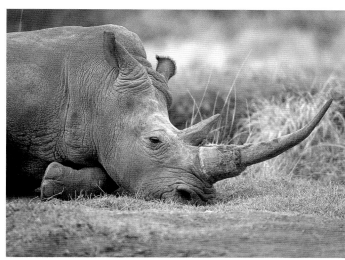
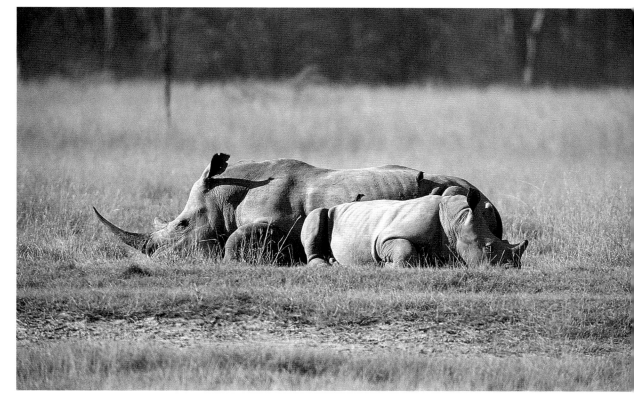

Hippopotamus

Hippos have a wide distribution south of the Sahara desert in central, eastern and western Africa, and in the northern part of southern Africa.

Their habitat includes rivers, streams, lakes and swamps.

Males tend to grow larger than females. They typically live in herds dominated by an adult bull. Young males sometimes live alone or in bachelor groups.

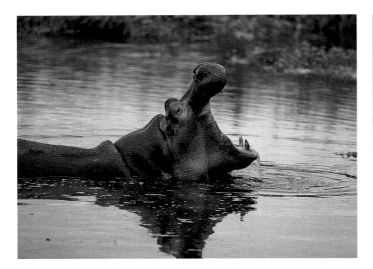
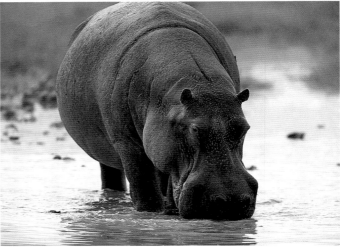

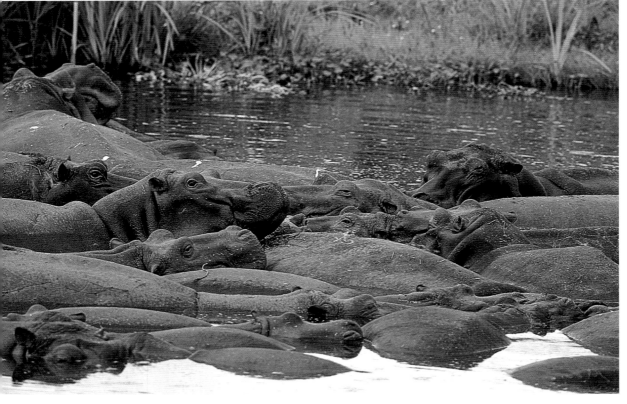

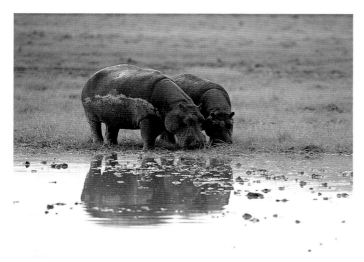 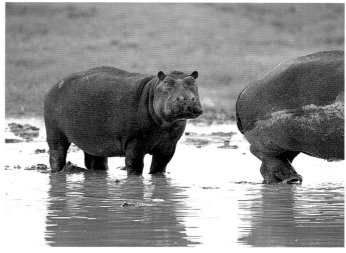

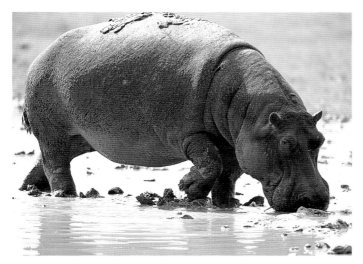 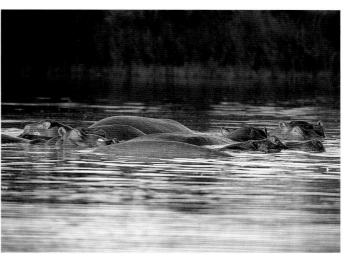

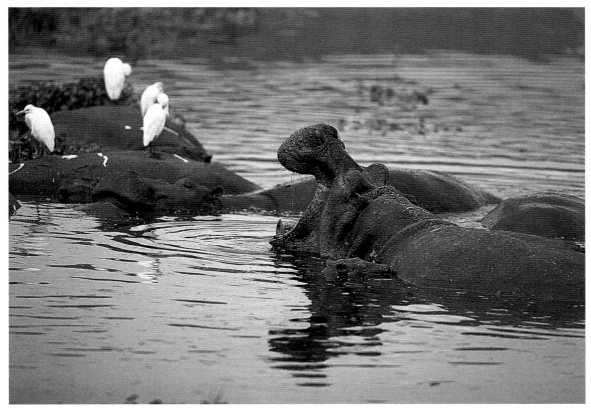

Plains Zebra (Burchell's Zebra)

The plains zebra is found in eastern Africa and northern part of southern Africa from Angola north to Ethiopia and Sudan. Their habitat includes grassy plains and open woodlands.

They live in small family herds led by an adult male (stallion), including several mares and their offspring.

The extent and pattern of zebras' stripes varies among different subspecies.

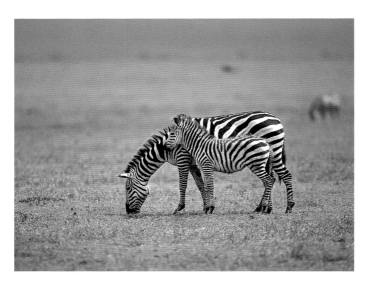
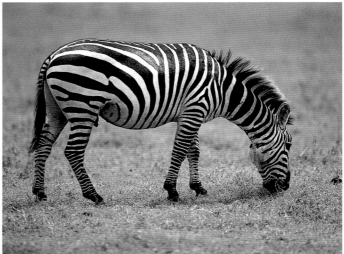

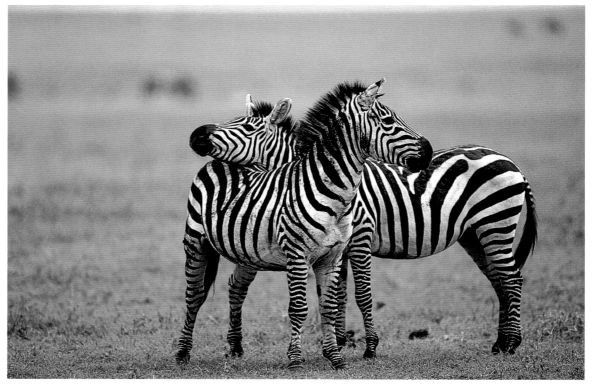

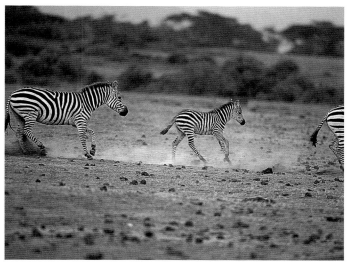

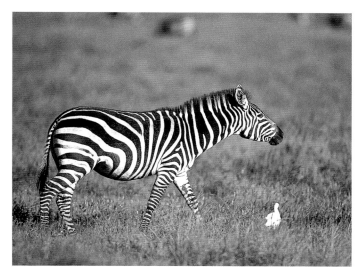

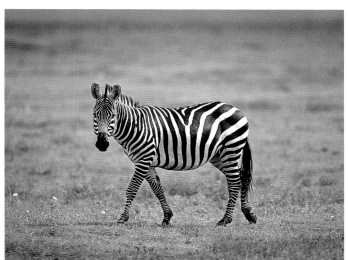

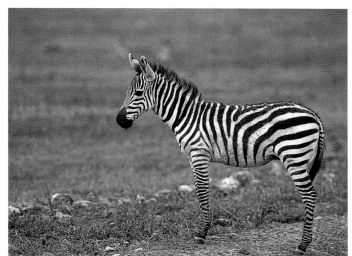

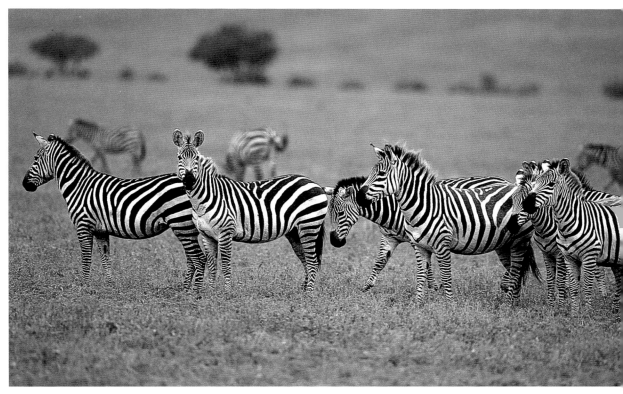

Impala

Impalas have a wide distribution from eastern Africa to the northern part of southern Africa as far north as Kenya and as far south as South Africa. There is an isolated population in Namibia and Angola.

Impalas prefer grasslands mixed with brush and trees.

Only males have horns, and males grow larger than females.

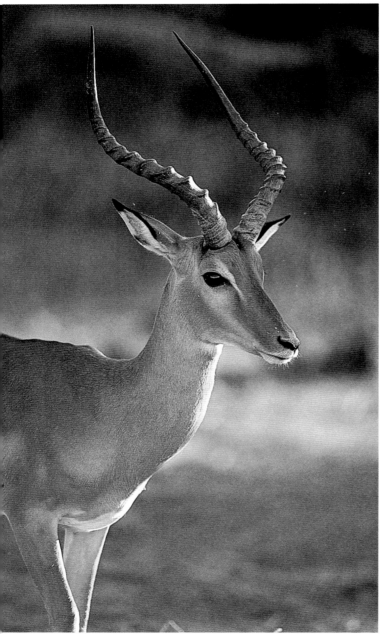

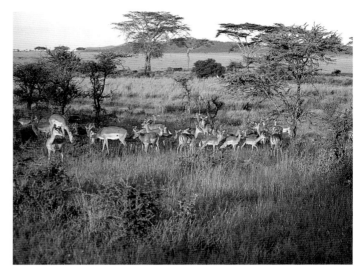

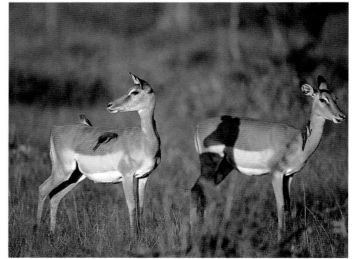

Male

Females

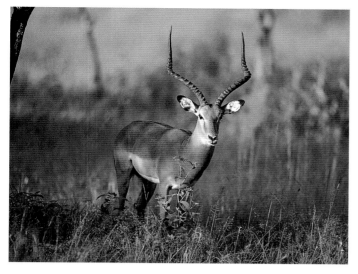
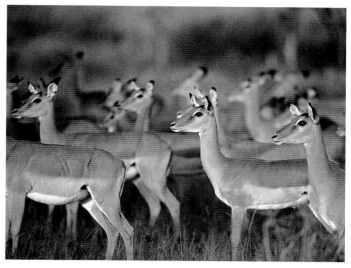
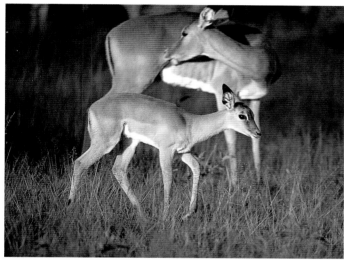
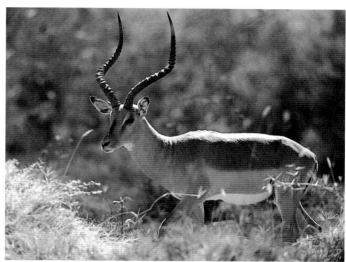
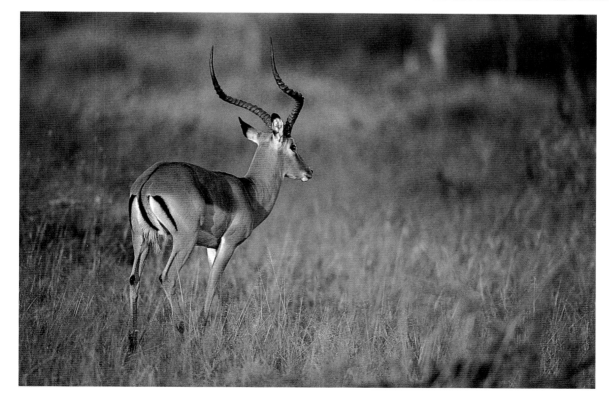

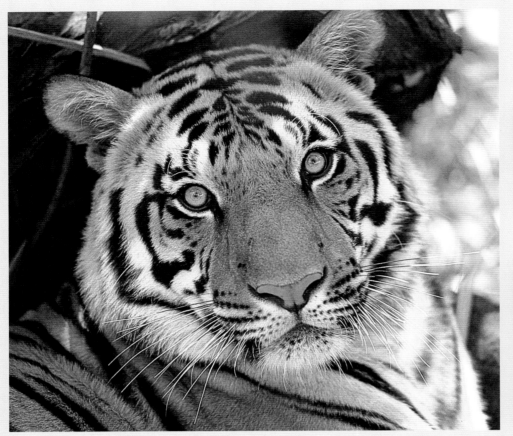
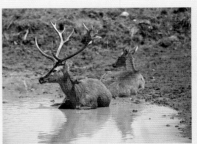
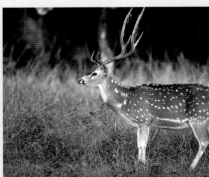
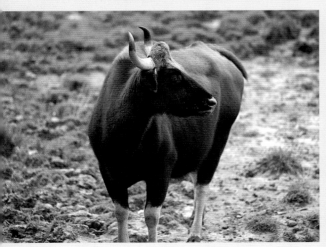
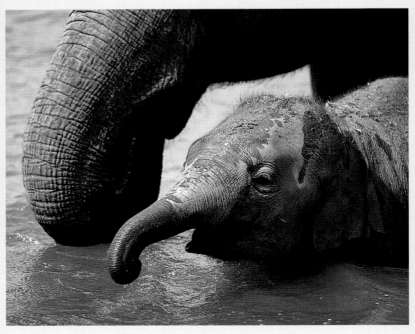

Wildlife of India

In tiger country other wildlife must be on alert, and the presence of a tiger is often advertised by the loud warning calls of other animals in the jungle. All of the photographs in this chapter were taken while I was on safari in India, and most came from inside Bandhavgarh, Kanha and Keoladeo Ghana National Parks. This is a diverse collection of different animals that share some of the same habitats in a land that is ideal for painting.

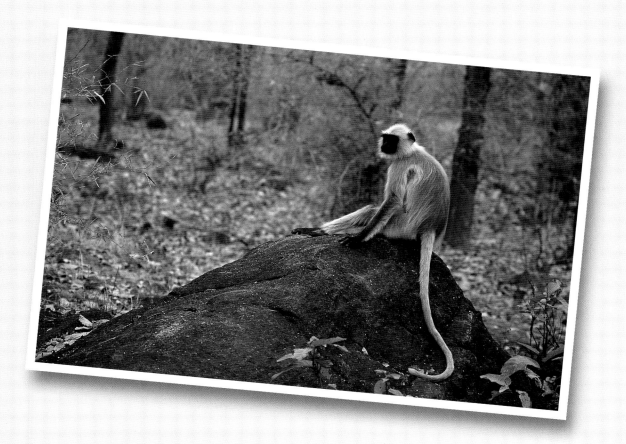

Tiger

Tigers are found throughout much of southern Asia including India, Nepal, Bhutan, Bangladesh, Thailand, Vietnam, southern China and parts of Indonesia. There are isolated populations in eastern China, northeastern China and eastern Russia.

Tigers use a large variety of habitats including all types of forests, heavy grasslands, swamps, brushlands, bamboo thickets, mountains and snow covered taiga.

There are several different subspecies of tigers that vary in color, size and number of stripes. The Bengal tiger subspecies, found in southern Asia, is shown here. Males grow larger than females.

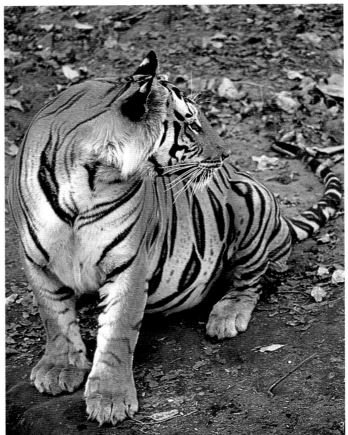

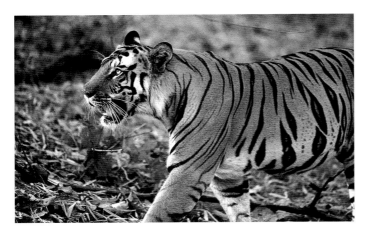

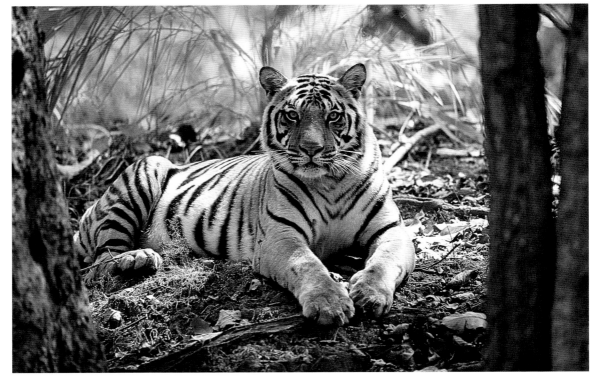

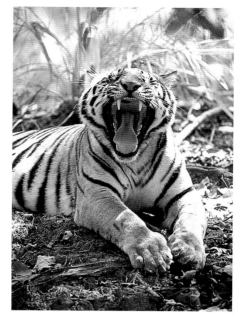

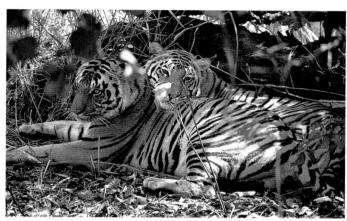

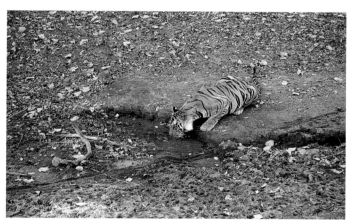

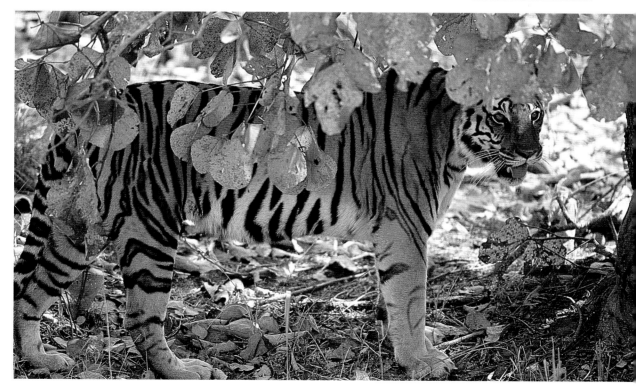

Tiger in Watercolor

Materials

Surface
Arches 300-lb. (640gsm) cold-pressed paper

Brushes
Rounds no. 000, no. 1, no. 3, no. 5, no. 8, no. 12, no. 14

Palette
Winsor & Newton Watercolors—Burnt Sienna, Burnt Umber, Cadmium Orange, Cadmium Red, Cobalt Blue, French Ultramarine, Lemon Yellow, Neutral Tint, Permanent Alizarin Crimson, Permanent Rose, Permanent Sap Green, Raw Sienna, Yellow Ochre

Other
Drawing paper
Hardboard panel
Masking tape
2B, 6B and 6H pencils
Scrap paper
Tortilions
Water used as a painting medium

As a child, my favorite subjects to draw and learn about were tigers, cheetahs and lions. Since then my biggest dream has always been to see those, and other, cats in the wild. I could hardly wait to paint the big cats of the world but decided to wait until I could experience them in the wild. Finally in 2001, with the help of my friend, Sarah Scott, I had an opportunity to photograph tigers in the wilds of India. I took these tiger photographs with a 400mm lens from the back of a trained Asian elephant in Kanha National Park. On elephant-back, with a guide, we were able to approach several tigers within 20 to 30 feet (10m x 9m) without spooking them or being in danger.

I don't normally paint portraits of animals, but for my first tiger painting it seemed fitting to focus on the tiger's face, in a pose that is similar to one I drew as a kid. This painting demonstrates how to paint the eyes, fur and stripes of a tiger.

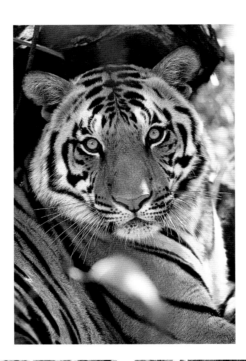

Main Reference Photo
This shot gives us a good pose and a close-up view of the details.

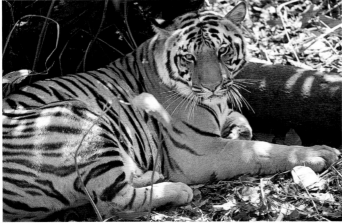

Body Reference Photo

Tree Reference Photo

1. Complete the Drawing

The composition in the photograph is already good. Begin with a drawing study to see if the idea will work, to get a feel for the direction of the fur and to work out the mistakes. As a rule, normally you don't place the subject in the middle of the composition, but sometimes you have to break the rules. Make adjustments until the anatomy looks correct. Use a 2B pencil for light and medium-toned details, and the 6B pencil for dark details. A tortilion will blend the pencil and help create soft edges. Pay special attention to the direction of the fur all over the face but particularly around the eyes and nose. Here I want the tiger's stare to be intimidating, so I put the eyes front and center.

Enlarge the drawing with a copy machine, and transfer the outline of the tiger and its stripes onto the watercolor paper.

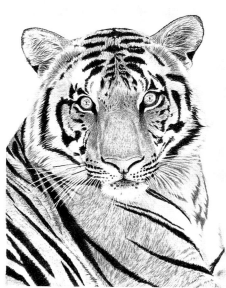

2. Complete an Underpainting

Start by painting the eyes' iris color with a mixture of Yellow Ochre and Raw Sienna using the no. 3 brush. Leave the subtle highlights in the eyes dry. Add Burnt Sienna and more Raw Sienna to the mix around the edges of the iris where the color is more intense. Use the no. 000 brush to paint the subtle dark patterns around the middle of the iris. Carefully build the iris color up with several washes of color on top of this.

Start the dark stripes and markings on the body of the tiger with a diluted mix of Neutral Tint and Burnt Umber. Wash Raw Sienna under the eyes, and start in with some of the fur details using the no. 1 brush and the same dark mix for the stripes. Alternate between washes of color and details to keep the edges soft.

Wash a mixture of Yellow Ochre, Raw Sienna and a touch of Burnt Sienna in the lightest, orange parts of the body using the no. 14 and no. 12 brushes. Add more Raw Sienna and Burnt Sienna for the darker, orange parts of the tiger. The end of the nose is a mixture of Cadmium Red and Cadmium Orange using the no. 5 brush. Paint in more of the tiger's stripes with a wash of Neutral Tint and Burnt Umber.

For the tiger's white chest, paint a broad, thin wash of French Ultramarine, Permanent Alizarin Crimson, Neutral Tint and a touch of Burnt Sienna with the no. 14 brush to indicate the subtle blue shadows. For the details in the ears, start by carefully and softly drawing the fur with a 6H pencil. Paint around the pencil lines, in the negative spaces created, with the no. 1 and no. 000 brushes and a mix of Neutral Tint, Burnt Umber and Permanent Alizarin Crimson.

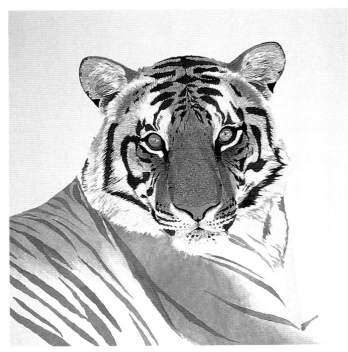

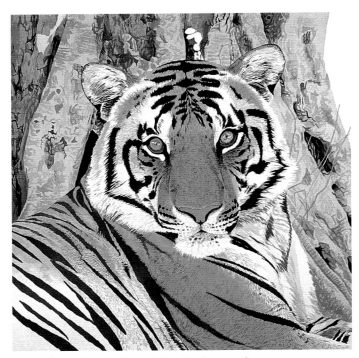

3. Work on Facial Details

Continue painting the details in the ears. Use the no. 1 and no. 000 brushes to work in the fur details all over the face with thin mixes of Neutral Tint and Burnt Sienna. In the white areas of the face add French Ultramarine to the previous mix. Next, darken the stripes with another wash of Neutral Tint and Burnt Umber. This time, however, use the no. 3, no. 1 and no. 000 brushes around the edges of each stripe to indicate the edges of the fur. Follow the reference photo carefully for these stripe edges. Use the no. 5 brush to fill in the middle of the stripes as you go along with the edge details.

Use a watered down version of the stripe mixture with a little Burnt Sienna added to paint the tiny hair details from the eyes to the nose with the no. 000 and no. 1 brushes. Pay special attention to the photo to duplicate the direction of the fur in this step. Notice how the fur patterns tend to radiate out from the inside corner of each eye and how the hairs follow the contours of the muzzle. For the subtle fur details in the white parts of the face use the no. 1 and no. 3 brushes and a diluted mix of French Ultramarine, Neutral Tint and Burnt Sienna. As you paint the tiger, try to duplicate the fur details in the photo, improvising as necessary.

4. Work on the Body and the Background

Paint the fur details on the body with the no. 000 and no. 1 brushes and a mix of Neutral Tint and Burnt Umber for the orange areas. Use French Ultramarine, Permanent Alizarin Crimson and Burnt Sienna for the white areas. The direction of fur changes throughout the body so be sure to pay attention to the reference photo as you progress. Go over the shoulder with a wash of Raw Sienna, Yellow Ochre and Burnt Sienna. Also paint a wash of this mixture on the muzzle from between the eyes to the nose. Darken the tiger's stripes once again, but this time with a strong mixture of Neutral Tint and Burnt Umber. Use the no. 000 and no. 1 brushes for the ragged edges of the stripes.

Start the background by alternating between broad washes to indicate color and shadow and a drybrush technique for the details of the bark. For both, use mixtures of Neutral Tint, French Ultramarine, Permanent Alizarin Crimson and Burnt Sienna. Paint the details with the no. 8, 5, 3, and 1 brushes, and the broad washes with the no. 12 and 14 brushes using a more watered-down mixture. Add a touch of Permanent Sap Green to the tree mixture for areas where the photo shows a greenish tinge on the tree.

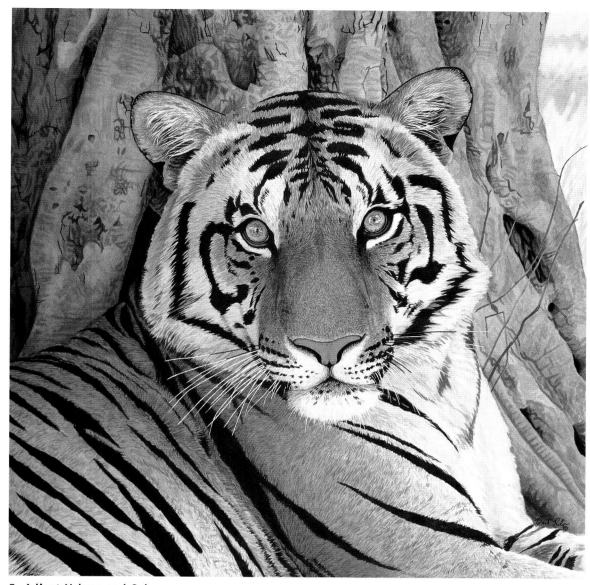

Tiger Portrait

Bart Rulon

22" x 21" (56cm x 53cm)

*Watercolor on 300-lb.
(640gsm) cold-pressed paper*

5. Adjust Values and Colors

Finish off the details of the tree bark with the mixes of Neutral Tint, French Ultramarine, Permanent Alizarin Crimson and Burnt Sienna. Then wash a watered-down version of this mix over the entire tree to put it in shadow and soften the details, which makes the tree recede.

The tiger is in the shadow of the tree, and her values will need to get darker too. Achieve this with more broad washes of the colors used in previous steps. Also paint a thin mix of French Ultramarine, Permanent Alizarin Crimson and Neutral Tint on the ears and white areas of the tiger. Use washes of this bluish mixture to dull down the orange fur on the tiger where it still looks too bright to be in the shadow, especially on the face. Look at the reference photo to see which fur details need to be darkened, such as around the eyes and nose, and use the no. 000 and no. 1 brushes to reinforce them with the same colors as before. Make sure the face is the most detailed part of the painting since it is the center of interest. Use a heavily pigmented mixture of Neutral Tint and Burnt Umber to finish the stripes using the no. 8, 3, 1, and 000 brushes as before.

Paint out-of-focus grass in the top right corner with a mix of Raw Sienna, Yellow Ochre and Raw Umber, adding Permanent Sap Green, Neutral Tint and Cobalt Blue for the dark area. Use the no. 12 and no. 8 brushes and paint wet-into-wet so the edges are fuzzy. Paint the small, green leaves over the tiger's head with a mix of Permanent Sap Green and Neutral Tint using the no. 3 brush.

Asian Elephant

The range of Asian elephants includes southern India, Malaysia, Sumatra, Borneo and southern Asia from Nepal to Thailand.

In many areas, elephants have been domesticated and used for heavy work such as moving timber from forests and for tracking tigers.

In the wild, elephants are very gregarious. Their groups are centered around the females, led by an old female, and extended family that help care for the young. Males are usually located around the edges of the group. Only males grow tusks.

Baby

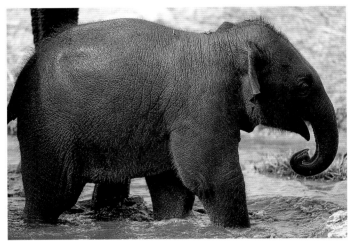

Females

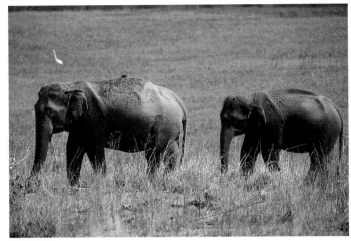

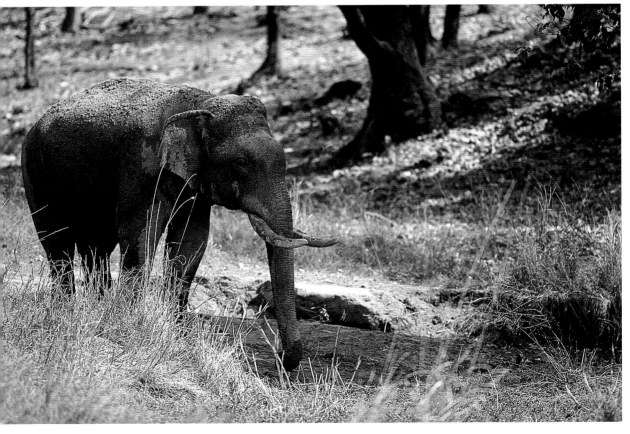

Male

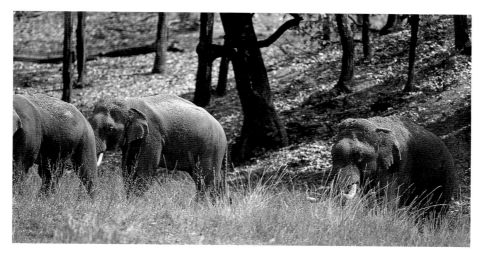

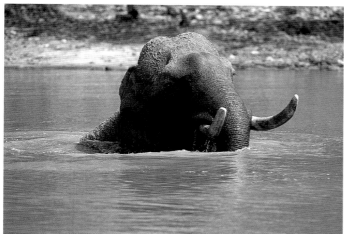

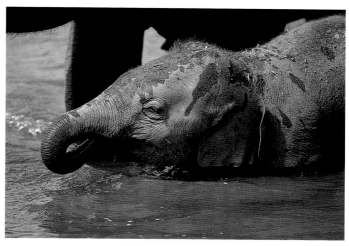

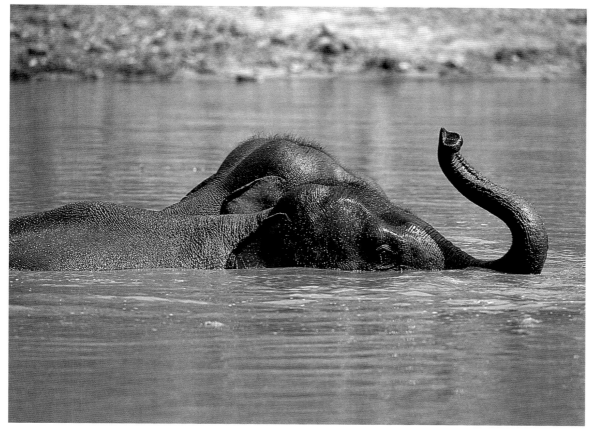

Spotted Deer (Chital)

The spotted deer's natural range includes India and Sri Lanka, but they have been introduced into New Zealand and Australia.

Their habitat includes open forests, forest edges and open grasslands for grazing.

These deer have spots all year round. Only males grow antlers. Each antler typically has three tines, or points, but older bucks may also have one or more false points on their brow antler. They can gather in huge herds.

Fawn

Doe

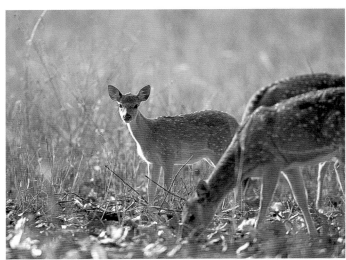

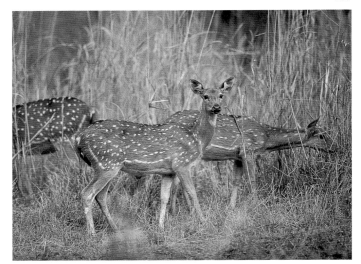

Male

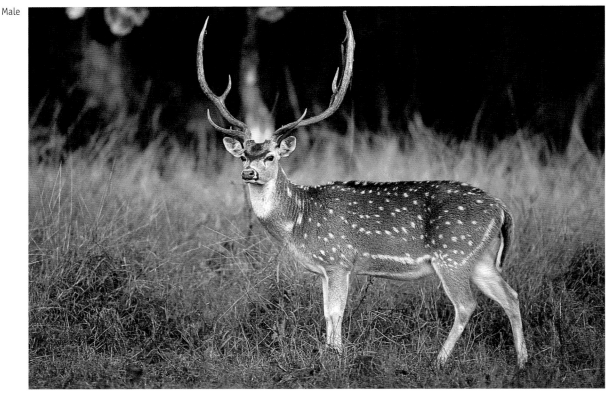

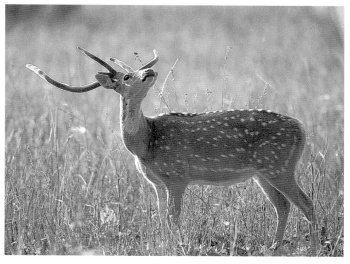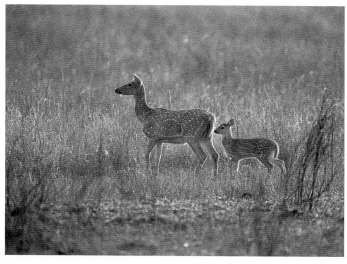
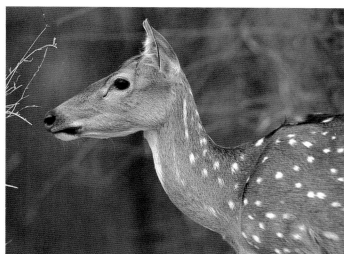
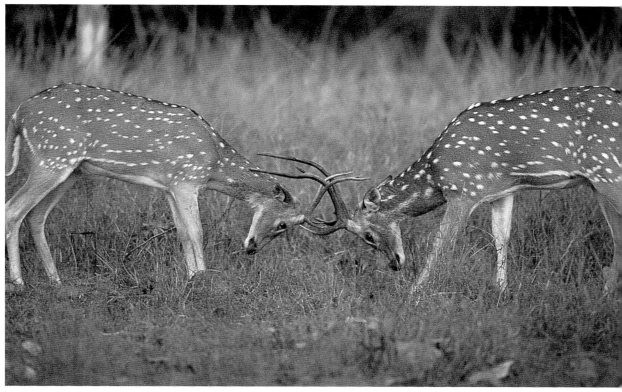

Males sparring

Swamp Deer (Barasingha)

Swamp deer are found in central and northern India and in Nepal.

Swamp deer gather in large herds. As their common name suggests, this deer prefers swamps and marshy grasslands, and they often wade in the water for food, although they can be found in dry grasslands and forests too.

The neck of the male is maned, and the hair of this deer is extremely fine. Only the male (stag) grows antlers (usually six points), and he grows larger than the females (hinds).

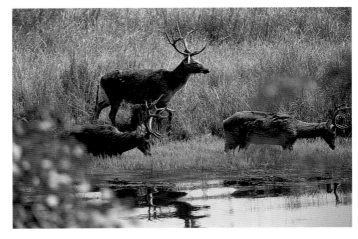

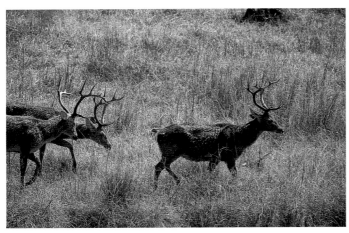

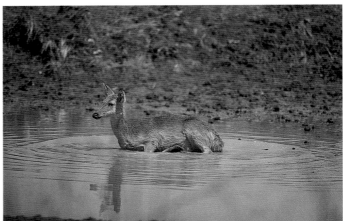

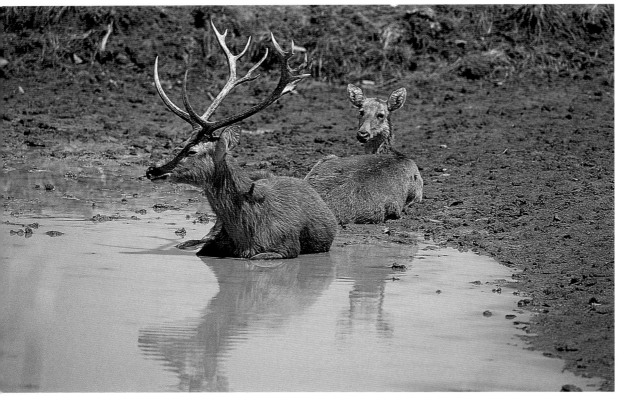

Male and female

Sambar

Sambar are found in southeast Asia, and their natural range extends from India to Burma and southern China, Sri Lanka, Indonesia and the Philippines. They have also been introduced to Australia and New Zealand.

The Sambar's main habitat is woodlands and hillsides. There are several different subspecies of sambar that vary in color and size. Males develop a shaggy mane on their necks in the cold weather months. Only males grow antlers, each of which usually has three points. Females are smaller than males and lighter in color.

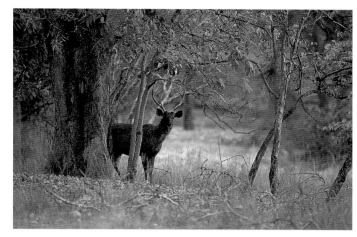

Female with young

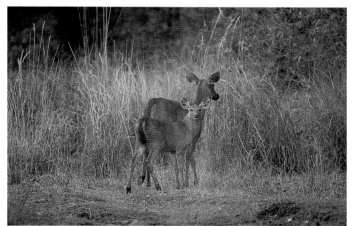

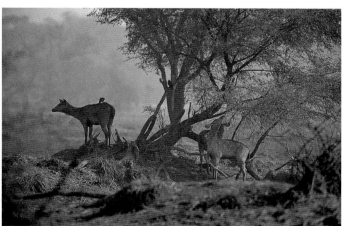

Male

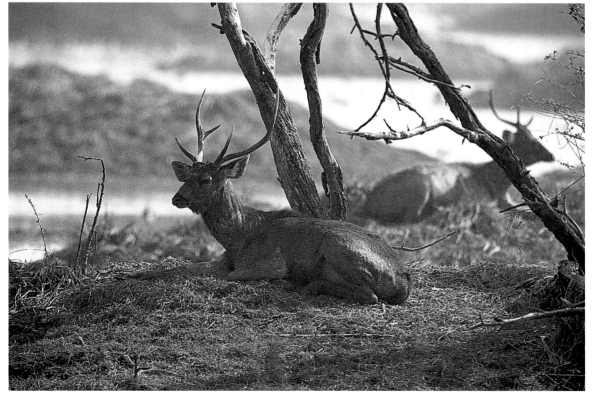

Gaur (Indian Bison)

Gaurs are found in India, Burma, Malaysia and parts of Indochina.

They prefer hilly forests and high altitudes, but travel over lower habitats in search of food.

Males (bulls) grow larger and thicker than females (cows). Both bulls and cows have horns, but the bulls' horns are larger. Bulls are shiny black in color. The cows and young bulls are dark brown.

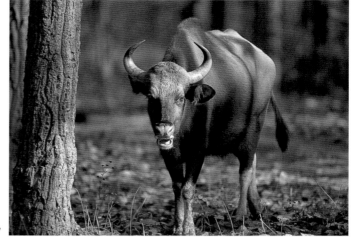

Cow

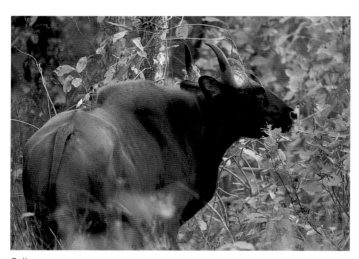

Bull

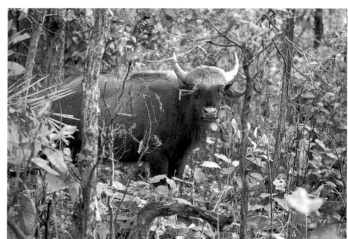

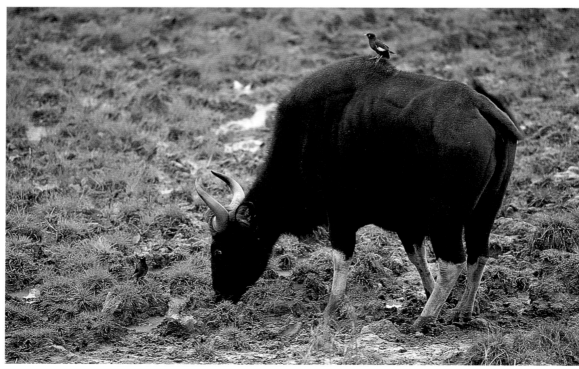

Rhesus Macaque

The rhesus macaque is found in India, Nepal, China, Pakistan, Thailand, Vietnam, Laos, Afghanistan, Bangladesh, Bhutan and Burma.

They use a variety of habitats throughout this range including urban areas in trees and on land.

An average male is larger in size than a female.

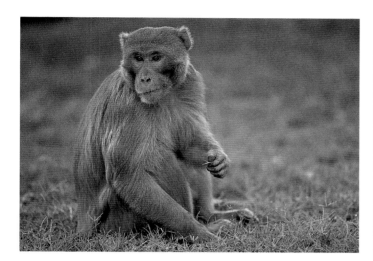

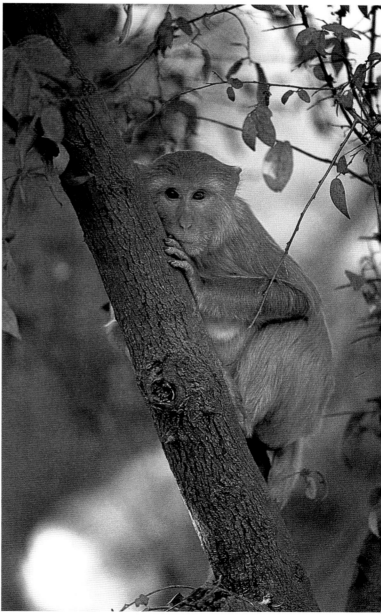

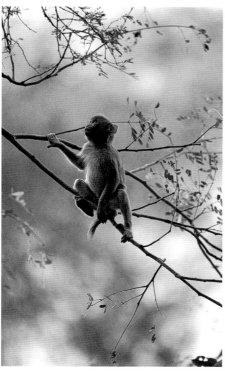

Baby

Hanuman Langur

Hanuman langurs are found in India, Sri Lanka, Nepal, China, Pakistan, Bangladesh, Bhutan and Burma.

They live in trees and on land and use a variety of habitats including cliff and rock dwellings, scrublands and rainforests. They are also common near human civilization, around temples and villages.

Males grow larger than females.

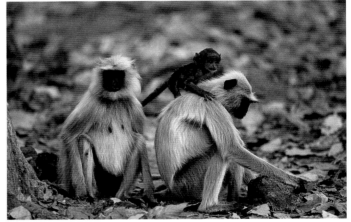

Females with young

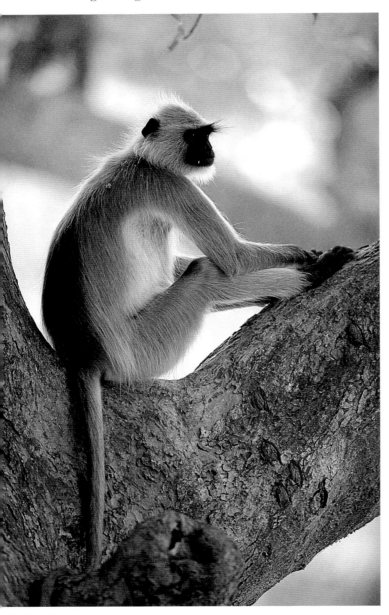

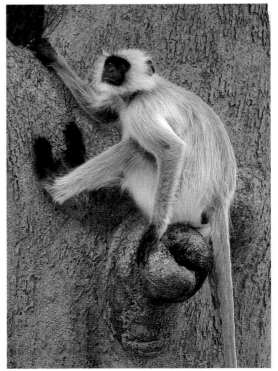

Male

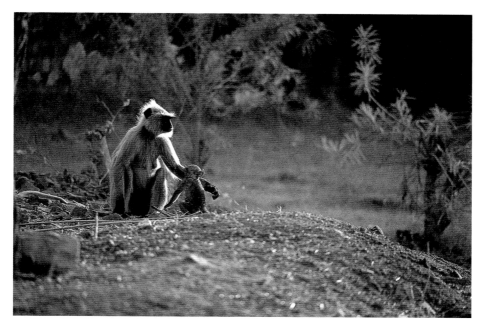

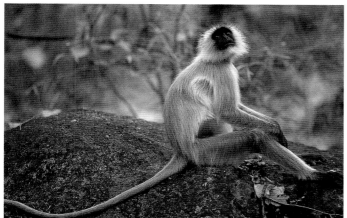

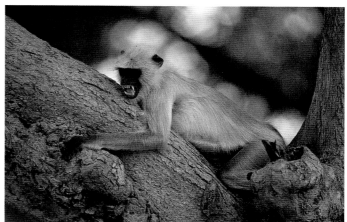

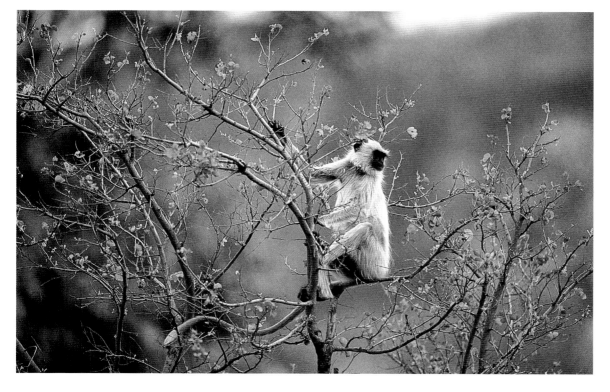

Contributing Artists

Kalon Baughan

Kalon Baughan currently resides in Longmont, Colorado, where he works as a professional wildlife painter. He received his bachelor of fine arts degree in 1988 from Albion College, where he graduated with honors and earned the Outstanding Artist Award. He has painted professionally since then, returning to Albion College as their Artist in Residence from 1992 through 1994. Kalon has also served as an instructor for artists at several art symposiums across the country, including the Acadia Symposium and Wolf Prairie Wildlife Art Symposium and seminars at the University of Tulsa and the *Northern Wildlife Art Expo*.

Kalon has exhibited in many group and one-person shows, and he has been honored as Featured Artist at the *Pacific Rim Wildlife Art Show*, *NatureWorks Oklahoma Wildlife Art Festival*, *Northern Wildlife Art Expo* and the *Prestige Gallery Originals Showcase*. He has also exhibited at the *Southeastern Wildlife Exposition*, *Wendell Gilley Museum National Wildlife Art Showing*, *Vancouver International Wildlife Art Show*, *Michigan Wildlife Art Festival* and the *Grand National Art Invitational*. Kalon has received numerous awards and honors, including several Best of Show, Judges' Excellence, People's Choice and Peer Awards at these various shows. He is a member of the Society of Animal Artists and has been juried into their prestigious annual exhibit. He was named *Michigan Wildlife Artist of the Year* in 1995 and was a Featured Artist for the Rocky Mountain Elk Foundation in 2002. Kalon has been interviewed by CNN Headline News as an up-and-coming artist and has had several articles and references in *Wildlife Art*, *U.S. ART*, *InformArt* and *Art Trends* magazines. He is the author of *Painting the Faces of Wildlife Step by Step* (North Light Books, 2001). Kalon is currently published by Bruce Mcgraw Graphics.

Sueellen Ross

Sueellen Ross combines her passion for making art with her love of animals to create works of strong design and subtle wit. A few years ago, she was known mainly for her work in original intaglio prints, but she has turned more and more to mixed media paintings. She uses a unique combination of India ink, watercolor and colored pencil.

Her work is often included in shows including *Birds in Art* at the Leigh Yawkey Woodson Art Museum and *Arts for the Parks*, and she had a one-woman show at the Frye Art Museum in 1986. She was the Region One Winner at the *Arts for the Parks* competition in 1991. Her North Light book, *Paint Radiant Realism in Watercolor, Ink and Colored Pencil*, was published in 1999. Her work can also be seen in the first two editions of *The Best of Wildlife Art* (edited by Rachel Wolf, North Light Books, 1997 and 1999), *Wildlife Art* (Alan Singer, Rockport Publishers, 1999) and in *Painting Birds Step by Step* (Bart Rulon, North Light Books, 1996). Articles about Sueellen's work have appeared in *The Artist's Magazine*, *Southwest Art Magazine* and *American Artist Magazine*. Her original paintings are represented by Howard/Mandeville Gallery in Kirkland, Washington. Reproductions of her work are represented by the Hadley Companies, Bloomington, Minnesota. Her artwork is included in the permanent collection of the Leigh Yawkey Woodson Art Museum.

Grassy, John, and Keene, Chuck. *National Audubon Society First Field Guide: Mammals*. New York: Scholastic Inc., 1998.

Ulrich, Tom J. *Mammals of the Northern Rockies*. Missoula, Montana: Mountain Press Publishing Co., 1990.

Winnie, John Jr. *High Life: Animals of the Alpine World*. Flagstaff, Arizona: Northland Publishing, 1996.

Forsyth, Adrian. *Mammals of North America: Temperate and Arctic Regions*. Buffalo, New York: Firefly Books Ltd., 1999.

Alden, Peter. *Peterson First Guides Mammals*. Boston, Massachusetts: Houghton Mifflin Co., 1987.

Craighead, Lance. *Bears of the World*. Stillwater, Minnesota: Voyageur Press, 2000.

Alderton, David. *Wild Cats of the World*. New York: Facts on File Publishing, 1993.

Stuart, Chris and Tilde. *Field Guide to the Larger Mammals of Africa*. Sanibel Island, Florida: Ralph Curtis Books, 1997.

Estes, Richard D. *The Safari Companion: A Guide to Watching African Mammals*. Post Mills, Vermont: Chelsea Green Publishing Co., 1993.

MacDonald, David, ed. *Encyclopedia of Mammals*. New York: Facts on File Publishing, 1987.

Boitani, Luigi and Bartoli, Stefania. *Simon and Schusters' Guide to Mammals.* New York: Simon and Schuster, 1990.

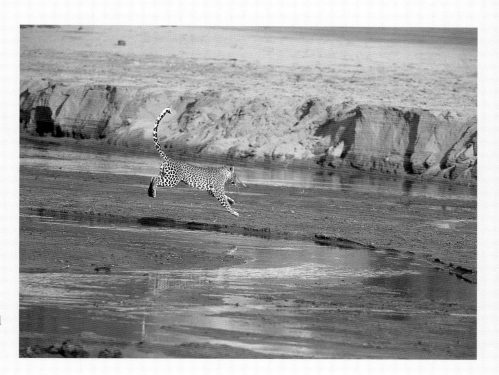

Index

A

Acrylics, using, 26-29, 76-78, 94-97
African elephant, 110-111
African wildlife, 100-121
Alligator, American, 81-83
Aquatic wildlife, 80-99
Asian elephant, 130-131
 See also African elephant

B

Baby
 alligator, American, 82
 cottontail, eastern, 74
 rhesus macaque, 137
 white rhinoceros, 114
 See also Cub, black bear; Fawn; Kid
Backgrounds, 128
 blocking in, 27
Backlighting, 12, 60
Barasingha, 134-135
Baringo giraffe, 109
Baughan, Kalon, 58-63, 140
Bear
 black, 46-47
 brown, 42, 44-45
Bengal tiger, 124
Billy, 34
Bison, 32-33
 Indian, 136
Bobcat, 54-55
Bracketing, 12
Brushes
 acrylic, 26-29, 94-97
 ink, 76
 oil, 58, 60-63
 watercolor, 76, 126-129
Buck
 deer, 16, 18, 20
 deer, spotted, 132
 pronghorn, 36
Buffalo, cape, 112-113
Bull
 bison, 32
 cape buffalo, 112
 caribou, 22
 elk, 24-29
 gaur, 136
 moose, 30-31
Burchell's zebra, 118-119

C

Calf
 moose, 30, 32
 killer whale, 84
Camera
 choosing a, 10
 composing with a, 12
 medium format, 59
Cape buffalo, 112-113
Caribou, 22-23
Cheetah, 106-107
Chipmunk, Townsend's, 68-69
Chital, 132-133
Color
 gradating, 60
 muddy, avoiding, 60
Colored pencils, using, 76-79
Color rendition, film, 11-12
Colors, mixing
 blue, 60
 brown, 96
 flesh, 78
 gold, 78
 gray, 60
 green, 27, 61, 77, 129
 orange, 60
 pink, 60
 yellow, 61
Cottontail, eastern, 74-75
 painting, 76-79
Cougar, 56-57
 painting, 58-63
Cows
 bison, 32
 cape buffalo, 112
 caribou, 22
 elk, 24, 26-29
 gaur, 136
 moose, 30
Coyote, 42, 50-51
Cub, black bear, 46

D

Deer
 as prey, 56
 black-tailed, 20-21
 mule, 18-19
 spotted, 132-133
 white-tailed, 16-17
Demonstrations
 cottontail, in mixed media, 76-79
 cougar, in oil, 58-63
 elk, in acrylic, 26-29
 sea otters, in acrylic, 94-97
 tiger, in watercolor, 126-129
Depth, illusion of, 29
Depth of field, 11
Doe
 deer, 16-18, 21
 deer, spotted, 132
 pronghorn, 36
Drawings, transferring, 95
Drawing studies, creating, 59, 76, 127

E

Edges, hard, avoiding, 29
Elephant
 African, 110-111
 Asian, 130-131
Elk, 24-25
 painting, 26-29
Equipment, photographic, buying, 10-12
Ewe
 bighorn sheep, 38
 Dall's sheep, 40

F

Fawn
 deer, 16, 20
 deer, spotted, 132
 pronghorn, 37
Film, 11-12, 58
Fisher, 64, 72-73
Flowers, 76-79
Focal point, planning a, 59
Foliage, 61
 See also Flowers; Grass; Trees; Vegetation
Fox, red, 11, 52-53
Frontlighting, 12

G

Gaur, 136
Giraffe, 108-109
Grass, 128
 See also Flowers; Foliage; Trees; Vegetation
Grizzly bear, 42, 44-45
 See also Bears, black

H

Habitat. *See* Photographs, habitat
Hanuman langur, 138-139
Hinds, swamp deer, 134
Hippopotamus, 116-117

I

Impala, 120-121
India ink, using, 76
Indian bison, 136
 See also Bison
Indian wildlife, 122-139

K

Kenyan giraffe, 108
Kid, 34

L

Lamb
 bighorn sheep, 38
 Dall's sheep, 40
Lenses, camera, 10-11, 26, 58, 126
Leopard, 104-105
Light
 low, photographing in, 11
 path, estimating the, 29
Lighting, consistent, achieving, 26-29, 58-59
Lion, 102-103

M

Mammals
 hooved, 14-41
 small, 64-79
Masai giraffe, 108
Masking, 78
Media, mixed, using, 76-79
Monopod, using a, 11
Moose, 11, 30-31
Mountain goat, 34-35

N

Nanny, 34

O

Oils, using, 58-63
Orca, 84-85
Otter
 river, 98-99
 sea, 92-93
 sea, painting, 94-97

P

Paper
 charcoal, 59
 cold-pressed, 126-129
 hot-pressed, 76-79

Paintings
 Contentment, 63
 *Desert Cottontail in Desert
 Marigolds*, 79
 Into the Light, 29
 Sea Otters, 97
Pencil, charcoal, 59
Pencils, colored, 76, 78-79
Photographs
 combining, 9, 26-29, 58-63, 94-97
 taking, 10-13
Photographs, using, 8-9
 habitat, 10, 26
 landscape, 59
 zoo, 48-63
Predators, 42-63
Print film. *See* Film
Pronghorn, 36-37

R

Rabbit. *See* Cottontail, eastern
Raccoon, 70-71
Ram
 bighorn sheep, 38
 Dall's sheep, 40
Reflections, painting, 95
Reindeer. *See* Caribou
Rhesus macaque, 137
Rhinoceros, white, 114-115
Rocks, painting, 60, 63
Ross, Sueellen, 76-79, 140
Rothschild's giraffe, 109

S

Sambar, 135
Sea lion, California, 86-87
Sea otter, 92-93
 painting, 94-97
 See also Otter, river
Seal
 harbor, 88-89
 northern elephant, 90-91
Sheep
 bighorn, 38-39
 Dall's, 40-41
Shutter speed, 11
Sidelighting, 12
Sketches, thumbnail, 27, 95
Slide film. *See* Film
Squirrel, eastern gray, 66-67
Stag, 134
Stallion, zebra, 118

Subjects, composing, 12
Subspecies
 Bengal tiger, 124
 deer, 20-21
 giraffe, 108-109
 sambar, 135
Surfaces
 panel, hardboard, 26-29
 panel, RayMar, 58-63
 paper, charcoal, 59, 76-79, 126-129

T

Techniques
 blending, 28-29, 97, 127
 blocking in, 27, 95-96
 drybrushing, 61-63, 128
 glazing, 28-29, 97
 scumbling, 28-29
 washes, 127-129
 wet into wet, 97, 129
Tension, visual, creating, 59
Texture, adding, 62, 96
Tiger, 123-125
 painting, 126-129
Tortilion, using a, 127
Trees, 62, 128-129
 See also Flowers; Foliage; Grass; Vegetation
Tripod, using a, 11, 26

U

Underpainting, 60-61, 97, 127

V

Values, blocking in, 60
Vegetation, 77-79
 See also Flowers; Foliage; Grass; Trees
Vibration reduction, in cameras, 11

W

Watercolor, using, 76-77, 126-129
Water, painting, 95, 97
Whale, killer, 84-85
Wildlife
 aquatic, 80-99
 in nature, approaching, 12-13
 of India, 122-139
 of Africa, 100-121
Wolf, 42
 gray, 48-49

Z

Zebra, plains, 118-119

Capture the *Beauty* and *Power* of Nature in Your Paintings!

With clearly annotated pictures and easy-to-follow technique demonstrations, this accessible guide highlights common problems and simple solutions for creating more realistic renditions of animals. You'll learn to portray a variety of popular animals accurately and gracefully in a wide array of mediums including watercolor, charcoal, pastels, acrylic, and more.
ISBN-13: 978-0-7153-2223-9, paperback, 128 pages, #41835
ISBN-10: 0-7153-2223-0, paperback, 128 pages, #41835

Learn how to create mysterious, atmospheric nature paintings! Whether rendering scales, feathers, sand or fog, dozens of mini-demos and step-by-step guidelines make each step easy. You'll learn to paint the trickiest of details with skill and style. A final, full-size demonstration, combining animals with their environment, focuses all of these lessons into one dynamic painting.
ISBN-13: 978-1-58180-457-7, paperback, 128 pages, #32709
ISBN-10: 1-58180-457-1, paperback, 128 pgs, #32709

Through step-by-step demonstrations and magnificent paintings, Patrick Seslar reveals how to turn oils, watercolors, acrylics or pastels into creatures with fur, feathers or scales. You'll find instructions for researching your subject and their natural habitat, using light and color and capturing realistic animal textures.
ISBN-13: 978-1-58180-086-9, paperback, 144 pages, #31686
ISBN-10: 1-58180-086-X, paperback, 144 pages, #31686

This new book in the bestselling No Experience Required series includes 6 step-by-step demonstrations and 10 exercises to show you how to depict a variety of animals in a full range of mediums. Perfect for beginners, the exercises in this easy-to-follow guide are designed to yield immediate improvement in your work. You'll learn to use the most popular mediums including watercolor, pen and ink, pencil, and colored pencil to create a range of appealing animal subjects including cats, dogs, wild birds, horses and farm animals.
ISBN-13: 978-1-58180-607-6, paperback, 112 pages, #33165
ISBN-10: 1-58180-607-8, paperback, 112 pages, #33165

These books and other fine North Light titles are available from your local art & craft retailer, bookstore, or online supplier.